W9-BFM-200

PAINTING:
Ideas,
Materials,
Processes

PAINTING:
Ideas,
Materials,
Processes

Virginia Gayheart Timmons
Art Specialist, Secondary Schools
Baltimore Public Schools, Maryland

DAVIS PUBLICATIONS, INC.
WORCESTER, MASSACHUSETTS

Copyright 1978
Davis Publications, Inc.
Worcester, Massachusetts, U.S.A.

All rights reserved. No part of this publication
may be reproduced or transmitted in any form
or by any means, electronic or mechanical,
including photocopying, recording, or any
storage and retrieval system now known or to
be invented, except by a reviewer who wishes
to quote brief passages in connection with a
review written for inclusion in a magazine,
newspaper or broadcast.

Printed in the United States of America
Library of Congress Catalog Card Number:
78-58904
ISBN 0-87192-102-2

Graphic Design: Diane Nelson

Consulting Editors: George F. Horn and Sarita
R. Rainey

Title page: *Constellation # 18A*. Acrylic. Allan
D'Arcangelo. New Jersey Museum Col-
lection, Trenton.

Copyright page: *Portrait*. Oil wash. Student,
John Marshall High School, Los Angeles.

10 9 8 7 6

Contents

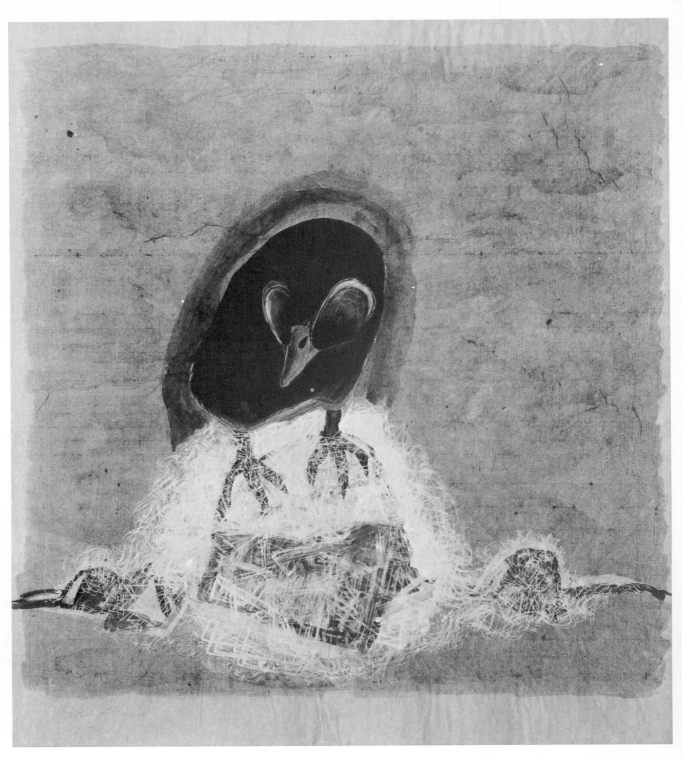

Blind Bird. 1940. Gouache. Morris Graves.
Collection, The Museum of Modern Art.
What does the bird symbolize to you? What
lies below the tangled web of white lines?
What mood does the painting suggest?

Understanding Painting

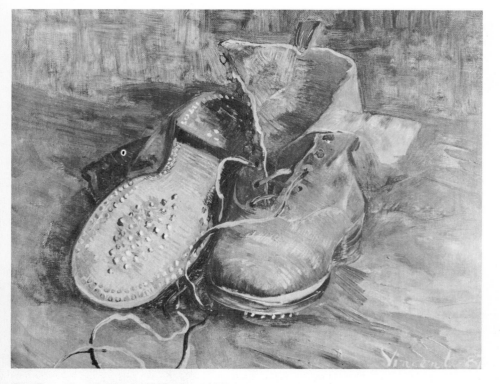

The Shoes (Les Souliers). 1887. Vincent Van Gogh. The Baltimore Museum of Art. Subject matter need not be pretty. What kind of person wore these shoes? Why do you think Van Gogh found the shoes interesting?

Long before people learned to write, they painted pictures. Ages before they developed symbols or letters for telling a story or recording history, people discovered a way to draw and paint pictures on the walls of the caves they inhabited. Faced with the unending struggle of obtaining food, clothing and shelter, why did early people somehow find time and the means to make pictures? The discovery that a charred stick left a mark on the wall of a cave or that certain dried clays or mud produced colors could be termed accidental. They are the kinds of discoveries a small child might make. But what of the urge or idea to use these discoveries to make pictures? The answers to many of these questions, particularly those related to materials, are lost in the darkness of the ages. However, paintings produced in the early ages have provided us with answers to part of the riddle: people have a need to express themselves, to say something, in ways that are not provided through spoken or written language. Painting is one of the ways people use to communicate their ideas, their responses to their environment, whether real or imaginary.

Subject Matter and Content

What can a painting tell us? If it were possible to see in one giant, imaginary gallery a sampling of the paintings produced throughout the ages, we would find that the artists have told us many things about themselves, their lives, their societies and cultures, their fears, loves, aspirations, and the gods they worshipped that were their subjects. Each painting differs because each painting reflects the artist's personal vision. It states how he or she saw an object, place or person; or how the artist felt about a circumstance or event. Furthermore, the artist has selected the painting material, technique and style that will best support what is to be communicated. This expression of personal feeling is essential in all truly creative and lasting art. Without personal expression, painting becomes an empty attempt to imitate nature, to produce "pretty" pictures or to duplicate the work of the camera.

But *what* have artists painted? Getting back to our imaginary gallery, let us look at the paintings more closely. There are people, animals, houses, landscapes, machines, city streets and objects from everyday life, including bowls of fruit or flowers, newspapers and old shoes. Toward the end of the gallery, are canvases that are covered with great expanses of flat colors and lines, nothing more. Artists have selected these things as *subject matter,* as motifs through which they communicate to us their impressions or feelings about what they have seen, felt or imagined.

But look again! In the gallery there are hundreds of paintings of people involved in various activities. What are the artists saying about these people, about the way they behave, about the things they do? There are card players, workmen, soldiers, dancers, politicians, clowns and mothers. Does the artist say that the soldiers are fighting an honorable, glorious battle? Or that they are inflicting destruction and suffering on innocent victims? Are the workmen proud of what they do? Or are they hopeless and down-trodden? These messages, impressions, or personal feelings go beyond the *subject matter* shown to tell us how they feel about war, human labor and how people are affected by them. This message is the *content* of the painting, the *feeling* that inspired the artist to create the painting. All artists, of course, are not intent on making judgements about their fellow human beings. Many have aimed to describe a particular scene or person in such a way that we might see the subject more clearly, or in a different focus: the patterns created by dancing reflections on water, the wrinkles and lines in an aging face or the textures and shapes in a still life of fruits and bottles. Other artists tell stories or report events that may be based on actual historical facts. Or they may illustrate myths, fables or events described in poetry or fiction. These paintings serve a different purpose but are still products of the artist's own imagination.

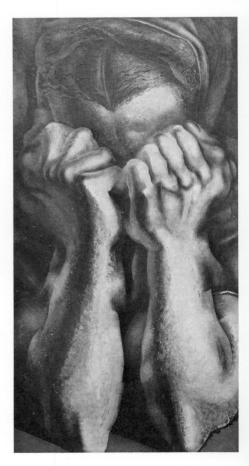

The Sob. 1939. Duco on composition board. David Alfaro Siqueiros. The Museum of Modern Art. Intense emotion is expressed in the tightly clenched hands. The hands are emphasized by distortion and strongly contrasting lights and darks. What do the hands tell us about the person who is sobbing?

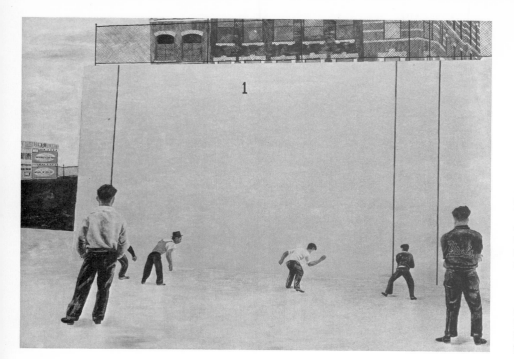

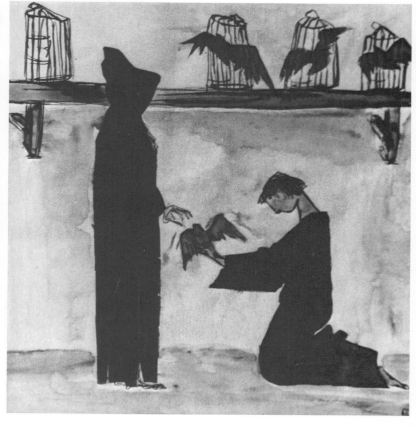

Handball. 1939. Tempera on paper over composition board. Ben Shahn. Collection The Museum of Modern Art, New York, Abby Aldrich Rockefeller Fund. Does this scene appear entirely realistic to you? What does the painting communicate? Is it really descriptive of a game of handball?

Death. Mixed Media. Student, Baltimore Public Schools. Starkly black figures evoke feelings of submission and finality. What does the bird symbolize to you?

Man of Sorrows. 1951. Tempera, 28″ x 24″. Peter Blume. Whitney Museum of American Art. In a surrealistic combination of fantastic and realistic forms, the artist expresses a violent and tortured view of a religious subject. What is the significance of the symbols in the lower right corner?

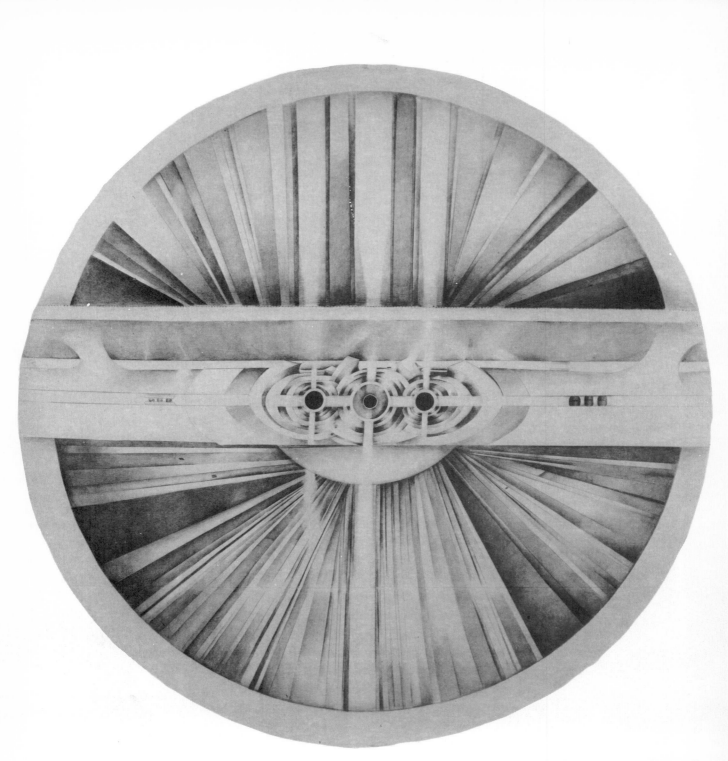

Untitled. 1963. Pencil and soot on muslin. Lee Bontecou. Whitney Museum of American Art. Contemporary artists do not hesitate to use unusual materials in a painting. What effect is achieved by the use of soot? Could this effect be obtained in another way?

The Frozen Sounds, Number 1. 1951. Oil, 36″ x 48″. Adolph Gottlieb. Whitney Museum of American Art. Abstract symbols appear suspended or frozen in the space that surrounds them.

A Little Paragraph of Red. Acrylic. Richard E. Barringer. John A. Waggaman photo, courtesy Nicholas Roukes. This "hard edge" painting is concerned with the formal relationship of geometric forms and values.

What of those paintings in which we cannot discover a single familiar object, those that are colored shapes and lines? How about those canvases that are inhabited by creatures we have never seen before, or in which familiar beings and objects are "behaving" in most unnatural ways? What is the artist saying, if anything? How do we find the clue to understanding what the artist would have us see or feel?

Often, for one to understand paintings that contain no recognizable objects, persons or situations demands involvement, or participation, in attempting to see as the artist sees. Titles can provide a clue that will help us to understand a painting; a title, such as *Sunrise #7,* may explain or interpret the orange and pink explosions of color. In other instances, the title provides no clue. We are left to our own devices. It helps to know that many artists do not feel an obligation to "communicate" with us nor to make their messages clear. They are concerned with mathematical relationships or illusions created by overlapping shapes, lines and colors. If these paintings are intriguing, innovative and hold our interest, well and good. There are still other artists for whom the *act* of painting is all-important. Their spontaneous, intuitive application of paint is apparent in the canvases they produce.

We need not like all the paintings that we see. Indeed, we may be repulsed by their subject matter, content or by their lack of them. We can, however, come to understand them and, through involving our own minds, imaginations and feelings, the artists who painted them.

Periods, Movements, Styles

In discussing a particular artist or a painting, a speaker will often say that an artist belongs to, or is identified with, a particular period, movement or style. What do these terms mean? Generally, they identify an artist as having worked during a certain period of time; with a group who shared the artist's beliefs about painting; or as having worked with materials or techniques in a specific way. For example, we say that Jacques Louis David was an artist of the *Neo-Classic* period, that Seurat painted in the *Pointillistic* style, and that Duchamp was a prominent member of the *Futuristic* movement. Are these *labels* of any use as we look at the paintings of the past and at those of our own time? Is a knowledge of these classifications essential to our understanding or appreciation of a painting? Not necessarily. They do assist us, however, in understanding the influences and events that affected the artist that time in history. These influences have included the prevailing ideas of the society in which the artist lived, scientific discoveries, inventions and the philosophies of what art should be. The more we know about these things, the more we can understand and appreciate what artists are attempting to communicate.

This chapter contains examples of paintings from various periods of time, from different movements and exhibiting a wide diversity of styles. Study them carefully! Then, decide which of the styles or approaches you feel best expresses what the artists are attempting to communicate.

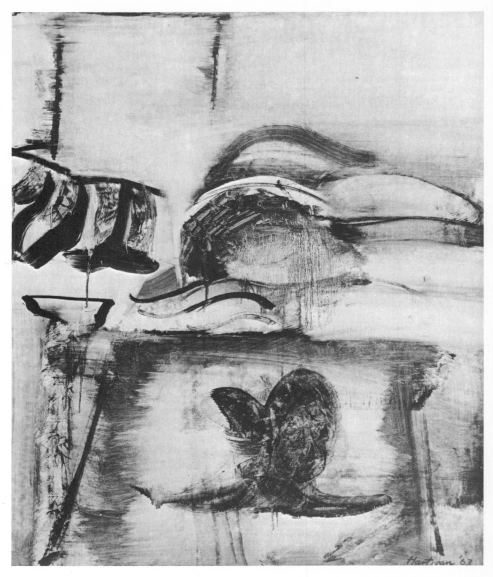

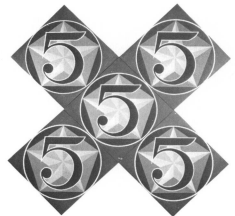

Pond Memories. 1962. Oil on canvas. Grace Hartigan. Courtesy Bocour Artists Colors. One of America's foremost contemporary painters, Hartigan is associated with abstract expressionism, in which artists translate both visual experience and emotion. Expressionistic paintings are usually characterized by strong colors and bold, energetic applications of paint.

The X-5. 1963. Oil on canvas. Robert Indiana. Whitney Museum of American Art. Pop artists focus on the signs and symbols of popular culture and advertising. Why do you think Indiana repeated the single element instead of painting other numerals?

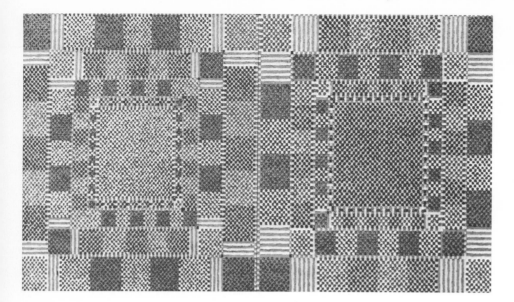

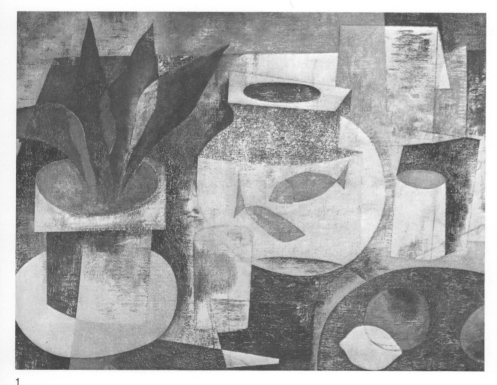

1

Timaeus III and IV (Diptych). 1966. Oil on canvas. Alfred Jensen. Whitney Museum of American Art. Minute squares, rectangles, and stripes of color create a pattern similar to a tapestry or weaving. Clearly, the artist's concern is not with "telling a story" nor with describing an object we might recognize. His concern is with colors, patterns and shapes. Do you find the subtle variations in value and shape interesting?

Changing Styles. Artists often change their styles, or manner, of painting as their experiences in art and life lead them to seek new artistic solutions. As an example of this kind of change, look at two examples of the work of Burton Wasserman, a contemporary American artist. The first painting was done in 1960, the other in 1974. Which painting requires more participation by the viewer?
(1) *Still Life.* 1960. Oil. Burton Wasserman. Although reduced to flat geometric shapes, the forms are recognizable. There is no attempt to simulate three-dimensional form or deep space; there is no foreground, middleground or background. The influence of Cubism is clearly apparent.
(2) *Untitled.* 1974. Oil on canvas. Burton Wasserman. There is no longer any reference to recognizable forms nor to conventional "principles" of traditional art. In the artist's own words, "—all of the shapes and colors in a surface simultaneously advance and recede. . .they quiver and vibrate with a life of their own." Look at this illustration closely: can you see the shifting, changing relationships the artist describes?

2

Periods, Movements, Style **7**

Judging a Painting: Good or Bad?

What determines the quality of a painting? What makes one painting *good* and another *bad*? Why have some paintings survived through the centuries while others have not? The answers to these questions have varied. In the Classical Period of Greece and during the Renaissance in Italy, it was felt that there existed a principle of "ideal beauty" by which all paintings could be evaluated; even then there were differences of opinion. Realism, or *truth to nature,* was still another standard. It, too, was debated by artists who could not agree as to what was real. In our own time, scientists and artists see new relationships between matter, space, energy, movement and time that point us to a new concept of reality. They incorporate symbols, or metaphors, that have meaning far beyond their outward appearance.

But where does all this leave us as we attempt to judge or evaluate paintings? In seeking an answer, let us review what we have said earlier: *The expression of feeling is essential to all good painting.* The artist sees, *feels* and then selects those forms and colors that will best express his or her feelings and reactions. Without this special quality, a painting becomes inconsequential except as decoration. We have all seen this kind of painting. Sometimes it is referred to as *calendar* art when it sinks to the level of slavish imitation of nature or sentimentality. It is often pretty or pleasant but, after a time, we no longer *see* it because it lacks that mystical quality that excites our continuing interest.

Aside from the characteristic of feeling, or intense emotional quality, a painting also possesses a *visual unity;* it "hangs together," it makes *visual* sense. This unity, or sense, is achieved through the skillful handling of the elements and principles artists use in solving the problems they have set for themselves—form, color, rhythm and movement. It is through these elements and principles that the painter achieves the total effect, or *composition.*

In the past, the manner in which artists used their materials was considered in the judgement of their work. Oil paints were to be applied in a certain manner, watercolors were not to be used in a "serious" painting, painting media were not mixed and only conventional painting tools were to be used. Most of these taboos have disappeared in today's climate of experimentation and exploration. Contemporary painters use any material available that will, in their opinions, support their visual statements.

In judging the worth of a painting, it is well to keep in mind that a painting usually possesses a certain mystical element, a certain something that we cannot always define. The total effect is, somehow, greater than the parts, or elements, that the artist has put together.

Our understanding will grow as we learn to see as the artist sees and as we become more familiar with those elements and principles with which the artist works. In the following chapter, we will examine those elements and principles in greater detail.

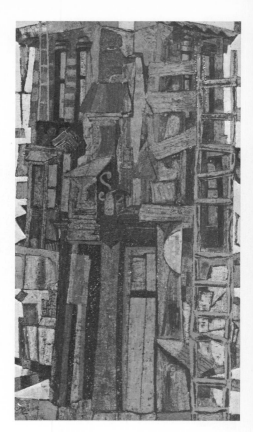

Harlem. 1952. Polymer tempera on canvas. Karl Zerbe. Museum of Modern Art. How has the artist unified the architectural shapes? What is the painting about?

Blue and Yellow. Acrylic. Kenneth Noland. Courtesy Bocour Artists Colors, Inc. Contemporary artists often employ personal symbols that provide little insight as to what their meanings are. In looking at these paintings we are required to put aside our ideas of conventional organization of the art elements.

Adam and Eve. Acrylic. Student, Fort Lee (N.J.) High School. Joan DiTieri, instructor. Biblical themes provide a rich source of ideas for painting. Note the patterns and textures achieved through the repetition of shapes in the foreground and in the figures. The *negative* spaces have been divided in areas that relate to the positive shapes of the figures and tree forms.

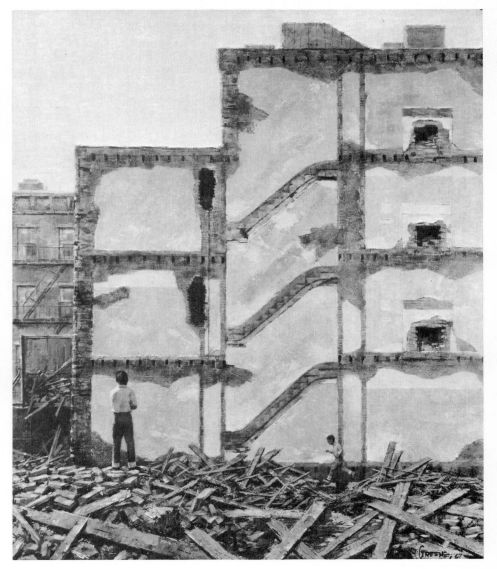

Playground. 1967. Acrylic. Mark Green. Courtesy M. Grumbacher, Inc. Pattern and movement are created by the repetition of the shapes and values in the partially-razed building. Plain and textured areas are balanced. What is the artist saying about this playground?

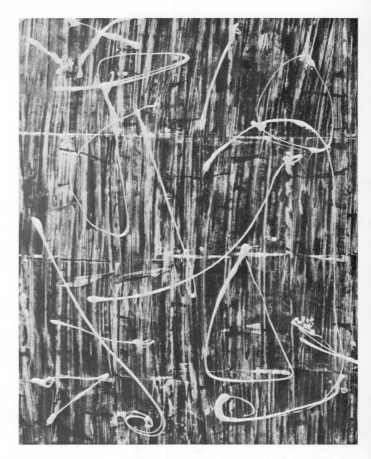

Charred Journal. Acrylic. Morris Louis. Collection Bocour Artists Colors. Light lines, similar to calligraphy, move quickly over a boldly brushed dark background. It is sometimes difficult for the viewer to understand symbols such as these which arise from the artist's personal feelings and experiences. They demand that we become involved by using our own imaginations. What do you see here?

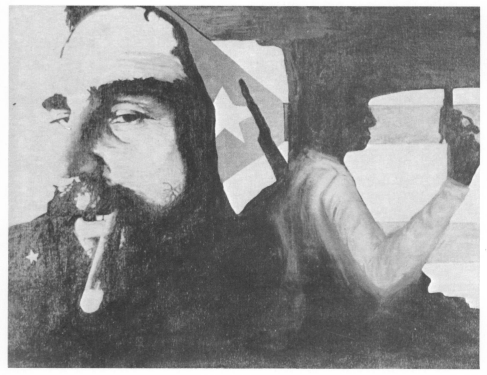

Untitled. Acrylic on canvas. Student, Fort Lee (N.J.) HIgh School. Painting can communicate the artist's feelings about the violence of revolution and war.

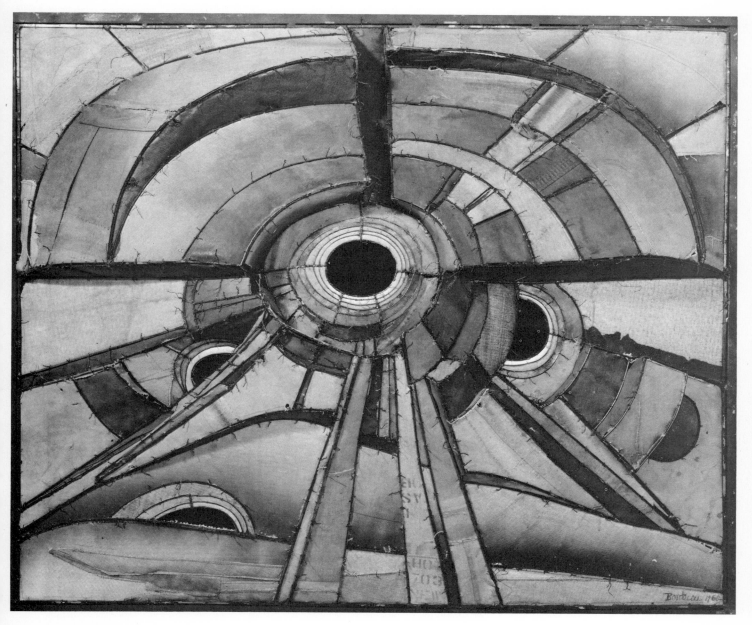

Untitled. 1960. Metal and canvas, 43½″ ✕
51⅝″. Lee Bontecou. Albright-Knox Art Gal-
lery, Buffalo, N.Y. Gift of Seymour H. Knox.
The works of contemporary artists are not
always easily classified. In this example,
pieces of canvas are attached (with copper
wire) to a welded steel framework which
projects 12 inches from a flat background.
The color of the canvas is changed by the
flame of a blow torch. Is it a ''painting'' or a
sculpture?

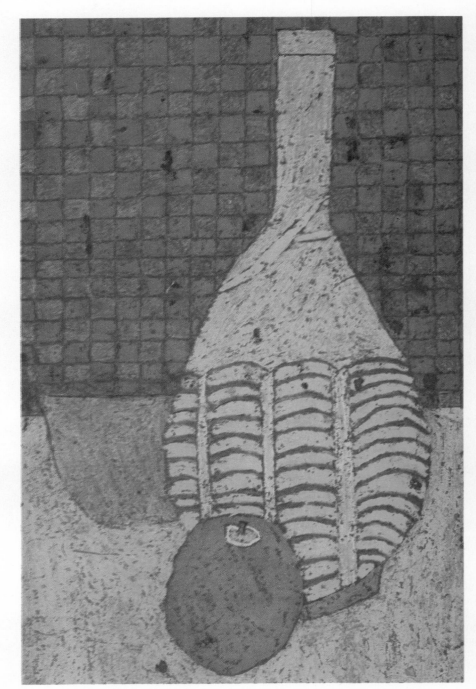

Wine Bottle with Apple. Student, Baltimore Public Schools. India ink over heavily applied wax crayon. When ink had dried, the entire surface was scraped with a dull knife blade.

Design in Painting: Organization

Abstract. Tempera. Student, Sarah Zumwalt Jr. High School, Dallas. Courtesy Susan Bethel. Based on an actual still life arrangement, the abstract shapes suggest plants and leaves. The flat areas are brilliant bold tones of red, green and blue-greens.

In designing or organizing a painting, the artist makes use of certain tools or devices to achieve the visual unity referred to in the preceding chapter. These tools are the elements and principles of design that determine the final, total effect the artist is attempting to express. These elements and principles are present in paintings of both the past and present, although artists have chosen to make use of them in different ways. Many contemporary artists discard the deliberate use of these traditional principles almost entirely. Instead, they choose to organize or compose their paintings freely or intuitively as they paint. Even in their freedom, however, these artists exhibit an awareness of the relationships between lines, colors, shapes and textures. We shall examine these and other painting styles in the following chapters.

As you gain experience in painting, you will develop a *style,* or method of working, that seems right for you. In the beginning, however, it is good to examine how artists have historically composed their paintings. It will help you in understanding why they painted as they did and, perhaps, assist you in discovering a style or method that you will enjoy in your own painting.

After selecting subject matter, the artist must decide how to arrange it on the painting *ground,* the canvas, paper or other support. In arranging it, the artist's main concerns are *line, shape, color* and *value.* These elements, along with *space* and *texture* are referred to as *art elements.* In using these elements the artist observes certain *principles of design — balance, movement, rhythm* and *emphasis*—which are essential to harmony or visual unity. The art elements are the artist's tools; the principles of design guide him as he uses these tools.

These elements and principles are not as complex nor as difficult to understand as they might seem if we remember that they do not function or work alone. They are interrelated and should work together to produce a unified composition. Until we become more familiar with the elements and principles of design as they function together, perhaps it is easier to consider them separately to learn how each contributes to painting.

THE ART ELEMENTS: The Basic Tools

Line

Line is perhaps the first art element all of us encounter: as very young children we scribbled with pencil or crayon. At first, the scribbles represented our exploration and discovery that, by pushing and pressing the crayon, we could make marks or lines on paper. Later, we used the crayon to create shapes or to draw pictures of people, animals and the objects around us. In preparation for painting, the artist uses line in a similar manner: objects and people exist in three-dimensional space but the painter, working in two dimensions, uses line to define shapes or forms.

Lines rarely exist in nature; there are only forms, or *shapes,* that we see in relationship to one another. To express this relationship, the artist draws lines to outline form or shapes which are organized in the composition.

Lines can do more than define the contour or shape of an object. Lines can express moods or ideas: tall, *vertical* lines may express dignity, growth and strength; *horizontal* lines express calm, rest, quiet and breadth. *Diagonal* lines create a feeling of movement, excitement, unrest and instability. *Broken* lines, as in a battle scene, cause us to feel conflict, chaos and disorder. Even the varying thicknesses of lines express moods: thin curved lines denote delicacy and grace; thick, heavy lines suggest boldness, and strength.

Movement and *direction* expressed by lines are familiar to all of us: an arrow points the way, lines direct us across streets, down corridors and off or onto expressways.

Lines printed on wrapping paper and fabric create *patterns.* In a painting, lines may simulate the grain of wood or the fuzziness of fur—the *textures* of actual materials.

The kinds of lines we have been discussing so far are lines we can see—they are drawn or painted. There is another kind of line. It is not drawn or painted; it is a line created by the way in which objects are arranged. This type of line is called *implied line;* it is suggested line. An example of implied line can be seen in a painting of a long lane of trees, a row of buildings, a line of soldiers, or a row of plants on a windowsill; they all suggest horizontal lines. Think of the moving, changing line patterns created by a marching band as they perform at a football game.

Study the illustrations in this chapter to see how line is used to define shape, create patterns or textures and how the implied lines emphasize the mood or feeling in the painting.

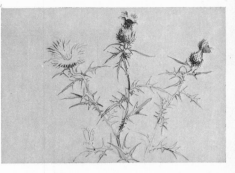

Study of Thistle. 1961. Conté crayon on paper. Charles Burchfield. Whitney Museum of American Art. Thin jagged lines are used to express the prickly, sharp character of the thistle plant.

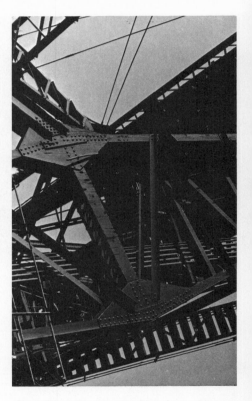

Steel. The criss-crossing lines formed by steel framework in giant machinery and bridges suggest ideas for composition in painting.

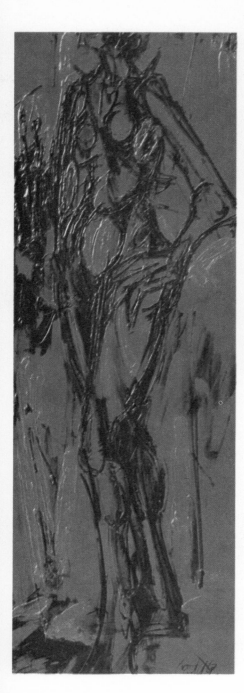

Abstract. Acrylic. Student, Bryan Adams
High School, Dallas. Nancy Miller, instructor.
Lines are used to create movement and pat-
tern against an otherwise plain, flat back-
ground. Note how the dark shape provides
a focal point that contrasts against the light-
er background. The line pattern is repeated
in the upper right corner. This keeps the
viewer's eye within the painting and provides
visual balance.

Woman A. Acrylic on panel, 48″ x 18″
Russell Woody. Courtesy Binney and Smith.
Line, a predominant element in this painting
defines contours and suggests forms. The
three-dimensional lines are not brushed,
however; they are extruded from a plastic
squeeze bottle. Acrylic paint, acrylic medium
and modeling paste were placed in a bottle
and then the thick lines of color were
squeezed onto the canvas. The result is a
lively, energetic highly expressive surface.

Abstract. Oils. Student, Baltimore Public Schools. Related warm colors and bold application characterize this abstract composition.

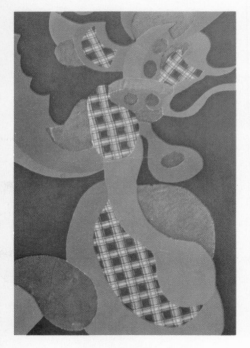

Abstract. Collage and acrylic. Student, Spruce High School, Dallas. Susan Ross Evans, instructor. Collaged fabric provides textural interest and contrast in a background of plain, flat colors. Note how the fabric shapes repeat the painted shapes. The plaid pattern of vertical and horizontal lines contrasts against the curving lines of the painted shapes. which are dominant.

Color

Color is often the element that immediately attracts our attention in a painting. Before we are aware of the forms or subject matter, we sense that the painting is bright, dull, subtle or that it is cheerful or gloomy in feeling. This expressive quality of color is something that we feel rather than something we can define or explain: We only know that colors associated with fire and sunlight, such as reds, yellows and oranges, make us feel happy and warm. Blues, greens and purples are quiet and, sometimes, depressing. We say that we "feel blue" when we are depressed; a friend who is always cheerful might be described as having a "sunny" disposition. In both instances, there are references to color to describe a mood.

From very early times, people have used color to symbolize certain qualities: white has stood for purity, red for danger or violence and purple for royalty. Blue is often used to symbolize truth and honesty; a good friend is said to be "true blue."

Before learning how we can use color more effectively in painting, it will be helpful to discuss how we see color and to learn some of the terms we use to describe it.

The source of color is light. We see color when a surface absorbs parts of the light spectrum and reflects the remaining parts. For example, the surface of a dandelion absorbs all of the colors except yellow which, reflected to our eyes, gives the dandelion its yellow color. An orange pumpkin reflects orange rays. Other surfaces reflect varying colors. Think of the colors of autumn leaves, the bark of a tree or the wide range of colors in peacock feathers. These are more subtle colors and are more difficult to describe.

The artist, of course, does not paint with light; the artist's colors are pigments or dyes in various forms of paints or chalks. Through the use of these colored paints, the artist attempts to duplicate, or at least to simulate, the colors of the objects or figures in his subject matter.

Properties of Color

How would you describe the color of the room you are in? Perhaps you say that it is a light, dull green? Or a light, bright yellow? In an effort to describe it fully, you have used *three* terms because they tell more about the color than would a single term, such as "green" or "yellow." These three terms relate to three properties, or characteristics, or color : *hue, value* and *intensity.* Let us discuss them one at a time.

Hue is the *name* of a color, such as red, yellow, blue, green. There are many variations of any one hue. We may say a yellow-green or a greenish blue, but the basic identification or hue is green or blue.

Intensity refers to a color's strength, richness or purity of hue. A fire-engine red is a *high* intensity red; red brick, weathered by sun and rain, is a *low* intensity red.

Value of a color refers to its *lightness* or *darkness.* Any color can be light or dark or any value between light and dark. Pink is a *light* value of red; navy blue is a *dark* value of blue. *Tint* and *shade* are two other terms used to describe color values. Tint refers to a light value; shade refers to a darker value. Thus, pink is a tint of red; navy blue is a shade of blue.

These definitions give us basic information. We need to discuss each in more detail for a better understanding of our color vocabulary.

Hue

Primary hues are red, yellow and blue. These are basic colors that cannot be obtained by mixing other colors. When we combine these colors we can produce almost all the other colors.

Secondary hues are those produced by mixing the primary hues: orange, green and purple. Red and yellow give us orange, blue and yellow give green, and blue and red produce purple.

Tertiary or *intermediate* hues are the colors produced by mixing a primary hue and a related secondary hue. Thus red-orange is a tertiary color, produced by mixing red (primary) and orange (secondary). Other examples include blue-green and blue-violet.

These hues and combinations are only a starting point because, as you will discover, there are almost limitless numbers of hues that can be produced by varying the colors that are mixed.

Analogous hues contain a common hue which relates them. For example, red, red-orange, and orange are analogous hues because they all contain red. On a color wheel, they are adjacent, or next to, each other.

Complementary hues are opposites; they appear opposite each other on the color wheel. Red and green, blue and orange, and yellow and violet are examples of complementary hues. The groups of hues described above produce different effects in painting. A painting done primarily in analogous hues of blue, blue green and green can appear subdued, restful and quiet; the colors are harmonious. Complementary hues, on the other hand, are contrasting. When placed next to each other, one hue appears to strengthen or intensify the other. When mixed together, however, they seem to destroy or cancel each other, producing a neutral or grayed tone.

A COLOR WHEEL

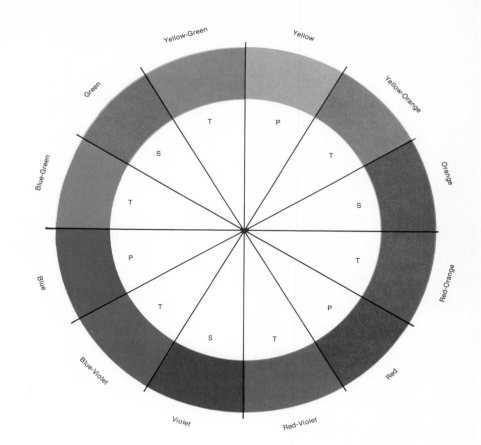

Primary (P) *colors:* Red, yellow, blue. *Secondary* (S) *colors:* Orange, violet, green. *Tertiary* (T) *colors:* Made by mixing neighboring primary and secondary colors. Also known as *intermediate* colors. *Complementary colors:* Colors opposite each other on the color wheel.

Woman's Head. Collage. Squares and rectangles, cut from Coloraid designer's paper, create a mosaic-like effect in this richly colored collage. The great variety of colors available in this special paper makes possible subtle blending and shading to show the planes of the face.

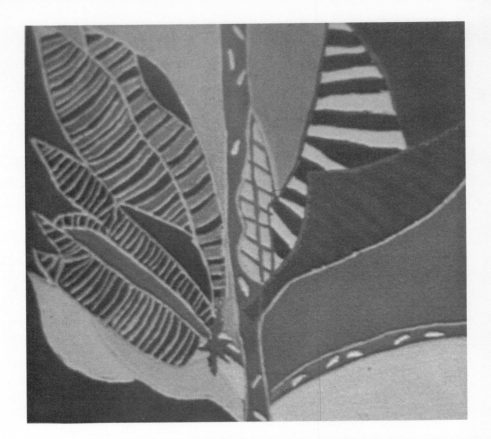

Color Studies. Tempera. Student, Spruce High School, Dallas. Courtesy Susan Bethel. A single design treated in two different color harmonies and value patterns. This is good experiment to try if you want to learn the effects of color in design.

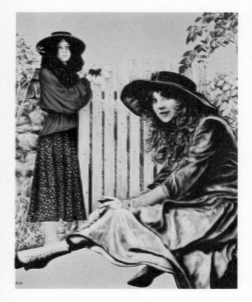

Untitled. Acrylic 40″ x 50″. Bob Anderson. Courtesy Russell Woody. The colors in this composition are delicate and subtle. Textures and patterns are emphasized. Note the patterns and folds of the dresses and the textures of the hair and leaves. Few background details are included: only a few leaves and the picket fence which bridges the space between the figures, unifying them.

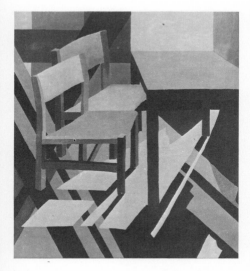

Chairs and Table. Tempera. Student, Fort Lee (N.J.) High School. Joan DiTieri, instructor. In this composition, values are arbitrarily arranged for purposes of design instead of the way they would normally appear. Note the opposition that occurs when the vertical and horizontal lines cross the diagonal lines of shadows and light. How many different values are used in the painting?

Intensity

As stated earlier, *intensity* refers to the degree of strength, purity or brightness of a color. A color that lacks intensity is dull. When we look at a color intently for a few moments, our eyes seem to demand that color's complement. To discover this yourself, look at a bright red object for a few seconds, then shift your eyes to a plain white surface. What do you see?

Intensity should not be confused with lightness or darkness; for example, a light green may be a light, *dull* green or a light, *bright* green.

The intensity of a color is affected by mixing it with its complement, or opposite, color or with black or gray. The intensity of a color can also be affected by the color placed next to it. Blue adjacent to orange seems to make the orange stronger. As with hue and value, intensity is affected by surrounding colors.

Colors of high intensity quickly command our attention and tend to hold it. When painting, reserve your brightest colors for those areas you wish to emphasize or for the area that is the center of interest.

Value

Value, as we stated earlier, refers to the degree of lightness or darkness of a color. How is the *value* of a color changed? In painting, the value of a color is changed by the addition of either white or black paint to the color. Another way to diminish the *apparent* value of a color is to place it against the same color, or another color of a similar value. For example, a medium value of green placed against a dark green does not stand out as sharply as it would if it were placed against a light, or white, background. The contrast in value is not as great.

In a painting, figures or objects that are dark in value appear to advance, or be nearer, while those of a lighter value appear to recede into the distance. Look at the scene outside your window. Note how buildings, hills or trees in the distance appear to be lighter in color than the buildings, hills or trees closer to you.

Color values also help to define or model shapes: the side of a figure or object that does not receive direct light may be painted or shaded in darker values to define its basic form. Without these shadows, a round vase would appear flat. The artist chooses how he or she wishes to show an object, however. Many artists, past and present, have preferred to work with areas of flat color rather than simulate a three-dimensional form on a two-dimensional canvas. It is a matter of personal style.

Value can also be used to create a mood: paintings in which darker values predominate may create a feeling of mystery, gloom, dread or depression; lighter values create a lighter feeling. Think of the colors and values you might use to create a painting of a dark, rainy night. How do they compare with the colors you might use to paint a sunny carnival scene?

A figure or an object in a painting can be emphasized through the use of contrasting values; a light figure stands out against a darker background and vice-versa. Look for examples of this use of value in the illustrations in this chapter.

While we have discussed the various characteristics of color—hue, intensity and value—separately, we should keep in mind that they do not work independently in a painting. Color *relationships* are all-important in the total effect the painting communicates and the artist must be aware of this at all times. Colors must relate to each other, to forms and shapes and be organized in a manner that strengthens the idea, feeling or message the artist is attempting to project.

While definitions are helpful in understanding the terminology of color, it is more important that you experiment with colors in your own painting to discover what happens when one color is placed next to another. It is exciting to find for yourself that warm colors appear to advance, or that cool colors retreat into the distance. Study the paintings shown in color in this chapter to determine how color has influenced the mood or feeling the artist has achieved. Then do a mood painting of your own.

Shape and Form

The terms "shape" and "form" are often used interchangeably in the discussion of a painting. More correctly, however, shape is used to describe a two-dimensional quality; form refers to a three dimensional quality. For example, a sheet of paper is a shape; the sheet of paper rolled into a cylinder is a form. Geometric shapes can be related to geometric forms: a square interpreted three-dimensionally becomes a cube, a circle becomes a sphere.

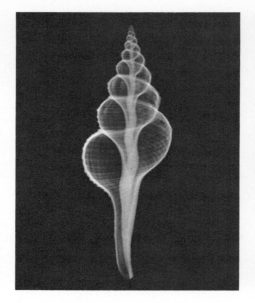

Spindle shell. Radiograph. Eastman Kodak Co. The spindle shell is an example of organic form produced by nature to function in a specific way. The radiograph allows us to see the inner structure of the shell, a progression of spiralling forms.

National Headquarters Building. National Republic Insurance Company, Des Moines, Iowa. Skidmore, Owings, and Merrill, Architects, New York. The forms of contemporary architecture are largely based on geometric forms and variations of them.

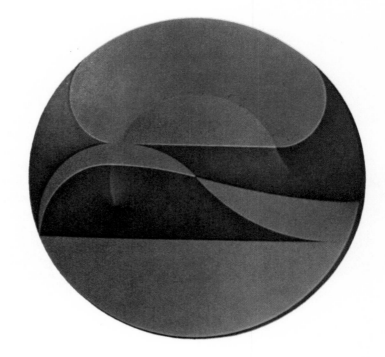

Circular Composition #79. Acrylic on shaped canvas, 48″ diameter x 4¾″ depth. Dave Yust. Courtesy Russell Woody. The relationships of shapes to each other and to the total surface of the painting are emphasized in this shaped canvas. Study the painting for a moment to see the subtle shifting of shapes that seems to occur.

Painted Relief. Acrylic on cardboard. 12″ x 30″. Student, Spruce High School, Dallas, Bob Nunn, instructor. Cardboard shapes are set out, at varying depths, from the background and painted with acrylic colors.

We are surrounded by shapes and forms. Some of these forms, such as a round pebble, a silo or a skyscraper, can be related to the geometric forms described above. Other forms, such as flowers, seashells, and birds are natural, organic forms that do not reveal their inner structures so readily. These are not manufactured forms but complex forms designed by nature to function in a specific way.

Forms made by people are usually geometric forms or combinations of them. How many different geometric forms and shapes can you find in a typical city street scene? What combinations of forms do you see?

The manner in which shapes and forms are combined can create an emotional feeling in the same way that lines or colors can. A shape repeated without change in its size or relationship to other shapes can be monotonous. Think of a checkerboard or a sheet of graph paper. It is *variety,* a visual surprise, that excites our interest and holds our attention.

Shapes and forms exist in three-dimensional space. For the artist working in the traditional manner, the problem in painting is to create the illusion of three-dimensional form on the two-dimensional surface. In order to do this, the artist must know something of the *structure* of the form he is painting. Cézanne said, "Everything in nature is modelled on the sphere, the cone or the cylinder; once one has learnt how to paint these simple shapes, one can do what one wants." Look carefully at the illustrations in this chapter to see how artists have used values of color to model shapes and to create the feeling of space and distance.

The way we see shapes and forms is affected by the light in which we see them. In bright sunlight, we can see the different shapes and forms in a city skyline; each building is clearly defined by areas of sunlit color and shadows. The same skyline appears quite different, however, in early morning or late evening: shapes are muted, less distinct and seem to blend together. At night, the buildings often form one giant, black silhouette against the sky.

The painter defines shapes and forms through the uses of line, color and value. Traditional painters use color values to model or depict forms as they would appear in nature in a certain kind of light. Artists such as Mondrian and Albers, however, were not concerned with achieving the illusion of naturalistic reality. Their paintings are concerned with geometric shapes and their mathematical relationships to each other. The paintings themselves, however, reveal the artists' sensitivity to balance, variety, emphasis and unity which are vital concerns of all great art.

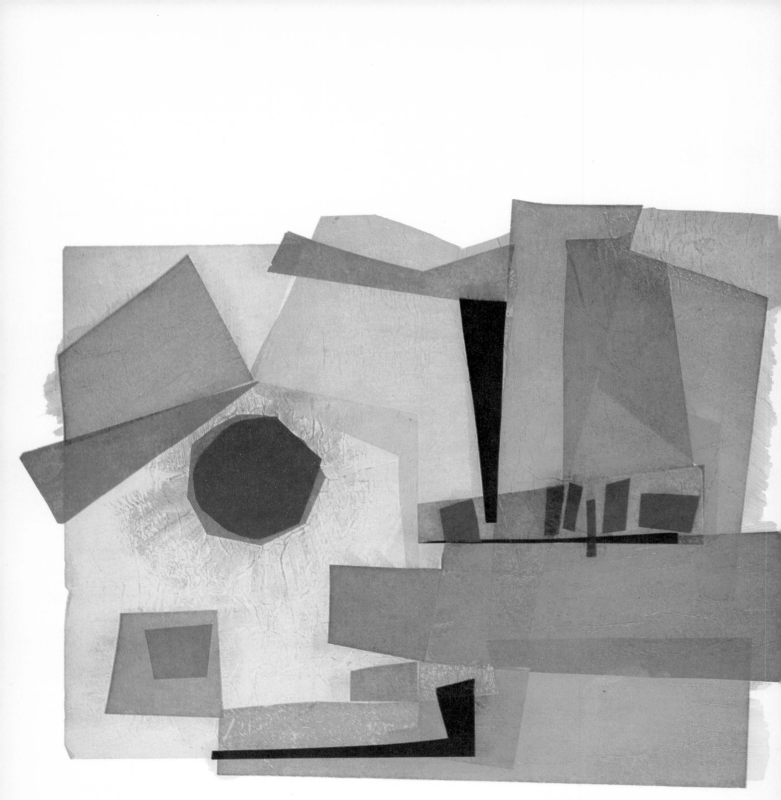

Collage. Tissue on cardboard. Virginia Timmons. Cut tissue shapes were adhered with P.V.A. Color variations occur when colors "bleed" from wet tissue.

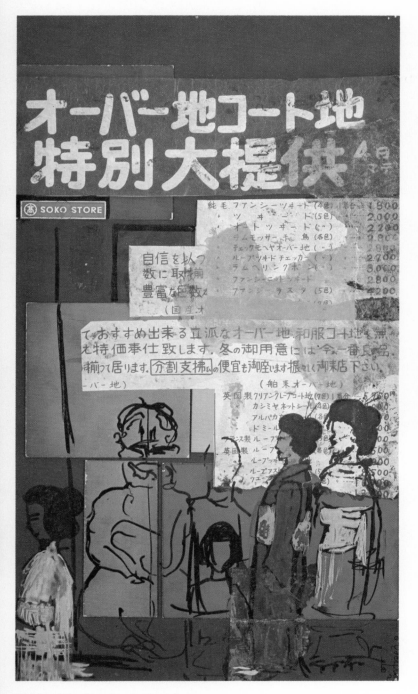

Collage. Mixed media. Student, Baltimore
Public Schools. A sketch, in pen and ink,
applied over collaged oriental papers and
cardboard shapes.

Texture

We discover the texture of a surface
or an object by touching it. We *feel*
that it is rough, smooth, pitted, bumpy
or fuzzy. When we see a texture,
however, what we are seeing is a
pattern of value (light and dark) and
color that tells us how the surface
might feel.

In a painting, the artist uses line,
value, and color to simulate, or
imitate, natural textures such as the
bark of a tree, the rough stones in a
wall, or the shiny, smooth surface of
satin. These textures assist us in
identifying or recognizing a surface or
form.

The artist uses many techniques and
tools to produce a variety of textures:
short strokes with a stubby brush
may be used to paint a grassy slope;
a fine pointed brush may be needed
to paint hair, fur or the grain of weath-
ered wood. Sponges, wadded tissue,
blotter paper and other found mate-
rials are useful in creating interesting
textures in clouds, rocks, and water.
Even sharp pointed objects, such as
nails, compass points, and sticks,
may be used to scratch into a painted
surface.

Another kind of texture can be
created in the way paint is applied.
Paint applied thickly with a brush or
palette knife becomes a texture we
can actually feel when it has dried.

Many artists choose to incorporate
actual textured materials in their
paintings. Sandpaper, tissue paper,
sand, and bits of fabric are used to
provide variety and a surface quality
that contrasts with the flat, painted
areas of canvas.

Texture can do more than assist us in
identifying a surface or form. A
texture repeated in a painting can
help to unify it, to pull it together.
Texture can also be used to empha-
size an area or form in a painting,
such as the center of interest, or to
provide contrast.

In using texture, it is important that you keep several things in mind: texture can provide contrast, variety and interest, but too many textures create visual confusion, distracting the viewer. Use texture and pattern carefully. Since our eyes do not see every brick in a building nor every leaf on a tree, try painting just a *few* bricks or leaves to *suggest* the surface that you want to identify; the viewer's eye will *fill in* the remaining surface.

In using texture and pattern in your own painting, try to achieve balance and proportion, leaving some areas in your painting plain, or free of texture. These plain areas provide rest for the eyes and, by their very plainness, contrast with and emphasize the textures and patterns you have chosen to paint.

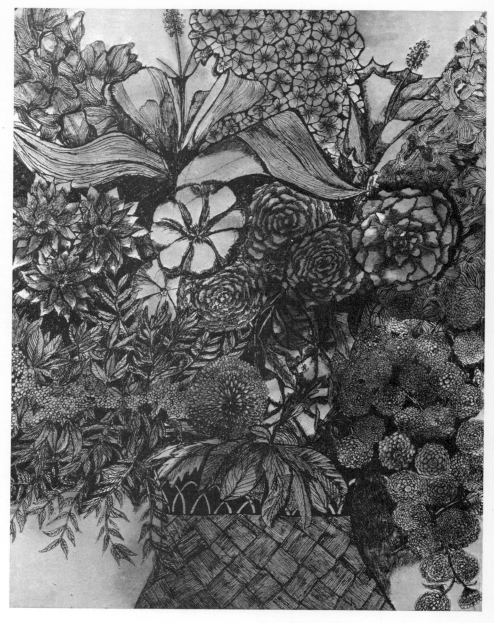

Floral. Watercolor and ink. Student, John Marshall High School, Los Angeles. Richly varied textures are achieved by painstakingly detailed attention to each flower and leaf. How have contrasts in value been achieved?

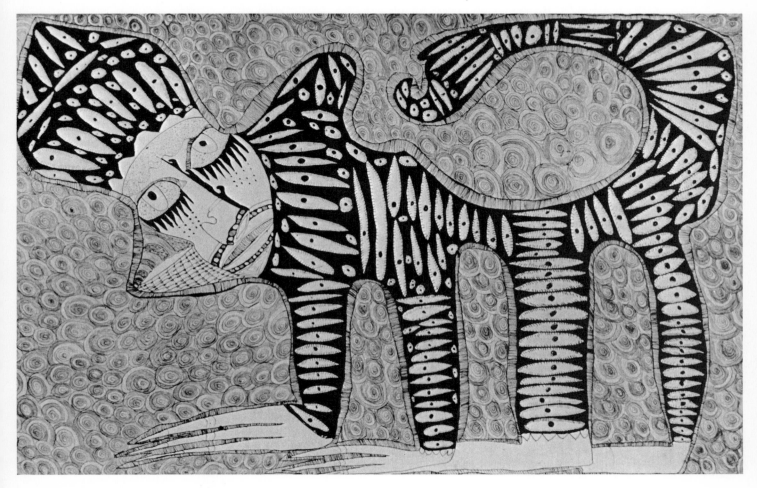

Eye-bodied Tiger. Mixed media. Twin Seven-Seven. Oshogbo, Nigeria. Courtesy the Standard Oil Co. Texture and pattern are emphasized in this fantasy painting by a primitive artist. What does this imaginary animal mean to the artist?

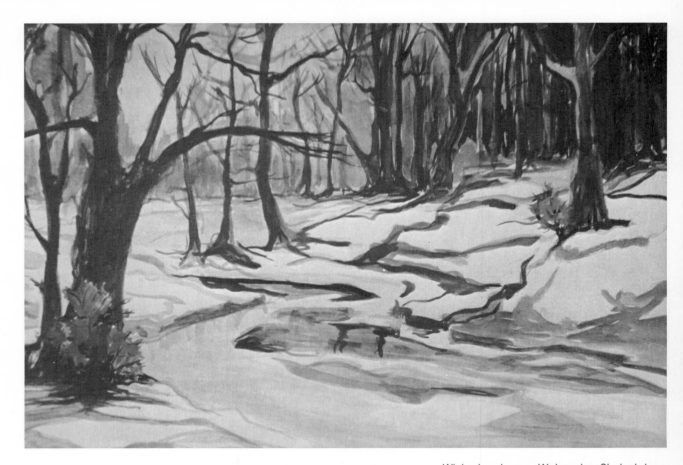

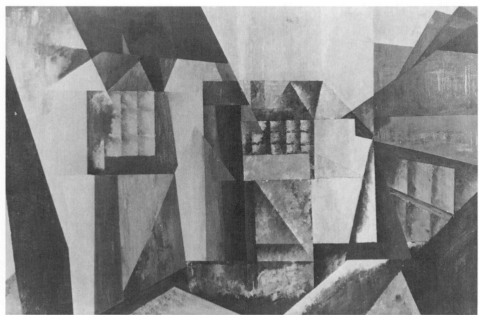

Winter Landscape. Watercolor. Student, Lutheran High School, Los Angeles. Courtesy Gerald Brommer. The feeling of distance is achieved through careful consideration of size, values and position: trees in the foreground are made larger, darker in value and are placed lower in the painting; trees in the distance appear smaller, lighter in value and are placed higher in the painting.

Untitled. Acrylic. Student, Fort Lee (N.J.) High School, Joan DiTieri, instructor. Spatial relationships seem to change and shift in this abstract composition. Overlapping planes of color create a transparent effect in some areas of the painting.

Space

In discussing space in painting, we are not now referring to those areas that surround the forms that we have painted, those negative spaces around trees, houses, people and other objects that are our subject matter. We are discussing, instead, *spatial organization* or how the artist has chosen to depict space. As we stated earlier, forms and objects exist in three-dimensional space but the artist must paint on the two-dimensional surface. To see how artists approach this problem, look at the two paintings on pages 47 and 135. In his painting of a hilly street, artist Roberts uses the principles of perspective to create the illusion of three-dimensional space: parallel lines converge toward a vanishing point. Forms and shapes appear to become smaller, values are less contrasting and contours are less defined, or clear, as they recede into the distance. In Nick Ruggieri's painting, *Venetian Quarters,* our eye is not drawn to a vanishing point, there are no converging lines and the light and dark values tell us nothing about distance, or which buildings are nearest us. In *Venetian Quarters,* the building forms and shapes are stated as lines and flat planes. Size and position suggest that some buildings are near, that others are farther away. Some of the buildings appear to be brought forward because they overlap buildings in back of them. Light and dark values are almost equally balanced; they do not suggest the distance or space we feel in Roberts' painting.

These two examples illustrate two different approaches to painting and each approach is "right" for the artist using it. Roberts' aim is to convey a naturalistic impression of a specific scene and he uses the devices of perspective, value and line in traditional ways to accomplish his aim. Ruggieri, on the other hand, is not telling us about a specific place. He is telling us that his concern is for repetition of shapes and forms, the balance of values and the vertical thrusts of the buildings in relationship to the two-dimensional surface of his canvas.

For another treatment of spatial relationships, look at Joan Miró's *Summer* on page 118. Is it at all similar to Roberts' street scene or Ruggieri's *Venetian Quarters*? How does it differ? Which do you prefer?

As different as the three examples discussed above appear to be, how are they alike in terms of what the artist is attempting to express? Are they all effective? Has each communicated his message to you? How?

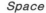

Doors. Acrylic. Student, Fort Lee (N.J.) High School, Joan DiTieri, instructor. Interior space is shown by the diminishing sizes of the doors and carefully controlled values in shadowed areas.

THE PRINCIPLES OF DESIGN

In the preceding section, we discussed the art elements as the basic tools of the artist but we also referred to the principles of design—*balance, rhythm* and *movement, emphasis* and *unity*—that the artist observes in using those tools.

How does the artist organize, or design, his painting? Another word for organization or design is *composition,* and when we compose, we *select.* As the musician composes a musical arrangement, selecting notes, chords, passages and emphases, the artist selects lines, shapes, forms, textures, values and colors. The aim is the same in both instances—to produce or create works that can be enjoyed as a whole, in an harmonious unity.

Balance

The degree to which unity in painting is achieved depends largely on balance. All of us have experienced the feeling of being off balance. It is an uncomfortable feeling and we, instinctively, attempt to regain our balance by shifting our weight, by moving from one foot to another, to regain our equilibrium. This, of course, is a *physical* balance that we can feel but the same kind of thing happens when we experience a *visual* imbalance in painting—our eyes seek a visual "balancing" with which we can feel comfortable. In a painting, balance can be achieved in a number of ways.

The simplest type of balance is *symmetrical balance* in which both halves of what we see appear to be the same, each half is a mirror-image of its twin. This type of balance produces a stable, static comfortable kind of feeling. It can, however, become monotonous and dull unless variety can be introduced in some manner.

A second type of balance is *asymmetrical* balance: the halves, or sides, are not the same but they *appear* to be balanced. Have you ever seen an adult on one end of a see-saw balancing two childern on the other end? This is a kind of asymmetrical balance. Asymmetrical balance in a painting produces a livelier, more active effect than symmetrical balance because it is less formal. Our eyes shift from one area of the painting to another because of the visual tension asymmetrical balance creates. In effect, our eyes are working a bit harder to find the balance that was much easier to see in the symmetrically balanced painting.

Still another type of balance is *radial* balance—all elements or parts of the design radiate from a central point or hub. An example of radial balance can be seen in a wagon wheel or the cross section of a grapefruit. Radial balance draws our attention to the central portion of a painting and, like symmetrical balance, projects a feeling of security and tight unity.

Moth. Radiograph. Eastman Kodak Co. The radiograph reveals that the structure of the moth is an example of symmetrical balance in nature, a balance that is essential to flying.

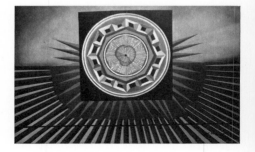

The Heart of Mayab. Acrylic on Masonite. José Guitierrez. Courtesy Nicholas Roukes. This "Op" painting illustrates the use of formal, or symmetrical, balance. One side of the painting is a mirror image of the other.

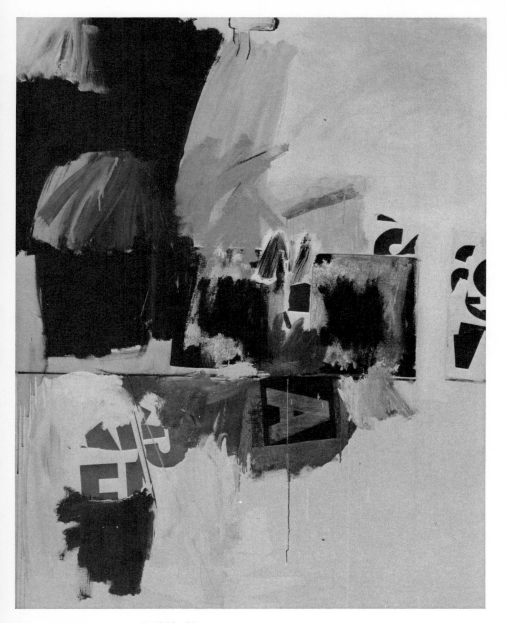

In painting, however, we are not dealing with *physical* weight but *visual* weight; we cannot weigh colors, shapes or values on a scale. We do know, however, that certain colors and shapes appear to be heavier than others. Dark colors and heavily textured surfaces appear heavier to our eyes than light colors and smooth surfaces.

Another factor that influences visual balance is *interest.* If there is something about an object or an area in a painting that commands our interest, we see it first. Have you ever looked for a friend on a crowded beach, or your own car in a jammed parking lot? The chances are that you didn't really see all the other people or cars because your interest was focused on finding your friend or your car. In painting, our interest can be focused on a small area by sharply contrasting colors or values or by a highly textured object. This focusing balances it against larger, less *interesting* areas.

As you do your own painting, you will need to balance colors, shapes, values and areas of interest to create the feeling you wish to express.

Summer Rental, Number 2. 1960. Oil on canvas. Robert Rauschenberg. In this combination of painting and collage, the artist incorporated fragments from everyday life in his composition. The letters and letter fragments are cut from paper and adhered to the canvas. Note that an informal, or visual, balance is achieved with economy of painting. Imagine removing any part of the painting. Would the painting still have visual balance?

Movement and Rhythm

When you think of movement and rhythm, are your first thoughts of music and dance? In music, rhythm is created by the repetition of a beat; in a dance, there is repetition of a step or movement. Rhythm may also be observed in the arrangement of things we see around us: the repeated vertical lines of telephone poles along a highway, the identical shapes of houses in a large housing development or the window arrangement on a tall skyscraper. Our eyes move smoothly along these lines because there are no interruptions or visual surprises.

Our eyes tire after too much sameness, however, and we lose *interest.* In music, we tire of hearing a single, monotonous beat and in painting we tire of a shape, color or form repeated without variation in size, placement or value.

Visual rhythms can be used to guide our eyes over a painting, to direct our attention to a particular object or figure or to create a certain mood or feeling. Look at the paintings shown in this chapter to discover how the artists have used the repetition of shapes, colors, textures and lines to direct our eyes to a certain point. How does the rhythm or movement they have created strengthen the message of their painting?

Untitled. Acrylic. Student, Bryan Adams High School, Dallas. Nancy Miller, instructor. Pattern and movement achieved through the repetition of shapes, lines and values. The oval shapes, which suggest eggs, beads or pebbles have been shaded to appear three-dimensional against the flatness of the background. Note how values are balanced and how the narrow bands of color surrounding the forms create a movement and pattern of their own. In actual color, black, gray, and white predominate with bright red on the central group of shapes.

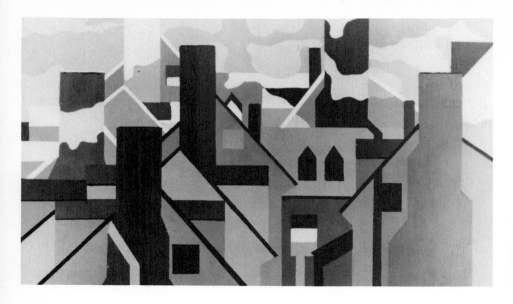

Roof Tops. Acrylic. Student, Fort Lee (N.J.) High School, Joan DiTieri, instructor. The repetition of the diagonal roof lines creates a contrast in movement against the vertical and horizontal lines of the buildings. The diagonals are repeated in two of the windows and in the chimneys in the foreground. The emphases are the patterns created by contrasting lines, shapes and values.

Swing. Acrylic. Anna E. Meltzer. Courtesy M. Grumbacher, Inc. The movement of a swing is expressed abstractly through the rhythmic patterns of shapes and values.

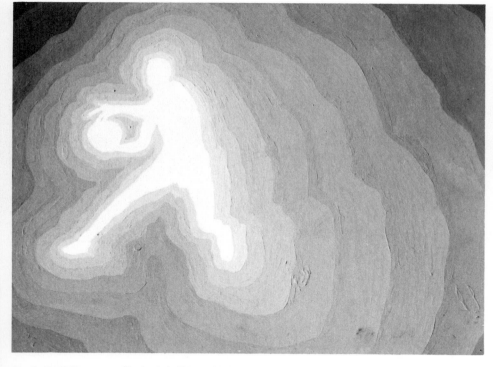

Basketball. Tempera. Student, Lutheran High School, Los Angeles. Courtesy Gerald Brommer. The repetition of the shape of the figure in gradually darkening values creates the feeling of movement and action. Note the variation in the width of the radiating light and dark values. How does this radiation affect the painting?

Emphasis

When we emphasize something, we make it stand out. In our speech, we emphasize words by speaking them more slowly, more loudly or, perhaps, by repeating them. A speaker who never varies his stress on words speaks in a monotone and is, therefore, said to be monotonous. This same principle applies to visual emphasis. Try to imagine a painting in which all the objects or figures are the same size, the same color and the same shape. How would you know what the artist is saying if everything appears to be of equal importance?

There are a great number of ways in which the artist can achieve emphasis: placement, size, contrast, distortion and action are some that are more easily seen. Placing the most important figure or object near the center of a painting draws our attention to it; a figure that is larger than the figures that surround it seems more important. Contrasts may be achieved by placing light against dark, patterned or textured areas against plain areas, bright against dull or vertical against horizontal. An active figure in an otherwise quiet or inactive background gains emphasis. *Distortion* can heighten or intensify emotions and moods. Study David Alfaro Siqueiros' painting, *The Sob,* on page 2 and Peter Bloom's *Man of Sorrows,* on page 3. How has distortion been used to emphasize what the artist wants us to feel?

Emphasis can also be achieved in a more subtle way. Lines created by the contours or edges of objects can lead the eye to the center of interest or most important figure in the painting.

Study the paintings in this chapter and see how many different methods the artists have used to create *emphasis.*

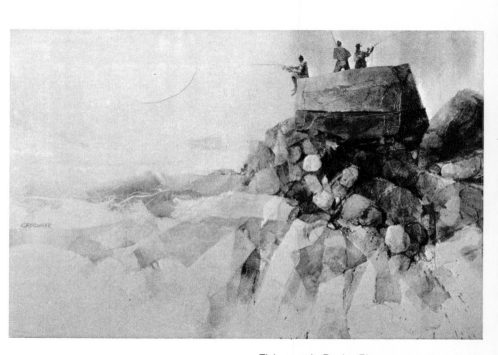

Fishermen's Rocks. Rice paper collage and watercolor, 22″ x 30″. Gerald F. Brommer. Emphasis and dramatic impact are achieved through several devices in this composition: the subject matter, in dark tones, contrasts against the light background; the elimination of possibly distracting background details; the direction of the wave-like forms (foreground) which point the viewer's eye toward the rocks and the figures atop them. A light circular shape is barely visible in the sky on the left, serving as a subtle balancing element that does not detract from the center of interest—the men of the rocks.

Unity

By unity we mean the harmonious visual effect the artist achieves by the use of all the elements and principles at his or her command. We are referring to the integrated relationship of all the parts (shape, form, line, color, texture and space) to each other, and their relationship to the whole of the painting. If a painting has unity, all the elements support each other and enhance the artist's expression: there are no jarring distractions, no extra parts and everything seems in order. *Unity* is the sense of *completeness* achieved through both visual and psychological means.

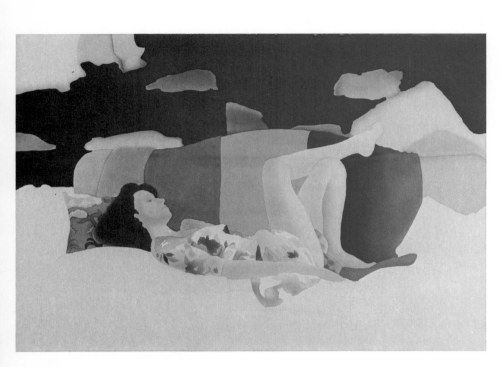

Nava Reclining. 1976. Acrylic on canvas. 48″ x 70″. Elizabeth Osborne. Shapes of color seem to float in this painting of a young girl. The effect is obtained by pouring color stains of thinned acrylic colors on unprimed canvas. Note the harmony of shapes. The movement in the legs is repeated in the background shapes in the upper right portion of the painting. The bottom of the sofa remains unpainted, enhancing the floating appearance of the figure.

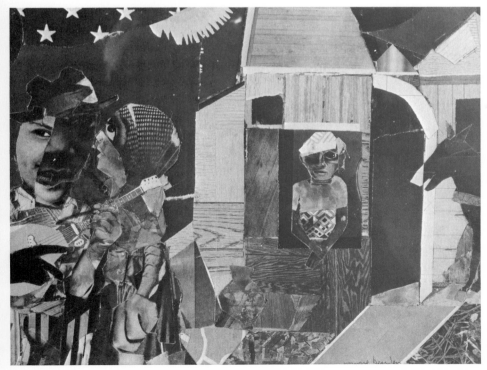

Farmhouse Interior. Collage. 9⅝″ x 12½″. Romare Bearden. Collection of the J. L. Hudson Gallery, Detroit. One of America's foremost contemporary artists, Bearden expresses his feelings and reactions to the roots, concerns, and conditions of Black Americans. In an extensive use of collage techniques, Bearden has developed a distinctive style that is visually effective and highly evocative.

GETTING STARTED:
The Process of Composition

The first thing to consider is your subject matter. You may know just what you want to paint but, if not, look at the things around you, the street outside or a favorite landscape. If you would rather start small, arrange two or three familiar objects on your desk or table top. Select objects of varying sizes, heights and shapes and arrange them in a way that is pleasing to you.

Or perhaps you would prefer a street scene or landscape? If all the detail is confusing, a simple viewfinder might help you in selecting and arranging subject matter. To make a viewfinder, cut an inch-by-an-inch-and-a-quarter opening in the center of a piece of cardboard. Cardboard the size of a postcard or small file card will do nicely. From your painting position, hold this card close to your face and look through the opening with one eye, just as you would look through a viewfinder of a camera. Think of the margins of the opening as a frame containing the things you will paint. Move the frame until you find an arrangement that satisfies you. This will provide a starting point; you may wish to eliminate certain objects or add others as the painting progresses.

Assuming that you have selected your subject matter, you might choose to do some small thumbnail sketches or perhaps a full-scale sketch. Sketches, indicating major forms and values, are helpful as they allow you to experiment in finding the most satisfying arrangement.

Whether you begin with a sketch or a full-scale drawing, you will follow very much the same process. Will your painting be vertical or horizontal? This, of course, will be determined by your subject matter and the way you have chosen to portray it; turn your viewfinder first one way, then the other. Study still-life objects to see how they fit into vertical or horizontal arrangements.

Determine how you will use the total area of your canvas; then draw objects and shapes in correct proportion to each other. Learn to take visual measurements in comparing heights and widths. Hold your pencil at arm's length, close one eye and, using your pencil as a ruler, measure the height of a building across the street. How tall is it? As tall as your pencil—two-thirds as tall? What about the tree or lamp post next to it? How do the heights compare? Using your pencil in this way will assist you in determining comparative heights and widths and in getting correct proportion.

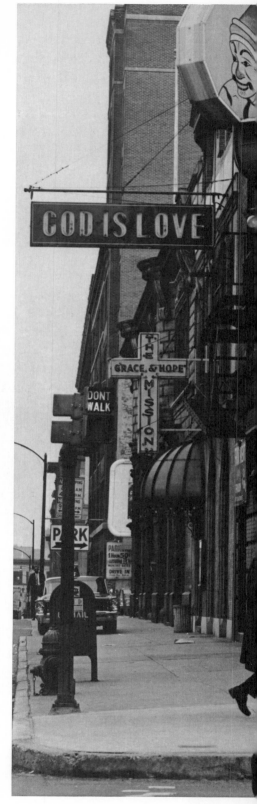

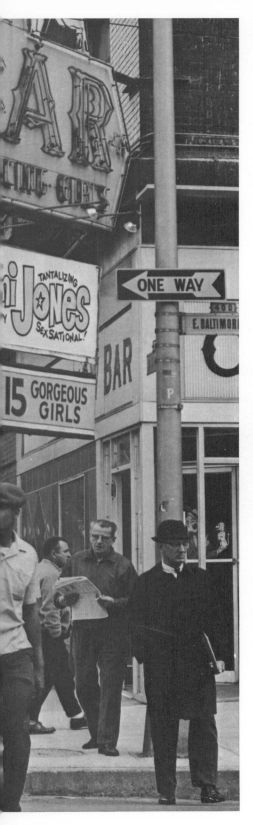

Once you have established the major objects and shapes, add enough detail to guide you as you paint. Don't draw *every* clump of grass or *every* street sign. Trivial detail gets in the way as painting progresses and is best left until last. Draw lightly! Heavy, ground-in pencil lines are difficult to erase. Their erasure can soil or mar the painting surface even before you start painting.

Now that the drawing is completed, where do you go from there? Consider the values, the lights and darks. Squint your eyes and look at your subject. What objects or forms are the lightest, the darkest? Look for strong contrasts of light and dark that clearly define areas and forms: the outer leaves and branches of a tree reflecting sunlight will appear light while those in shadow will appear darker; in a still life, the side of a vase or a box receiving direct light will illustrate the same effect. It is important that you remain aware of these lights and darks as you mix your colors. A sketch that shows light and dark values is your best guide. Note, too, that the contours or edges of some forms appear fuzzy or blurred as you squint at them; these are objects that are similar, or close, in value.

What about the textures, or surfaces, of the objects or forms? Are they rough, bumpy, crinkled, smooth? Experiment on a piece of scrap paper if you are unsure of the way to show these surfaces.

Color, of course, is the big issue. In the beginning, keep it fairly close to what you actually see and keep it rather light. You can always make it darker, but lightening it may be more difficult. Modify or change colors to tone down an object's importance or to emphasize it, if you wish. *Remember:* you are not attempting to simulate a color photograph; you are composing a painting and you are free to change any part of it to obtain the feeling or expression you would like to achieve.

As you paint, move from one area of the painting to another. There is often the temptation to finish one object, or area, that your find especially interesting, but you may find that, once finished, it doesn't fit into the total composition. Moving from one area to another makes it easier for you to adjust colors, shapes and placement as relationships seem to change. A color may appear too bright, a texture too pronounced, or an object too large. Staying "loose" gives you the flexibility to make these changes easily and quickly.

The choice of painting media—acrylics, watercolors, oils or pastels—will greatly influence the manner in which you will work.

The Block. Photograph. Elaine Roussos. The unrelated forms and textures of a city street, visually jarring and often unpleasant, provide interesting subject matter for paintings.

Painting with Transparent Watercolors

The use of watercolors can be traced as far back as classical times. However, it was not until the eighteenth century, in England, that artists began using watercolors in the transparent, or aquarelle, manner. Before that time, European artists had used watercolors primarily to tint ink drawings or to do miniature paintings which were popular during the sixteenth century.

Paul Sandby, an English painter of the eighteenth century, is credited with the development of the pure watercolor technique, without the use of inks. Other English artists, especially Cozens, Girtin and Turner, expanded and perfected the transparent technique that is characteristic of modern watercolor paintings. Transparent techniques were quickly adopted by American painters of the nineteenth century, including the artists of the Hudson River School, for a spirit of impressionism, characterized by free handling, more daring color, and the simplification of subject matter.

Spool Bed. 1947. Watercolor. 20⅝″ x 28¾″. Andrew Wyeth. Whitney Museum of American Art. Details of the room are obscured. Major areas of light and dark values emphasize the effects of the light entering through the window.

During the twentieth century, an American artist, John Marin, discarded the naturalistic approaches of Homer and earlier American artists and began painting abstractly structured city scenes and landscapes. Marin's work, characterized by calligraphic style and arbitrary placement of color, greatly influenced the work of the artists who followed him.

MATERIALS AND TOOLS

Transparent watercolors are not completely transparent. The degree of transparency really depends on how greatly the colors are diluted and the color of the paper, or ground, to which they are applied. If a considerable amount of water is mixed with the paints, they are translucent—the color of the paper can be seen through the film of paint; if very little water is added, they are nearly opaque. Transparent watercolors differ from tempera paint, showcard color, gouache, or casein paints in that white paint is not used to lighten them. To obtain lighter values, the colors are thinned with water which permits the white paper to show through, producing the "transparent" effect. Obviously, the choice of a suitable white paper for transparent watercolors is an important consideration.

Papers and other Supports

The best quality watercolor papers, usually imported from Europe, are handmade from linen rags. These professional-grade papers are available in various weights which refer to how much a ream (500 sheets) of the paper will weigh. A 72 pound paper is light and will buckle or wrinkle more readily than a heavy, thick paper of 400 pounds. These papers vary, too, in surface quality. *Hot pressed* papers are smooth while *cold pressed* papers have considerable roughness or *tooth*. A third type of paper, called *rough*, is highly grained.

All of these papers are generally too expensive for classroom use but it is good to know their characteristics and how they influence the final effects of painting. Smooth papers permit the paint to slide rapidly down the surface of the paper. Cold pressed or rough papers catch the paint, leaving bits of white paper sparkling through.

A type of paper, referred to as *school grade,* is usually provided for use in the classroom. Generally, this paper has sufficient tooth, or roughness, to provide a fairly satisfactory painting surface. Other white papers, usually much smoother, may also be used. These may include all-purpose white drawing paper, oatmeal paper, and charcoal paper. Because they are not especially heavy, these papers tend to wrinkle or buckle and will not withstand vigorous brushing. To improve their working qualities, apply a size, such as an acrylic medium, which will reduce the absorbency of the paper and make it tougher.

Acrylic gesso may be applied to lighter weight boards to provide a satisfactory surface for transparent watercolor.

Colors

The best quality watercolors are packaged in tubes. These tube colors are more brilliant and more permanent than the pan colors provided for classroom use and, predictably, are much more expensive. Pan colors, however, are quite satisfactory, especially for the beginner involved in exploratory techniques. Pan colors may be dry and hard or semi-moist; only experimentation will determine the best methods of handling the colors provided. Generally, it is best to drop a bit of water on top of the colors to soften them before they are lifted on the brush.

In the interest of economy, squeeze colors from tubes only as needed and in the amounts you expect to use.

Deer Island. 1923. Watercolor, 17½″ x 13⅞″. John Marin. Whitney Museum of American Art. One of America's earliest Expressionist painters, Marin used bold, energetic lines and semi-abstract forms to describe the sea, rocks and trees of the Maine coast. What unifies this composition? How is balance achieved?

Brushes

Brushes used for transparent watercolor may include red sable (preferred by professionals), ox hair, camel hair and squirrel hair. All of these are available in round or flat shapes and in a variety of sizes. Study the exercise sheets shown in this chapter to see the various kinds of strokes produced with different kinds of brushes.

Given a choice, look for the brush that remains springy when it is saturated and for the round brush that comes to a fine point when it is wet. A limp, lifeless brush is a frustrating tool. Other kinds of brushes are also useful: bristle brushes, stencil brushes, soft varnish brushes and even tooth brushes produce interesting varied textures. Experiment with these to discover the effects they produce.

Begin by using the largest brush possible for the painting at hand. This will require you to give your attention to the major forms in your composition, ruling out trivial details which can be distracting. You will find, too, that large areas in your composition are more quickly painted if a large brush is used.

Your brushes, regardless of their quality, are important tools and deserve proper care. At the end of a painting session, wash the brushes carefully and remove the water by snapping them sharply. Do not squeeze or pull on the bristles but, instead, let them take their natural shape. Store them to dry, bristle ends up.

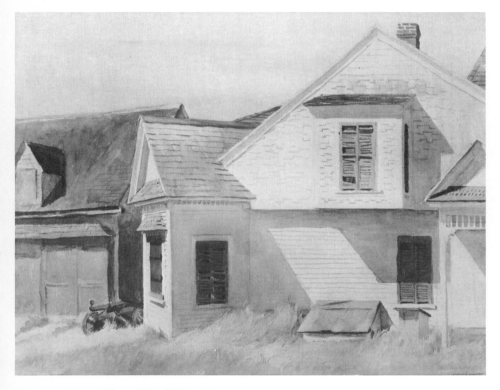

House on Pamet River. 1934. Watercolor. 19¾″ x 24⅞″. Edward Hopper. Whitney Museum of American Art. In this painting of a New England house, the artist revealed his concern for light and for solidity of forms. Note the strong contrasts in lights and darks. What time of day is suggested?

Other tools, materials

In addition to brushes, there are other painting tools which you will find useful. Small sponges and facial tissues are handy for wiping out colors and for removing unwanted puddles of paint; experiment with dabbing on colors with a sponge as you paint foliage or grasses. Erasers, spray bottles, cotton swabs and even nails may be used to create special effects and textures. In the beginning, however, concentrate on learning how to use your brushes since these are your basic tools.

Materials used in resist techniques which mask out areas of the paper or previously applied color include rubber cement, crayon, candle wax and "Maskoid." The latter, a commercial product, is especially prepared for use by artists, but the rubber cement, wax and crayon will serve you just as well. Study the examples of resist techniques shown on page 44 for the special uses of resist.

Palettes, water containers

The small mixing wells found in the lid of a metal paint box are of little or no use to you. There are simply not enough of them to hold all the colors you will want to use, and keeping them in a flat position is awkward. Separate pans of metal or plastic work well because you can mix a small or large amount of color in them and avoid accidental mixing and muddying of color. The best solution is a muffin tin with six or more cups. Cafeteria (or army) mess trays with four or five wells are also satisfactory. Painting them with a white enamel improves them considerably, allowing you to see colors more clearly. Choose a palette that suits your method of working.

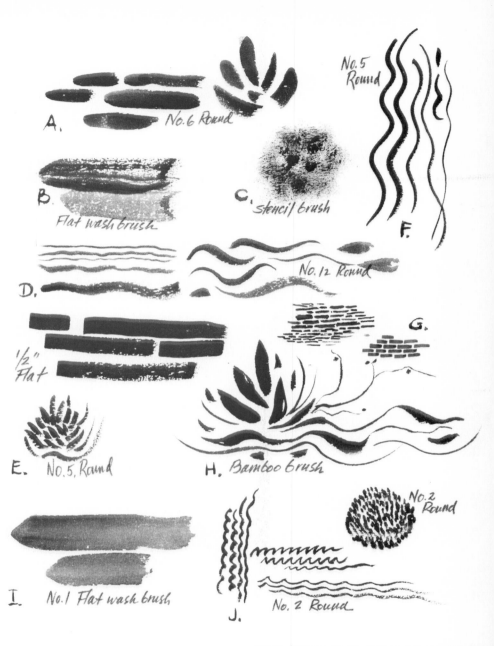

A. No.6 Round
B. Flat wash brush
C. stencil brush
D.
E. No.5 Round
F. No.5 Round
G.
H. Bamboo brush
I. No.1 Flat wash brush
J.
No.12 Round
No.2 Round
No.2 Round
1/2" Flat

Brush Strokes. Brush strokes can be varied by simply varying the pressure on the brush, the amount of paint in the brush or even the manner in which the brush is held in your hand. The examples above which were done on dry paper would appear softened or blurred on wet paper. Experiment with your brushes to learn the varieties of brush strokes that are possible.

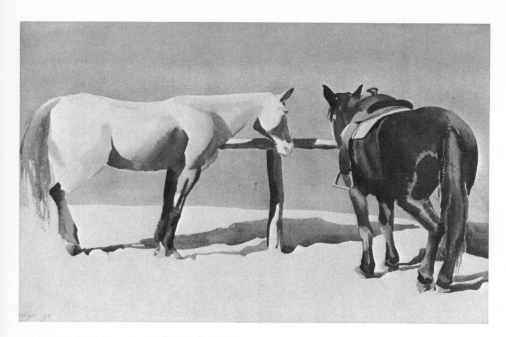

Hitching Rail. Watercolor, 15″ x 22″. Paul Souza. Flawlessly applied washes form a striking background for the simply painted horses. A lack of distracting background and sharp contrasts in value dramatize the animals and create an effect of brilliant light.

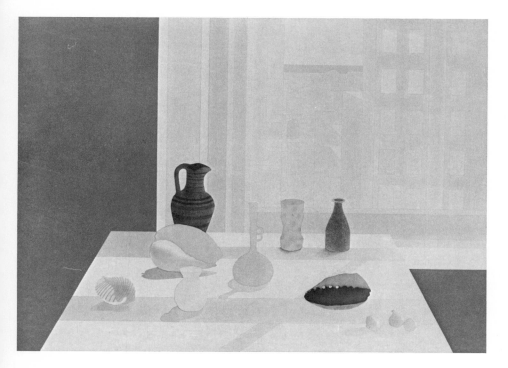

Water containers should be large enough to hold *at least* a pint of water so that brushes can be kept clean. Food jars, small plastic buckets, coffee cans, and plastic food containers are all suitable. The important thing is that you have a generous amount of water and that the water is changed often to avoid muddying the colors.

Clean cotton rags and newspapers are always useful in mopping up spills, wiping brushes and in keeping work surfaces clean.

METHODS OF APPLICATION

Lines

As you look at the illustrations in this chapter, you will discover that artists have applied paint in various ways. Some of the paintings are very much like drawings in that color has been applied in *lines*. Note, however, that the lines vary in width, value and texture. Experiment with your brushes to see how many different kinds of line you can produce.

Washes

Large areas of color, such as sky, water, beach, hills or a background, may be applied in *washes*. These washes of color may be *flat* or *graded*. A *flat* wash is uniform throughout; it appears even, without changes in value. A *graded* wash goes from light to dark or dark to light.

Still Life with Buildings. 1977. Watercolor, 30″ x 40″. Elizabeth Osborne. Osborne's watercolors are characterized by muted, delicate colors that are uniquely luminous. The effect is achieved through transparent washes expertly handled on the watercolor paper. In this illustration, the translucency of the bottles and jars contrasts with the opaque areas in the left and right portions of the canvas. The buildings outside the window are subordinated and serve as a kind of back-drop for the still life.

1

2

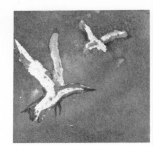

3

4

5

6

7

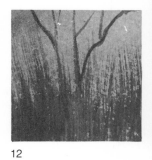

8

9

10

11

12

13

14

15

16

Watercolor Techniques. A demonstration by Clyde Roberts. Learning how to create a variety of effects in color and texture can be fun and add interest to your paintings as well. Experiment with these techniques before trying them in a painting.

(1) To block out an area you wish to remain unpainted, first cut a piece of masking tape to fit the area and press it into place. Run your washes over the area and, when the wash has dried, carefully peel away the tape.

(2) After peeling away the tape, add to the area any needed color or details, as shown in the birch bark branch.

(3) Using one of the commercial masking materials, such as *Maskoid* or *Maskit*, or rubber cement, block out areas to remain light. (Use an old brush.) After the overlying paint has dried, rub away the masking material and add details.

(4) A wax crayon, white or yellow, can be used to do lettering or any detail that requires careful drawing. When a wash is run over this area, the wax resists the paint and the lettering stands out clearly.

(5) Before washes dry, use a pocket knife or small spatula to scrape out certain values which you wish to be lighter. When the wash has dried, add details as shown in the trees.

(6) A soft facial tissue can be used to blot out large cloud areas. The soft edges can be allowed to dry and details painted over them.

(7) Textures created by scratching with a point of a single-edge razor blade can be effective: it can give the effect of rain or sleet, and direct painting can be used with it.

(8) A balled-up paper towel can give soft and rather sharp edges in combination, when blotted into a wet wash. In this example, the addition of rocks creates a wave pattern.

(9) A hard ink eraser can be used to remove an area of color and can be used to produce a soft foggy effect. Be sure the washes are dry before erasing.

(10) After laying a wash, you can drop table salt on the wet paint to create an interesting texture. When the paint is dry, brush away the salt.

(11) A soft cosmetic sponge can be used to create a random textural effect often useful in painting leaves or ground areas. This would be done over a dry wash area.

(12) Dry-brush is interesting and useful in creating a field of weeds or grasses very quickly. (An old oil brush is good for this purpose.) Start at the *bottom* of the area and pull the brush up in single strokes. Do not use too much water with the paint; it should not run.

(13) After a wash has dried, a light rub with some medium sandpaper will create a texture by removing some of the paint.

(14) For a fairly uniform spatter effect, dip an old tooth brush in paint and scrape a knife blade across the bristles, pulling the knife toward you.

(15) For a different kind of spatter, fill the brush with paint and tap the color on by hitting the brush with your finger.

(16) Wet drops of paint squeezed from the brush and allowed to run into still-wet surfaces create interesting textural effects.

To lay a flat wash: prepare enough color (in a small pan or jar) to cover the whole area to be painted, mixing it thoroughly. With a large brush, apply the color in a band across the paper in a *single* even stroke, moving from left to right. Pick up another brushful of color and, touching the bottom of the first band of color, sweep it evenly across the paper. Do not stop or go over any areas of color. Continue this until the whole area is covered, then look at the work you have done. It should be even, without definite lines appearing anywhere, and the color should be uniform. Tricky? Try again until it is really a *flat* wash.

Laying a graded wash is a bit more difficult. You may prepare washes in advance or, if you are painting a small area, you may increase or decrease the amount of color as you go.

To lay a graded wash from dark to light: Load your brush with evenly mixed dark pigment and water and then apply it, to the top of the paper, in a single horizontal stroke. In the strokes that follow, add more and more clear water to dilute the paint, making it lighter. As in the flat wash, there should be no hard lines dividing the values. In the second stroke and those that follow, touch the brush to the bottom edge or "bead" of water of the preceding stroke. Practice laying a graded wash until you can estimate the right amount of clear water to add after the first brush stroke. To lay a graded wash from light to dark, reverse the process. You may even turn your paper upside-down, if you find it easier, or if you have to paint around objects in a background.

Washes may be applied to dry or wet paper; the trick is to keep the wash wet and flowing freely. Tilt the paper so that the paint will flow easily down the paper; but not so freely that it puddles at the bottom. Learn to pick up unwanted puddles with a slightly dry brush.

Textures

Paint may also be applied in textures by stippling, dabbing, spattering or spraying. Use the ends of your brushes to produce stipples and dabs of color. To spatter, dip an old toothbrush or other bristle brush in paint, then brush or pull it against the edge of stiff cardboard (or a stick) so that the paint spatters on the paper. To spray the paint, pour diluted color in a household spray bottle. Unless you want the spray to cover the whole area, cover the sections *not* to be sprayed with a paper stencil or rubber cement. Usually, sprays are applied early in a painting, eliminating the need to mask out certain areas, if they are applied *lightly.*

As with a wash, the above techniques may be used on wet or dry paper, depending on the effect desired.

Handling Color

Before starting to paint, add a few drops of water to pan colors and set them aside to soften. This will make lifting the color from the pan much easier. When using tube colors, which are already soft, simply squeeze out the amount of color needed and add enough water to produce a workable consistency. You are now ready to mix whatever color you need in whatever way you prefer.

Colors may be blended on a palette or in a pan before they are brushed onto the paper. This will, of course, produce a uniform color if you have mixed it thoroughly. In the beginning, you may feel safer mixing color in this manner because you can see, in advance, exactly what you are getting. There are other ways, however, that provide less predictable and often more interesting results.

Experiment with mixing colors on the paper, which may be wet or dry. Put down a generous amount of two colors—perhaps blue and yellow—then, with a wet brush, begin to blend them, adding water as needed. Permit one color to flow into the other; leave some areas unmixed. Note the variety within a small area and the subtle changes that occur.

Colors may be mixed by letting the eyes do the mixing: With a small brush or cotton swab, put down separate dabs of blue and yellow (or any other two colors), but keep the dabs close to each other so that only a tiny bit of paper shows between them. When you have filled an area about half the size of a post card, hold the paper at arm's length and study it. What happens?

Values

Earlier in this chapter, it was pointed out that the value (lightness or darkness) of watercolor paint is changed by the amount of water mixed with it. The more water, the lighter the *value.* Values may be changed in other ways: if the color is broken, or dry brushed, across the paper it will not cover the paper evenly but, instead, will leave flecks of white paper showing through. Because the eyes of the viewer will blend the white of the paper with the color, the color will appear lighter. Dabbing a color on the paper, leaving some white show through, will also produce a lighter effect. Try this for yourself on small test papers. To produce a darker value, add less water to the color, place dabs of color closer together or add a bit of black.

The addition of white to a color will lighten it, of course, but the addition of white would produce an *opaque* color, not the transparency which is our aim at this time.

To lower the intensity, or brilliance, of a color, add a bit of its complementary color. (For example, green to red, orange to blue, yellow to violet.)

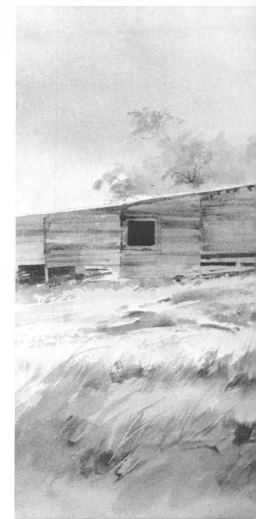

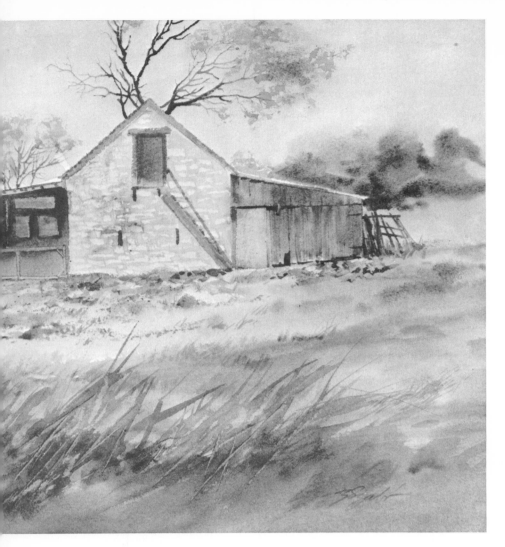

Glazing

In this color technique, one wash of color is superimposed, or layered, over another. To experiment with glazing, paint three horizontal bands of color, about one inch wide, across your paper. (Leave some space between them so that they do not run into each other.) Use red, yellow and blue, keeping them rather light in value. After they have dried, paint three vertical bands of the same colors across them, again using light washes. How have the colors changed in the areas where one band crosses another? Experiment with using additional colors, in darker tones.

In glazing, it is important to permit the first colors applied to dry before you apply the second colors so that they do not mix. This creates the effect of one color glowing through another, as in layered stained glass. Do not scrub or go over the colors a second or third time since this would destroy the clear, brilliant effect of the glaze. Remember, too, that a warm color applied over a cool color (or vice versa) could have a neutralizing, or graying, effect.

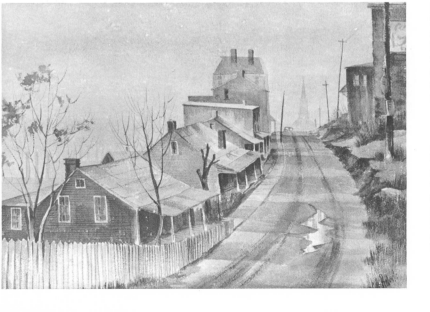

Strange Antlers, Fredericksburg, Texas. Watercolor, 15″ x 23″. Zoltan Szabo. Courtesy the Robert Rice Gallery, Houston, Texas. Major areas of color were applied in loose washes. Textures and dark values were added in a dry-brush technique. The overall effect is fresh and spontaneous. To what does "antlers" in the title refer?

Street scene: Western Maryland. Watercolor. Clyde Roberts. The street, sidewalk, fence and the carefully controlled light and dark values lead our eye up the street, to the crest of the hill, where the shape of the church in the distance holds our eye within the painting. What season of the year is suggested? What is the mood of the painting?

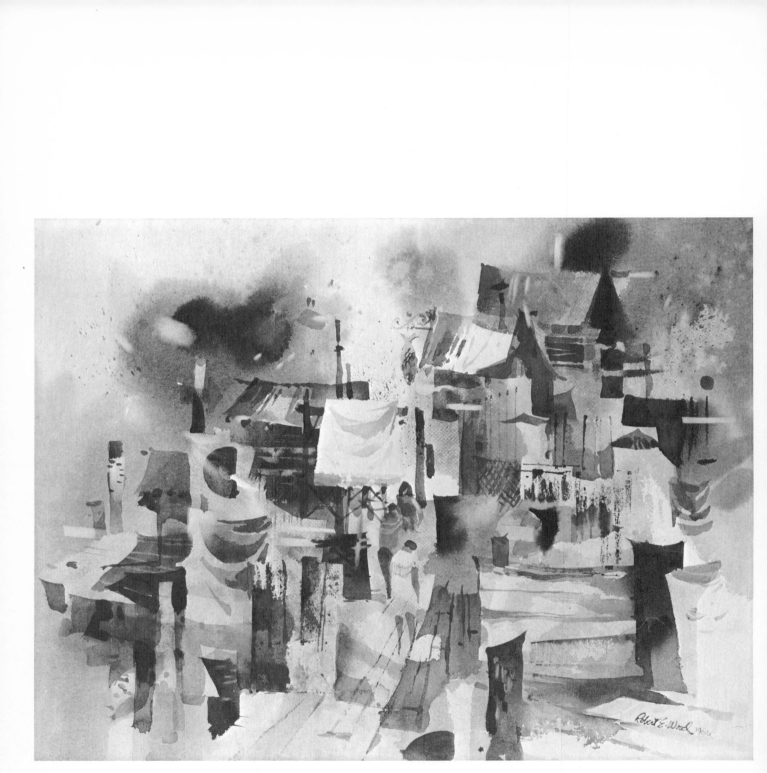

Wharf Space II. Watercolor. Robert E. Wood. A lively pattern of light and dark shapes that is semi-abstract in approach. The movement and spirit of the wharf are emphasized in a fresh, spontaneous manner that reflects the mastery of the artist.

1

2

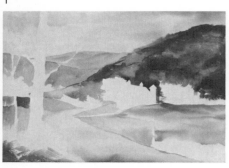

3

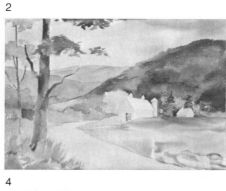

4

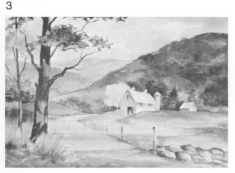

5

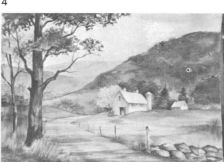

6

Watercolor Demonstration. Artist and painting consultant Clyde Roberts demonstrates and describes the steps involved in painting a watercolor landscape.

(1) Before you begin, a good compositional sketch showing major values, light source and balance should be made. The correct materials are important: a fairly heavy, moderately rough watercolor paper (stretched on a drawing board), a medium soft pencil and an assortment of brushes are needed. A large palette, with at least 12 colors, should be available and a soft cloth or paper towel. If you are painting outdoors, you may want a portable easel, a small camp stool—and perhaps some insect repellant!

(2) On the watercolor paper, make an enlarged drawing from your sketch but do *not* shade any part of it. Keep the drawing light so that pencil lines will not show through the light areas of the finished painting. If you think the drawing is too dark, erase over it lightly. This drawing is your guide to begin the painting.

(3) Starting with the sky area, all large planes are given basic color washes that eliminate most of the white areas. but not all of them. (Be careful not to allow colors to run.) The strongest washes are applied over the lighter areas. Do not become involved with small details in buildings or trees; these will come much later. I equate painting with the development of a photograph in which I see the values start light and gradually develop into dark, final effects.

(4) I next begin to finish the basic washes on the trees, the barn and the distant hill areas. The very basic color values of the rocks are indicated and also the simple and final treatment of the white house.

(5) Now the pattern of dark values begins to take form. The details of rock, texture in the bark of the tree trunks, details of the barn and the weeds in the foreground are defined. Shadows are added to the road.

(6) Here, further details and textural needs are added to give strength to the picture: the darks in the rocks, wire on the fence, twigs, grasses and some barn wood textures. Now it is time to sign it off and compare it with the subject.

BASIC APPROACHES

As you prepare to begin you painting, keep in mind that transparent watercolors differ from oil paints, for example, in that they cannot be reworked, or painted over, without destroying their characteristic transparency. Learn to keep larger forms in mind, shutting out trivial details and accents which can be added later if needed. You are less apt to make mistakes that may prove difficult, or impossible, to correct.

Preparing Papers; other Supports

You can, of course, paint directly on dry paper, if you wish, without wetting or stretching it. In the beginning, this approach might appear the safest way to go but, as your work progresses, you will find that the results may appear too tight, too dry, and lack the flowing wet quality of many fine watercolors. The paper, too, will be difficult to manage: it will buckle, or refuse to lie flat, and paint will flow into puddles. Stretching the paper on a frame or board will largely eliminate many of these problems.

Before the paper is stretched, the entire paper must be evenly wet. With a soft cloth or sponge, wet the back of the paper evenly and thoroughly, then turn the paper over and wet the front, where the drawing is. You are now ready to stretch the paper on a frame or board. (For your beginning efforts, a board will do nicely and is much easier to obtain than a frame, which must be made from wood strips or stretcher strips.)

To stretch paper on a board, lay the thoroughly wet paper, face-up, on a clean drawing board or piece of plywood. With heavy gummed tape, fasten the edges of the paper to the board, being sure that you tape all the way around the paper. Since the paper will shrink as it dries, it is important that the tape equally overlaps the paper and the board to prevent the paper from working loose.

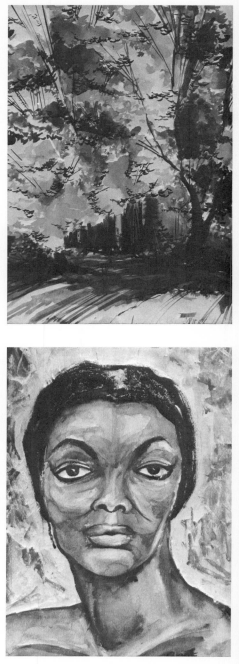

Trees. Watercolor and ink. Student, Lutheran High School, Los Angeles. Courtesy Gerald Brommer. Masses of foliage and color were established with washes of contrasting values. Tree trunks, small branches and shadows were added with ink.

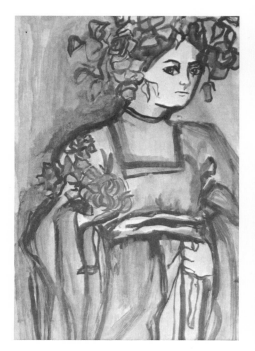

Figure Study. Watercolor. Student, John Marshall High School, Los Angeles. The figure and costume were developed with succeeding washes of color. Details of costume, face and flowers were added in bold, dark brush strokes.

Portrait. Watercolor. Student, Lutheran High School, Los Angeles. Courtesy Gerald Brommer. Controlled watercolor washes define the planes of the face in this bold direct portrait. Lines of dark values emphasize the eyes, nose and mouth.

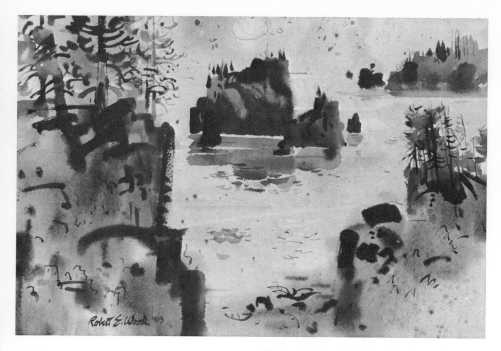

Golden La Push. Watercolor. Robert E. Wood. A sparkling, directly-painted composition exhibiting a variety of brush strokes. The softly flowing areas of color illustrate the effects of painting wet-in-wet. Compare this technique with the indirect approach of the demonstration series by Clyde Roberts and Gerald Brommer included in this chapter.

Trees. Watercolor. Elizabeth Walton. Forms and movement were developed through overlapping, controlled planes of color.

If the paper is large or very heavy, a second layer of tape may be added as reinforcement. Very flimsy papers do not stretch well; experiment with the papers you have to determine how each reacts to stretching.

At this point, you have the choice of permitting the paper to dry before starting to paint or of painting immediately on the wet paper. Either of these approaches is equally correct; the choice is up to you. Before making your choice, experiment with both techniques to learn the differences in the effects produced.

Wet-in-wet method

In this technique, wet paint is applied to wet or dampened paper—hence the name, "wet-in-wet." As you might imagine, the paint spreads on the set paper, creating soft, fuzzy areas of color that are difficult to control. If the paint is extremely watery, it may create "runs" or blots that you have not planned. In using this technique, it is generally wiser to start with the areas that are to be the *lightest* values; add darkest values when the paper has dried slightly and the color will be easier to control.

It is important to remember that colors will dry out much lighter in value than they appear when wet. Be sure that the brush is loaded with color, especially for the darker areas.

The wet-in-wet technique is useful in creating certain atmospheric effects, such as fog or haze, but you should not rely on the accidental blendings or runs of color to form the basis for all your painting. Instead, learn how to use your brushes effectively and how to control colors in achieving the effects you have *planned*.

Direct method on dry paper

Artists who favor this technique prefer the crisp, luminous effects produced by the direct application of color on dry paper. This technique may be more difficult for you at first, as reworking or correcting washes will destroy their freshness. Therefore, the correct values must be established at once. If there is a need to apply a corrective second wash, wait until the first one has dried. Otherwise, a muddy, labored effect will occur, destroying the sparkling, spontaneous effect that is desirable. Learn to test your color washes on a scrap of paper before applying them to your painting. Keep in mind that colors will dry lighter and less intense than they appear when wet.

Techniques

You may use a variety of painting tools and techniques for achieving special effects in color, textures and for blocking out, or reserving the white or color of the paper. Study the demonstrations of these techniques by artist Clyde Roberts on page 44 As you experiment with these techniques, remember that scrubbing and sanding are possible only on heavier papers. A lightweight paper would simply disintegrate under such vigorous treatment.

Tricky techniques are interesting and fun to do, but they should be used only as needed. In the beginning, it is more important that you keep the total composition in mind, giving attention to larger forms and shutting out trivialities. Add accents last and use them sparingly. In watercolor, understatement is important; learn to put it down, then leave it alone.

Mixed Media

Although we have been concerned primarily with transparent water color techniques, interesting effects can be produced by using other paints and other materials with transparent watercolors.

Gouaches

The addition of white paint to transparent colors is a widely used technique among those artists who do not feel bound by the restrictions of the basically transparent, or aquarelle, manner of painting. This technique may be used in selected areas of a painting or used throughout the painting. It is especially effective on toned papers. Spattered and dry-brushed, it can be used to achieve snowy, wintry scenes, and to highlight surf and spray.

Resist Techniques

Resist techniques involve the application of materials that will repel the waterbase paints. Rubber cement, wax crayon, candle wax and paraffin are commonly used resist materials. A commercially prepared resist, Maskoid, may be painted on areas to be reserved.

Rubber cement may be used in trailed lines, as in drawing, or may be brushed on to block out larger areas of ground or previously applied color. In either instance, the cement should be allowed to dry thoroughly before a wash is superimposed. After the wash has dried, the rubber cement is rubbed away to reveal the underlying ground or color.

Candle wax or paraffin is used in much the same way except that drying time is not a concern and the wax remains on the ground or color.

Wax or oil crayons may be used in a variety of ways: white crayon, applied to the ground, reserves the whites. Colored crayons may be used under or over washes of color. Unusual brilliance and depth of color can be achieved by combining related colors in watercolor and crayon, such as green crayon over yellow wash; red crayon over an orange wash. Interesting textural effects can be achieved by varying the strokes used in applying the crayon.

Figure. Watercolor and nylon drawing pens. Houston (Tex.) Public Schools. Note that this drawing appears complete even without the inclusion of every detail of the figure and clothing. Note how the dark, patterned area of the shirt is balanced by the darkness of the hair and the shadowed area over the shoulder.

Still life. Watercolor and inks. Student, John Marshall High School, Los Angeles. Textures are added with fine pen and ink lines over dried watercolor washes. How are values balanced?

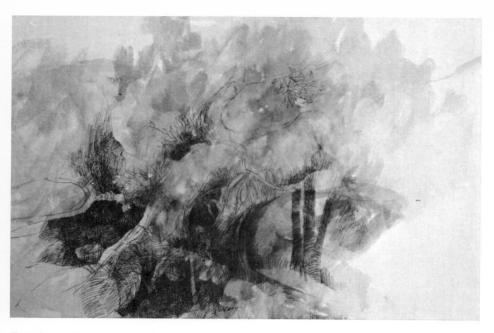

Tree Study. Watercolor with pen and ink.
John Marshall High School, Los Angeles.
Texture and values are added with pen lines
over dried watercolor washes.

Inks, used with pens or brushes, may be combined with watercolor techniques. Pen or brush lines may be used to accent or shade previously applied color washes or to strengthen textural pattern. Again, this technique should not be overworked to the point where it becomes a distraction.

Felt-tipped marking pens may be used to complete a drawing over freely applied areas of color, using the wet-in-wet or "dry" techniques, depending on the effect desired.

Colored chalks may be worked over wet watercolor washes. It is important to keep the wash fairly wet if a blended effect is desired.

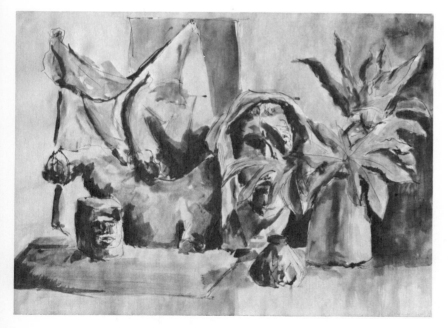

Still life. Watercolor and ink, 18″ x 24″.
Student, Lutheran High School, Los Angeles.
Courtesy Gerald Brommer. Large forms
were created with "loose" washes of brown
watercolor. Dark lines that accent shapes
and textures were added with a stick and
India ink.

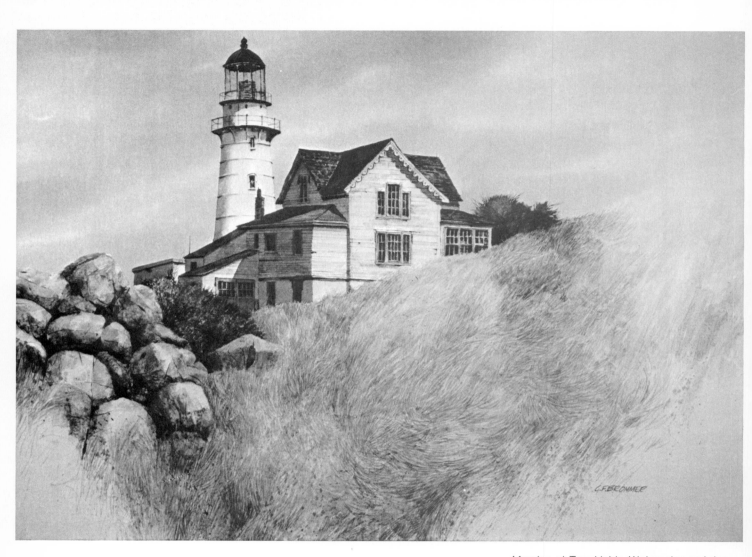

Morning at Two Lights. Watercolor and rice paper collage, 22″ x 30″. Gerald F. Brommer. The forms of the buildings and rocks are clearly defined by strong contrasts in values. Note the variety of textures created by the addition of collage and skillfully handled brush techniques.

Terraveil Split No. 9. Transparent water-color, 28½″ x 40″. Robert Perine. Abstract shapes and color are the primary concerns in Perine's uses of sweeping washes of transparent watercolor. What does the title suggest to you?

Geoglyphica 29. Transparent watercolor, 40″ x 40″. Robert Perine. Can you find an image in this bold composition? What is the importance of the huge slashes? How do they relate to the rectangular shape and to the white negative areas?

Collage

Shapes which may be cut from a variety of papers can be used to establish major forms in a painting or to add textural interest. Papers commonly used are colored art tissue or rice paper adhered with waterproof adhesive or acrylic medium. As you work, keep in mind that most colored tissues will fade, or bleed, color. If the color is to be controlled, seal the tissue with acrylic medium or a resist material, such as wax or rubber cement. Rice papers may be painted or used as is. For an effective combination of watercolor and collage, see the demonstration by Gerald Brommer, page 54

SUGGESTED PROBLEMS

1. On a sheet of white drawing paper: Lightly sketch a single object—cup, jar, box, ball, a vegetable. Using only one color, paint the object to show its basic form. Work with light to dark washes. Give attention to texture.

2. With a sponge, lightly moisten a sheet of white paper. Using a large brush, apply washes of related color, at random, with attention to variety of sizes and shapes. Tilt paper slightly so that color edges blend, or blend edges with a soft brush. Permit the washes to dry. With a contrasting color, sketch a composition suggested by the colors and the shapes they have taken.

3. On white paper, at least 12″ X 18″, apply a graduated wash of a single color of your own choice. Remove excess color or puddles with a blotter or sponge and permit the wash to dry. With a second contrasting color, create a simple landscape whose mood is suggested by the color of the wash.

4. On white paper or board, draw an animal or figure with trailed rubber cement. Work quickly, stressing basic forms and action. Permit the rubber cement to dry, then cover it with a wash or blended color. When the wash has dried, use fingers to rub away the dried cement.

5. Sketch a composition lightly with pencil. With a small brayer, roll on washes of transparent watercolor. When the color has dried, use India ink (pen or brush) to emphasize contour, texture and details.

6. From a posed model, sketch lightly in pencil. Create color areas with transparent watercolor washes. When color has dried, use wax or oil crayons to establish values, create textures and to strengthen areas of importance. Emphasize masses, lines of movement and the spirit of the pose.

7. Dampen a sheet of white drawing paper with water using a wide brush or sponge. With a large soft brush, create an abstract compostion, using colors that express a particular mood. While the washes are still fairly wet, use colored chalks to darken values, emphasize linear movement and to create texture. Experiment with the chalk, using the sides and ends of the stick to create a variety of lines and surfaces.

8. On a toned paper, lightly sketch a landscape, street scene or seascape. Add white paint to transparent colors and develop the scene to suggest atmospheric effects, mood or spirit. Experiment with spatter and stippled effects with a stiff bristle brush and cotton swabs.

9. Pour a strong watercolor wash into a spray gun. On white paper or board, arrange a variety of cardboard shapes to create a non-objective composition. Spray the wash over the arrangement. Lift strips and evaluate results. Rearrange some of the cardboard shapes and respray. Work toward balance of shapes and values.

1

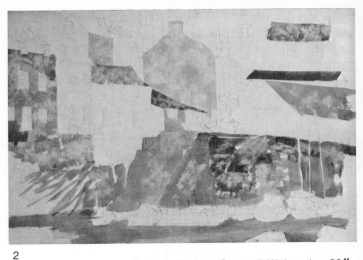

2

Polperro Harbor, Cornwall. Watercolor, 22″ x 30″. Gerald F. Brommer. California artist Brommer demonstrates the steps in this painting of an English harbor. The painting is done on heavy watercolor paper; colors were allowed to dry between each step.
(1) Sketch big shapes first, with enough detail (windows, chimneys, boats) to get them in the right places. Eliminate all material that you feel is unnecessary.
(2) With a large flat brush, put down the areas of light value first. (To indicate the textural surfaces of the buildings, facial tissue was used to blot textures into the wet paint.) Work the light areas all over the painting. Whites and *very* light areas are left alone. Some dark areas get a light wash of local color.
(3) Middle values all over the painting are brushed on next. No details yet! All work was done with a large, flat brush. A few second washes are put over the areas of darker values, beginning to build up the rich, deeper transparent colors.
(4) With a pointed, medium-sized brush, begin to indicate larger details (windows, doors, roof edges). Textures are enhanced. Areas of darkest values are indicated, all over the painting.
(5) Addition of final details (some with small brush) shading and textures. If you squint your eyes, you will see that the big shapes and values are the same as in several previous steps. Shadow washes are bluish and cool to contrast with warmer, light-valued areas. Notice how your eye moves into the picture from the lower right area, along the light-valued shapes of the boats.

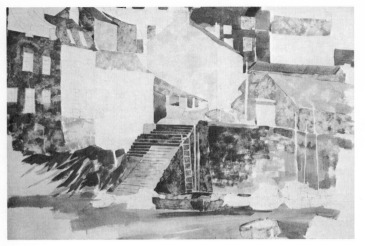

3

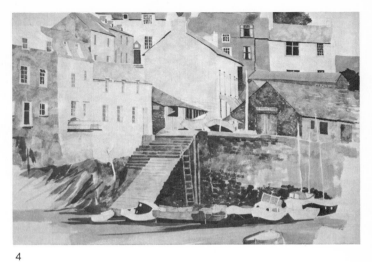

4

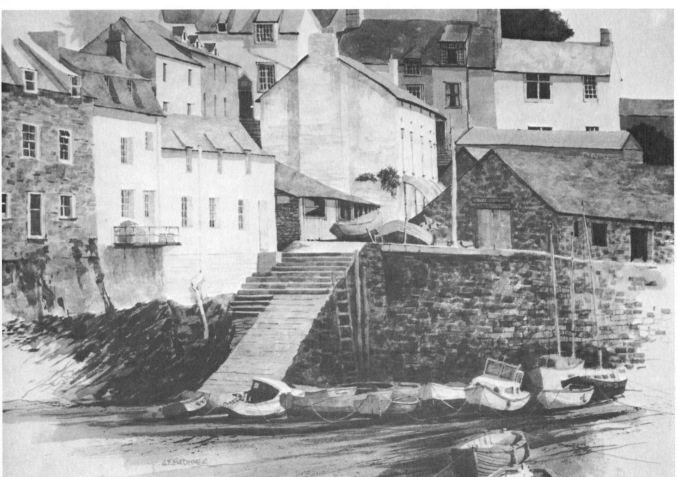

5

Experimental problem: Mixed media. A mixture of thinned acrylic gesso, sand and fine paper pulp was applied in layers of varying thickness on a Masonite panel. When dry, this textured ground was treated with thin washes of white, blue and dark gray paints.

Painting with Synthetic Media

Drift No. 2. 1966. Acrylic on canvas, 91½″ x 89½″. Bridget Riley. Albright-Knox Art Gallery, Buffalo, N.Y. Gift of Seymour H. Knox. "Op" paintings are characterized by hard edges, lack of focal points and an all-over organization. There is no reference to recognizable "real" objects; the purpose is to produce the sensation of movement or flux on the surface of the painting.

The development of synthetic painting media has created much excitement in the world of painting. What do we mean by *synthetic media*? All paints, including tempera, oil and watercolors, are made up of two basic ingredients: *pigment,* which is the dry, powdery material used to color the paint, and *medium,* the liquid with which the pigment is mixed. In the manufacturing of oils and watercolors, natural resins and oils, such as linseed oil, are used as media; in synthetic paints, chemically produced media, *polymers,* are used. The paints produced are called *polymer emulsion paints.* There are many different kinds of polymer paints and they vary in chemical makeup, depending on their resin base. Generally, the term acrylics is used to include all types of polymer emulsion paints because the acrylic types are the most widely used. While this term is not technically correct, we will use it in our discussion for the sake of convenience. If you purchase synthetic paints for yourself, however, keep in mind that they are not all alike and that different brands are not always compatible.

What makes acrylic media so exciting for the artist? Their chief characteristic is an amazing versatility that permits an almost unlimited scope of exploration and experimentation.

They can be used in ways that duplicate and, in many instances, surpass the effects produced by the traditional media of transparent watercolor, oils, tempera, casein and encaustic. They also offer these distinct advantages:

1. Quick-drying. Ten to thirty minutes in normal application; impastos require more time, depending on thickness of application.
2. Highly resistant to sunlight, gases, acids and, when dry, impervious to water.
3. Retain flexibility. Canvas or paper with a normal application of paint can be rolled without cracking.
4. Sizing and priming of canvas or other supports are not necessary, except to seal porous surfaces.
5. High degree of adhesion to almost any painting surface. Exceptions are glass, metal, Formica and oily or waxy surfaces.
6. May be combined with a variety of other water soluble media.
7. May be used in other art techniques and processes such as sculpture, printmaking, papiér-mâché and various crafts projects.

Painting Media

It is not necessary to have a detailed knowledge of their chemistry to use acrylic paints. Some general guidelines, however, will assist you as you explore their possibilities:

1. Each manufacturer uses the same medium in all his products. This accounts for the compatibility of all the products within a given line or brand. This medium or binder, may also serve as glaze, color vehicle or adhesive.

2. When using these, try to limit them to one brand name.
3. Water-based synthetic media should not be mixed directly with oils.

A particular type of synthetic has been chosen for this discussion—the acrylic polymer emulsion. The colors, with their accompanying media, are briefly described:

1. Colors. Available in tubes and jars. (Jar colors are water-thinned). May be thinned with water or medium.
2. Acrylic emulsion medium (matte or gloss). Versatile base medium used to thin paints; to glaze them; to coat the painting surface. May be used as an adhesive in collage techniques. Acrylic medium may also be used as a varnish.
3. Gel medium. Pure acrylic emulsion. May be used to increase the body of jar or tube colors, to create textures and impastos. Dries transparent and provides an excellent glaze vehicle. May be used to adhere collage or other additive materials to painting support. Extends drying time of paints.
4. Modeling or molding paste. Composed of finely ground marble. Used to build impastos, alone or in combination with paints. May be shaped, modeled or textured. When dry it may be carved, cut or scratched with knives, files, nails or other sharp tools. It may be smoothed by sanding.
5. Acrylic gesso. Extremely white, strong and pliable. One coat will cover canvas; rigid supports, such as masonite, require several thin coats. Sand, gravel or other additives may be adhered to a rigid support with gesso. May be mixed with modeling paste; may be tinted.
6. Matte varnish. Protective coating for paintings. If water is added, use little. In applying varnish, use flat, soft brushes and avoid overlapping strokes. Gloss medium may be used as a final varnish if a higher gloss is desired.

The Ages of Medicine. (Detail) Acrylic and tempera. Tom Vincent. Collection of the Schering Corp., courtesy Russell Woody. With acrylic colors all the subtle "painterly" effects of oils can be achieved. In this subdued composition, the textures of the underlying gesso are clearly seen, the brush marks are softly blended and the application of paint ranges from completely covered areas to thin glazes. What is the mood of the painting?

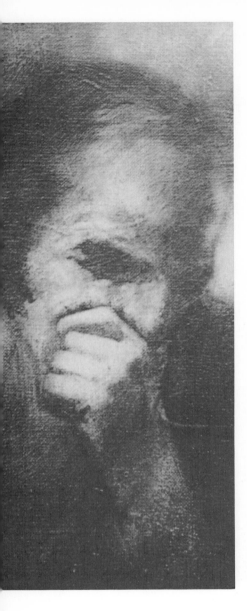

Palettes

Palettes used for acrylic paints should be of smooth, nonabsorbent materials. Any of the following may be used successfully: sheets or slabs of glass, Plexiglas, Formica or other nonporous plastics. Hard, nonporous white surfaces such as enamel trays or opaline glass are ideal. Plastic cups and plastic egg trays make excellent container palettes and will keep colors moist for a longer period of time.

To avoid waste, small amounts of colors should be prepared at the beginning of a painting session. Leftover colors may be saved by covering the palette or containers with plastic wrap or aluminum foil.

Palettes are easily cleaned by washing with water soon after use or, if paints have dried, by covering them with water-soaked rags or newspapers. (Hardened shapes of colors or gel may be removed, intact, from the palette and re-adhered to a later painting or collage surface.)

At the end of a painting session, the tops of paint jars, lids, tube tops and caps should be cleaned and securely sealed. Since the colors are insoluble in water when they are completely dried, a carelessly sealed jar or tube may be difficult to open. If a jar color has started to dry, remove the skin which forms on top and add a bit of water or medium to the paint.

Self-Portrait. Acrylic on wood. Student, Fort Lee (N.J.) High School, Joan DiTieri, instructor. The grain of the wood panel does not show through the paint surface if the panel is first coated with acrylic gesso which is then sanded to a smooth finish, as in this illustration.

Supports

Acrylic media will not adhere to glass, metal, shiny plastics or to greasy, oily or waxy surfaces. However, they will adhere to and strengthen a wide variety of other supports: wood, burlap, linen, cotton, synthetic fabrics, cardboard, kraft paper, paper towels, canvas board, wallboard, mortar, plaster and untempered Masonite. (Tempered Masonite is treated with oil and is, therefore, unsuitable.)

Highly absorbent materials, certain papers and fabrics, should be pre-coated with the acrylic medium but it is not necessary to size or apply a ground coat to other surfaces.

Rigid supports—Masonite, bookbinder's board, hardboard and wallboard—are recommended for collage techniques and for paintings that incorporate heavily built impastos or three-dimensional objects. To lessen the possibility of their warping, both sides of these rigid supports should be coated with the acrylic medium. For better adhesion, untempered Masonite may be lightly sanded.

Tools and Materials

Brushes of any size or type may be used with acrylic media. In addition to traditional art brushes and brayers, you may use paint brushes and rollers of the type available in most hardware stores. Nylon brushes are usable and wear well. Brushes should be wet before use and should be kept wet during the painting session since the colors and related media are *not* soluble in water when dry.

If paint should dry on brushes or tools, they may be cleaned with the solvent supplied by the manufacturer or with lacquer thinner. If the paint has not hardened, laundry detergent may be used to clean them.

A great variety of other tools are useful and provide greater opportunities for exploration. Some of these are:

1. Painting knives for textured and impasto surfaces. Putty knives may also be used.
2. Household spatulas for application of paint, gel medium, and modeling paste may also be used for texturing.
3. Files, knives, rasps and sandpaper for carving, cutting, and texturing hardened modeling paste.
4. Flat, soft brushes for wide application of acrylic medium or varnishes.
5. Found objects with interesting shapes or textures may be pressed, rolled or scraped into modeling paste, gesso or colors to modify their surfaces.
6. Plastic squeeze-bottle. Paints or modeling paste (mixed with gel) may be placed in these bottles and extruded or *trailed* onto the painting surface.
7. Sponges can be used to wipe or lift colors and to create textures.
8. Spray bottle, or plant mister, for spraying or misting colors to retard their drying. Use sparingly.

Storage and handling

Since acrylic media dry rapidly, storage is not usually a problem. A face-to-back stacking arrangement is always wiser, however, and, as an extra precaution, sheets of waxed paper should be placed over not-quite-dry surfaces if paintings *must* be stacked.

Paint spills and smears on cabinet tops, easels, equipment, and clothing should be removed promptly. A generous supply of water, rags and newspaper will make for easier clean-up procedures.

Techniques

Acrylic colors and media possess certain unique characteristics that have earned for them the regard generally accorded the more traditional media of watercolor and oils. They are unequalled in their permanency, luminosity and versatility. Their compatibility with other media and additive materials, with the exception of oils, provides an awesome range of exploration that frees the artist of the limitations imposed by traditional media. In addition, acrylic paints can be used to duplicate the effects achieved with traditional watercolors, tempera, casein and oils.

Acrylic Paint Techniques

1. Acrylic color can be handled in the same ways that oil paints are used: they can be applied in thin washes (lighter face) or applied heavily (face in background).
2. Glazing techniques are especially effective with acrylic colors. In this example, a light, translucent glaze was applied over the lower part of the painting.
3. An example of the blending of colors in a wet-in-wet technique.
4. Acrylic paste used to adhere cloth and wood in a collage. Paints and acrylic medium are also adhesive.
5. Scumbling techniques—light paint dry-brushed over dark areas—suggest the rough textures of a tree.
6. Collage. Acrylic medium was used to adhere color tissue to the surface of the painting. Washes of acrylic colors add richness and subtle color variations.

1

3

5

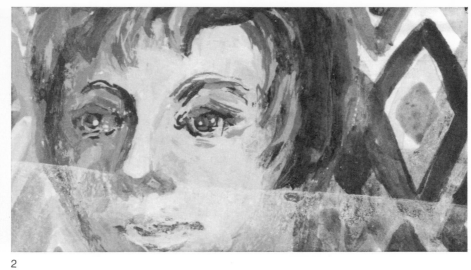

2

4

6

1. Watercolor Techniques

Acrylic colors, from tube or jar, may be thinned with water or acrylic medium and handled in the same manner as traditional watercolors. The papers and brushes may or may not be the same as for watercolors. There are some differences, however, that are advantages: acrylic watercolors are permanent and can be framed without glass. When brushed with acrylic varnish, they may be washed without damage. This permanency also makes the application of washes over a previously painted ground much easier; the wash will not pick up the underlying color as would occur with traditional watercolors. Great depth of color not always possible with traditional watercolors can be achieved through this technique.

Corrections in a painting may be made by applying opaque white paint, which will effectively cover underlying color and provide a fresh white ground. When the ground has dried, corrections may be painted in without loss of freshness.

Dry techniques or wet-in-wet are accomplished in the traditional manner. In the direct dry technique, the color is mixed on the palette and applied directly to dry paper. In the wet-in-wet technique, the paper is first thoroughly wet. Colors are then applied over the wet surface.

Traditional aquarelle techniques involving a controlled handling of transparent washes may be followed, or a gouache effect may be achieved by limiting the palette to opaque colors. Because acrylic paints remain flexible, they allow a heavier application of paint films than is normally possible with traditional gouache, such as casein. The latter will crack if built up too thickly.

Untitled. Acrylic. Student, Fort Lee (N.J.) High School. An illustration of the textural effects achieved by wet-in-wet application of acrylic washes and glazes.

Untitled. Acrylic. Artist, Susan Bethel. The lower area of the canvas was sprayed over a paper stencil which blocked out certain areas. The large circular shape is a thinned, or stained, application of paint. The circular shape appears menacing; is it an atomic cloud?

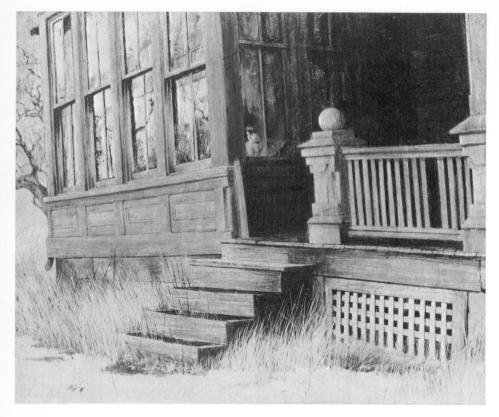

The qualities of value, texture, and line associated with traditional watercolors may be duplicated with acrylic paints: washes, stipple, spatter, dry-brush and spray applications are all possible.

Masking out of objects or areas of color is accomplished through the application of resist materials (rubber cement) or stencils. Wiping out or washing out of color, however, must be done while the paint is wet because once the paint dries it is waterproof.

Mixed-media techniques associated with watercolor may be used. Wax crayon, conté crayon, rubber cement, and colored inks may be used under or over washes of acrylic paints. When acrylic medium is added to tempera and casein paints they will then acquire the permanency and adhesion associated with the acrylic paints.

Acrylic paints possess unique leveling characteristics and are, therefore, highly effective in opaque, flat applications. Soft sable brushes are recommended if a brushless smooth surface quality is desired. Sharp, clean edges may be created by using masking tape to shield specific sections of the painting. This procedure is recommended for a painting using the hard edge techniques.

In addition to a variety of brushes, paint rollers, brayers, sticks, tongue depressors, sponges and edges of cardboard may be used in opaque techniques.

Completed acrylic watercolors require no final varnish for permanency. However, a final matte varnish may be applied to protect unpainted areas or to retain the matte quality of watercolor if this is desired.

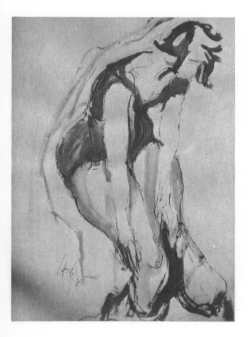

Repine. Acrylic. George Sottung. Courtesy M. Grumbacher, Inc. An example of acrylic paints used in the manner of tempera. Fine, dry-brushed lines are used over dried flat areas of color to achieve a richly-textured and sensitive interpretation of subject matter. Note how a dramatic effect is achieved by the very dark values on the porch wall. What effect is achieved by the inclusion of the figure staring through the window?

Study for Ballet. Acrylic wash, 30″ x 22″. Russell Woody. An illustration of how acrylic colors can be used in the transparent manner. Here, washes are used to establish masses and the basic movement of the body as a preliminary to the actual finished painting. Lines were made with a bamboo pen dipped in thinned Mars Black acrylic paint.

Young and Pensive. Acrylic. Lawrence Zink. Courtesy M. Grumbacher, Inc. An excellent example of the use of painting with painting knives. Colors are applied in large flat areas with an emphasis on the basic forms of the figure. The values are strongly contrasting and well-balanced, adding great strength to this direct and forceful painting.

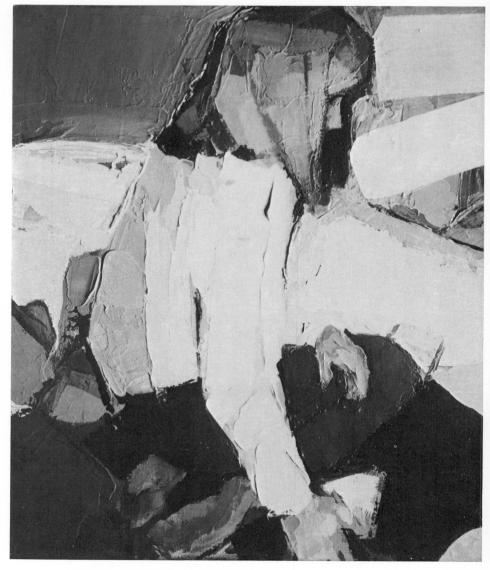

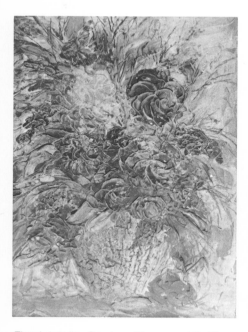

Floral. Acrylic. Courtesy Binney and Smith. The forms of flowers and vase were established by impasto application of acrylic modeling paste which was allowed to dry. Colors were added by brushing on opaque colors and transparent glazes. Some of the color has been wiped away to create highlights on the ridges of dried modeling paste.

Still life with Watermelon. Acrylic on canvas. Romeo Tabueno. Collection Galeria de San Miguel, San Miguel Allende, Gto., Mexico. Courtesy Nicholas Roukes. Note the interesting variety of forms and textures in this well-balanced still life arrangement of melons, cheese and fruit. The stripes in the background and the seeds of the melons provide contrast to the otherwise plain surfaces. Note, too, that the negative shapes are varied in size and value, adding greatly to the unity of the total composition.

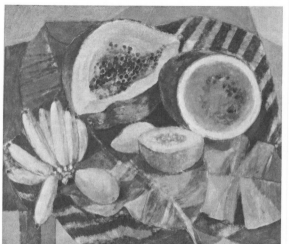

2. Impasto Technique

Thickened paint, jar or tube colors, may be applied with bristle brushes, knives or a variety of improvised tools. For heavier impastos, it is best to add modeling paste to the colors rather than build impasto of color alone. These thick paints should be applied in several layers to avoid cracking. Heavy transparent impastos can be created with gel medium combined with acrylic colors. The effect is similar to stained glass in transparency and brilliance.

To avoid warping, a rigid support should be used if extensive use of impasto is anticipated; Masonite or other hardboard is recommended.

3. Glazing and Scumbling

In *glazing*, acrylic colors are mixed with acrylic medium until thin washes of color are obtained. (When dry, the washes will be transparent.) These washes are then brushed or rubbed over underlying color, or over a base of textured gesso, gel or modeling paste. These glazes may be applied quickly, layer over layer, and the result is a sparkling depth of color unique to acrylic media. (Mixing colors with water does not produce the transparency desired in a glaze.)

Scumbling is effective in achieving textured or broken areas of color. Colors, usually opaque, are brushed or dragged over a dry, underlying color or textured surface. Use a bristle brush, with most of the color brushed out, in a kind of dry-brush technique, since the aim is to achieve broken color rather than a flat, solid color.

4. Textures

A variety of tools and gadgets may be used to texture thickened paint, gesso or a layer of modeling paste. Saw blades, combs, corrugated board and sponges are only a few tools that may be used to cut, scrape, gouge or otherwise texture the surfaces. When the surface is almost dry, brush away the loosened bits of gesso or paste.

Strings and yarns may be dipped into acrylic medium or gesso and adhered to the painting to define shapes or areas or to create a linear movement.

Net, cheesecloth or tissue may be dipped in gesso or acrylic medium. Then they can be manipulated and shaped into interesting shapes and three-dimensional forms. When dry, these forms may be painted, glazed or become a part of an all-white composition.

Dry materials, such as sawdust or vermiculite, made wet with acrylic medium, may be added or pressed into colors, gesso or modeling paste. Wetting the dry materials with medium will ensure that they will be firmly adhered to the surface of the painting.

Untitled. Acrylic on canvas board. Student, Fort Lee (N.J.) High School. Joan DiTieri, instructor. The painting was first painted in light and medium values and allowed to dry for a short time. The darkest value was then applied over the entire surface of the painting. While still wet, the dark areas were scratched to reveal the underlying light and medium tones. The scratching produces an interesting texture that enhances and unifies the total painting.

5. Collage

Polymer medium is an excellent adhesive for use in collage. Plain and textured materials, including papers of all types, fabrics, yarn and threads, may be adhered to a great variety of supports. (To avoid warping, coat both sides of the support with acrylic medium.) Supports should be rigid enough to support the weight of collage materials used.

Papers may be painted with acrylic colors to create a wide range of hues. Papers may then be cut or torn and adhered to the support with acrylic medium.

Paint that has dried on a nonporous palette may be soaked with water until loose and then incorporated into a collage surface for an added dimension.

6. Murals

Acrylic media are excellent for use in painting murals. They may be used on plaster (sanded), Masonite, canvas, and a variety of hardboards and papers. Colors remain brilliant and permanent and will neither yellow nor crack. Gesso or medium, applied before painting, will strengthen whatever support is used. Murals painted with acrylic media may be easily cleaned with a mild detergent mixed with water.

Panels and other supports for murals should first be coated on both sides with acrylic medium. This will lessen the danger of their warping and also serves as an added protection for the surface of the support.

The finished mural should be coated with acrylic matte varnish or with acrylic medium. If a higher gloss is desired, gloss medium should be used.

7. Mixed Media

Acrylic media—gesso, colors, modeling paste, gel, and varnishes—combine with most traditional media to produce an unlimited range of experimental techniques.

A. Pastels and pressed chalks may be applied over a surface made wet with acrylic medium. The medium will fix the powdery chalks, preventing them from rubbing off.

B. Acrylic medium may be combined with most powder paints. The medium may also be used with liquid tempera, casein or traditional pan or tube watercolors.

C. Colored inks and dyes may be added to acrylic medium.

D. Washes of acrylic colors may be applied over India ink or resist materials, such as wax crayon, grease crayon or rubber cement.

E. Acrylic gesso provides an excellent ground for oil colors. Acrylic media should not be mixed *directly* with oil media, however, since they are not compatible.

8. Other Uses

A. Acrylic medium serves as an excellent binder in pâpier maché. Acrylic colors and modeling paste may be used in painting or decorating finished projects, such as figures, animals or jewelry. Decorative relief surfaces can be created from the thick modeling paste.

B. Acrylic medium can be used as a silk-screen blockout. Waterbase printing inks or thinned acrylic colors can be used to complete the printing. If thinned acrylic paints are used instead of ink, the printing must be completed quickly or the paints will dry on the screen and clog it.

C. Acrylic medium may be used in building a textured surface for printmaking. Textured materials and cardboard are adhered to a hardboard or Masonite surface with acrylic medium. The completed arrangement is sealed with the same medium and printing proceeds in the usual manner. The resulting print is called a collagraph, from collage.

D. Acrylic colors on a plastic, glass or hardboard base may be used in monoprinting. Use them as you would use any other paint or ink.

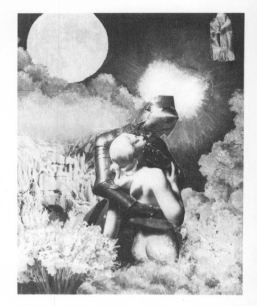

Montage. Photos and acrylic paints. Student, South Kingstown High School, Wakefield, R.I. Teacher, Jean Hogan. Acrylic paints used in an opaque manner create a variety of textures in an imaginary background. Note how the textures and values of the figures contrast against the background.

Shirt. Acrylic. Student, Spruce High School, Dallas. Susan Ross Evans, instructor. A shirt becomes part of the canvas in this imaginative use of materials. Note how the shapes of the pockets have been painted and integrated with the remaining colored shapes. The folds of cloth add a three-dimensional textural effect. Acrylic media are ideal for a project such as this because they adhere materials in addition to coloring them.

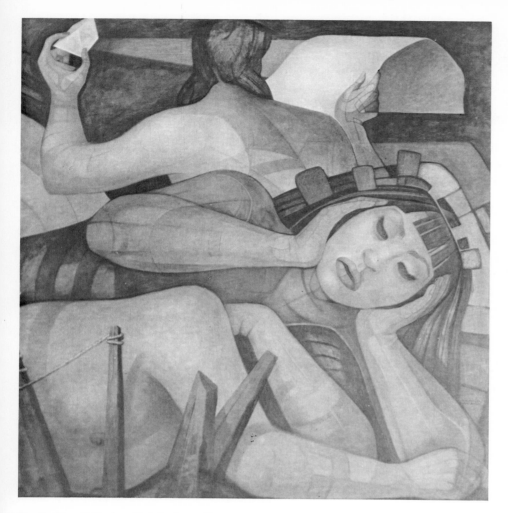

Awakening of Mexico. (Detail of mural). Acrylic on polyester. 80 sq. meters. Gonzalez Camerina. Escuela de Capacitacion. Photograph by Nicholas Roukes. Painted on a fiber-glassed panel, this mural has a luminous surface quality created by many glaze applications of transparent washes of acrylic colors.

E. Acrylic gesso and modeling paste may be used to decorate picture frames and to construct or repair sculpture.

F. Modeling paste, applied in a smooth layer on Masonite and allowed to dry, may be carved and cut to produce a printing block. Print by rolling the surface with a soft brayer; heavy pressure would crack the block.

Getting Started

Acrylic media present such a staggering variety of techniques and possibilities that deciding where to begin can be difficult. You might start with some simple experiments that will acquaint you with how the paints and the various media behave on different kinds of painting surfaces, such as drawing paper, watercolor paper and canvas. Look at the techniques shown on page 63 and then, with a variety of brushes, try some of them yourself. Don't attempt to do all of them at one time. Instead, start with a simple technique that you have done before—perhaps, a wash—and go on from there to less familiar techniques.

Resist the temptation to use all your newly learned techniques in *one* painting! Remember that the purpose of any technique is to enhance and strengthen the painting, not to dazzle the viewer.

A caution: Acrylic paints, when dry, are not soluble in water and brushes should be kept wet at all times. If paint is spilled on your clothing, wash it out immediately. If the paint dries before you discover it, you might as well expand the accidental spill into an attractive design, because acrylic colors are excellent and permanent textile paints.

SUGGESTED PROBLEMS

1. Lightly sketch a street scene or landscape on white drawing or watercolor paper. (Use rubber cement to block out areas that are to remain white.) Prepare a generous quantity of transparent wash by thinning a color with water. Use layers of wash to establish masses and darker values. When the paint has dried, rub away the rubber cement. Use drybrush techniques for further definition of contour, to darken values and to create textures in buildings, grasses or trees.

2. Sketch a still life arrangement of objects of contrasting textures and surface patterns. Use light, middle and dark values of one opaque color to define major forms, planes and tones. Prepare a glaze in a darker tone of a *related* color and dry-brush over the entire surface of the painting. When the glaze has dried, use bold brush strokes of black to deepen values and to accent patterns and textures.

3. Prepare a fairly rigid support (Masonite; hardboard) by coating it with acrylic gesso. Using only acrylic gel and a painting knife, create a non-objective "texture" painting, use no colors. Emphasize contrasting surface qualities (smooth, ribbed, stippled) and work for a balance of shapes and sizes. When the gel has dried, finish the painting by applying glazes in a limited color range, such as ochre, sienna and black.

4. On a canvas support, sketch a subject of your choice, giving careful attention to establishing a center of interest and the harmonious arrangement of values and textures. Use tube colors, or jar colors to which modeling paste has been added, to complete the painting. Experiment with impasto applications in selected areas; use painting knives, sticks or broken comb to create textures and lines. (A more rigid support is needed if *very* heavy impasto is used.)

5. Cover a poster board with a flat, smooth application of one opaque color. After it has dried, use colored chalks, oil crayons, or conté crayons to create a figure study. Apply color in lines, layer upon layer, to indicate mass, volume and movement.

6. Spread a layer of modeling paste evenly over a rigid surface. While the paste is still wet, create areas of textural interest by adding materials such as sand, fine gravel or vermiculite. To assure adhesion, press the material into the paste with the palm of your hand or a brayer. Create line by using heavy cord, applicator sticks or strips of balsa wood. Finish with brush application of solid color or color glazes.

7. Coat a rigid support with acrylic gesso and set it aside to dry. Dip cheesecloth or other thin, white material in acrylic medium, being sure that the cloth is completely wet through. Place cheesecloth on the dried support and shape it into interesting contours of varying heights and depressions. (Consider a swirling movement, a movement that suggests flight or a definite direction.) When the arrangement is completed and the material has dried, apply flat white paint over the entire surface. This all-white composition may be satisfactory but, for a different effect, cover the dried white paint with a dark glaze, wiping out the glaze on the high points of the arrangement.

Mexican Fishing Boats. Acrylic on Masonite panel, 20″ x 28″. George A. Magnan. Courtesy the artist and *Today's Art* magazine. A demonstration of the variety of painting techniques used in creating a bold and powerful beach scene.

(1) The surface is a Masonite panel coated with a thick ground of acrylic gesso mixed with modeling paste, with brushmarks leaving surface textures. Over this, transparent washes of yellow ochre, burnt sienna and violet acrylic colors were washed in light tones for a background approximating the general coloration of the beach scene. When this was dry, the scene was lightly sketched in charcoal. Once the composition was established, major masses and lines were painted in thinned ultramarine blue with a #4 pointed sable brush, relating subjects within an organized design pattern.

(2) Painted thinly with violet, viridian green, thalo blue and burnt sienna, shadow areas of the background and of the boats were laid in, vignetting them against the light beach tones. Foreground shadows and mud flats were indicated in subdued middle tones. Areas of light-toned beach were highlighted in blocky strokes of undiluted titanium white tinted with cadmium yellow medium, accenting the bright contrasts of the scene.

(3) The scene was overpainted with heavy, opaque colors, leaving some areas of transparent color, giving definition to the boats and introducing forms within the background. When dry, charcoal was sketched on to re-establish the main design patterns, delineate masts and then sprayed lightly with fixative.

(4) Working with ½″ and 1″ flat bristle brushes, impastos of undiluted tube colors, some mixed with acrylic gel to add more body, were applied to define details further. Opaque overpainting was applied mostly to the light and highlight areas, leaving shadow areas transparent wherever possible. This varied treatment added to the depth, textural quality and interest of the scene.

1

2

8. On a cardboard support coated with acrylic medium, arrange shapes of colored tissue, using a still-life sketch as a basis for composition. With a brush dipped in the medium, go over tissue shapes to seal them to the cardboard. (Note "bleeding" of colors from the shapes of tissue.) Experiment with overlapping shapes and colors. Use tube or jar colors to create transition from painted surfaces to collage surfaces. With a brush or the edges of cardboard dipped into black paint or India ink, create accents, movement and pattern.

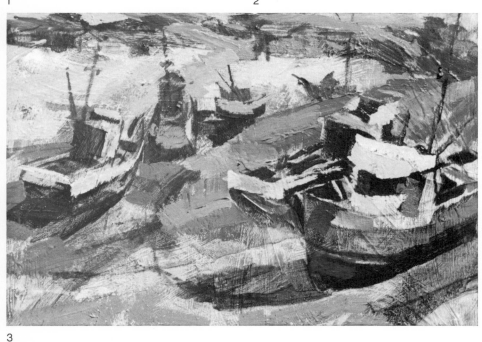

3

4

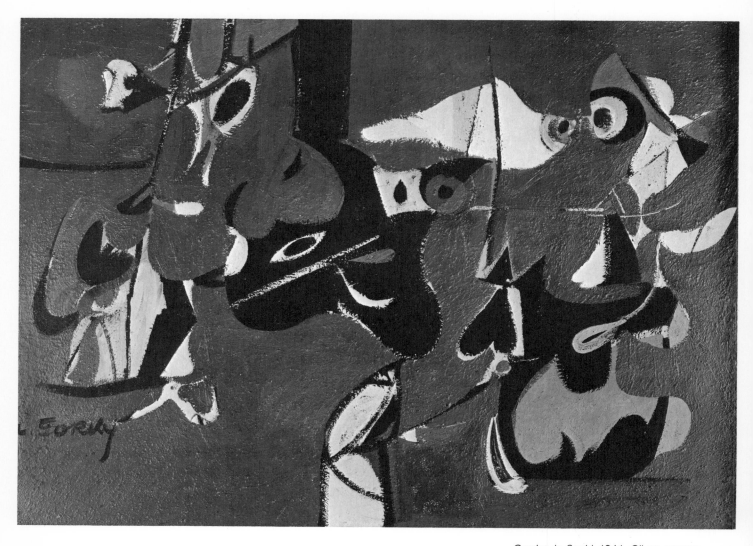

Garden in Sochi. 1941. Oil on canvas. Arshile Gorky. The Museum of Modern Art. Purchase fund and gift of Mr. and Mrs. Wolfgang S. Schwabacher. Free-form shapes seem to float in unbounded space. What do the forms suggest? What is the spirit of the painting?

Painting with Oils

November Evening. 1934. Oil on canvas, 32⅛″ x 52″. Charles Burchfield. The Metropolitan Museum of Art. George A. Hearn Fund, 1934. Burchfield, a regionalist painter of The American Scene, depicted the coming of winter to the Middle West as it might have appeared to the early settlers. The great dark clouds overwhelm the scene, overpowering and threatening the figure and the landscape below. Burchfield, like many other regionalist painters, expressed feelings about people and their relationships with nature and everyday life.

Oil paints are the most versatile of all traditional painting media. Oil paints make possible a greater variety of techniques than either transparent watercolors or gouache colors. With oils, the artist may combine body color, scumbles, glazing, impastos, opaque, and transparent applications in methods that are unique to oils. In addition, the rich, "buttery" consistency of oil paints holds a special fascination for those artists who prefer oils to all other media, including the newer synthetic paints.

Oil paints dry more slowly, of course, than either traditional watercolor or acrylic paints. As a beginner, you may find this to be an advantage since it will allow you to correct or rework your painting in a more leisurely manner. If you work quickly, however, you may become impatient with having to wait a few days before you can apply a glaze or scumble. Later, we will discuss ways of controlling the drying rate of the paint. For now, let us examine the more basic materials and tools.

Colors

Although there are dozens of oil colors available, the following selection provides a basic palette sufficient for your needs as a beginner. The selection of a palette is a highly personal matter and you may add or delete colors as you gain experience and develop preferences: titanium white; ivory black; burnt sienna; burnt umber; Venetian red; cadmium red light; alizarin crimson; cadmium yellow light; Naples yellow; Prussian blue; ultramarine blue; cerulean blue; yellow ochre; viridian green.

Palette

Traditional wood palettes are available in various sizes and shapes. If you prefer to obtain one of these, fine. If not, one of the following will serve nicely and at less cost: A white porcelain butcher's tray, a sheet of thick glass or clear plastic placed over a sheet of white paper (so that you are better able to see colors), disposable paper palette or an old white china platter. Whichever you choose, be sure that it is large enough to hold generous amounts of colors and that it provides sufficient space for mixing paints.

Brushes, knives

There are basically two types of brushes for oil painting—bristle and sable (or other soft hair). Both are available in long, short, round, and flat types. Stiff bristle brushes produce a variety of active, vigorous textures; soft sable brushes produce smoother, finer surfaces and, in smaller sizes, are used to add detail. Brushes are sized from 1 through 12, small to large. Sable or soft hair brushes are somewhat smaller than bristle brushes of the same number.

Three basic brushes are enough for a start: A large (no. 10) flat, long-hair bristle brush, a medium (no. 7) flat, long-hair bristle brush, and a small (no. 3) round, long-hair sable brush. Use the small sable brush to sketch in the basic composition or to outline forms. Use the largest brush to apply large areas of color, such as sky, water, ground or other background colors. The medium size brush is useful for further refining of shapes and forms such as buildings, foliage, and smaller objects. Use the smallest brush last to add details, such as the rigging of a ship, architectural details, grasses, and other fine textures.

Palette knives are used for mixing paints on the palette and to scrape leftover or excess paints from the palette. The knives come in a variety of sizes and shapes. The type with a long narrow blade is recommended for cleaning the palette and general use; trowel-shaped knives may also be used for cleaning and for creating interesting textural surfaces. Experiment with combining brush and knife techniques to discover the tool you prefer.

Painting mediums

A painting medium is used to thin paint to the working consistency you desire. Squeezed directly from the tube, some colors are smooth and buttery, while others are stiffer and less-workable. The addition of the medium makes the paint easier to apply and makes it smoother in texture.

Commercially prepared mediums are available; but, you may mix your own from equal parts of linseed oil and rectified gum turpentine. This mixture is well-balanced. Linseed oil, used alone, produces a too-oily paint; turpentine, by itself, dulls or deadens colors.

If you want to speed up the drying of your paint, add a few drops of copal varnish as a dryer.

Working the Brush. 1977. Oil on canvas, 20″ x 16″. G. Harvey. Courtesy the Texas Art Gallery, Houston. Harvey, a Texas artist, paints scenes of the Southwest that are noted for their mood-provoking qualities and for the unique light that is suffused over the surface of the canvases. In actual color, this scene appears bathed in warm yellow sunlight, with many subtle color variations. Harvey is a contemporary artist who paints in the traditional manner.

Stretched canvas and wood panels are the supports, or bases, preferred by most professional artists. For beginning efforts, however, less expensive canvas boards, Masonite, and other hardboards are satisfactory. You may improvise other supports by glueing window shade cloth, burlap or other plain, sturdy fabric to a rigid support. These improvised supports should be sealed with shellac or thinned acrylic medium.

If you do not use a white canvas or canvas board, you will need to prepare the support by coating it with a white ground that will be the painting surface. Acrylic gesso, mixed according to the manufacturer's directions, is an ideal, all-purpose sealer and primer. It may be applied to Masonite (untempered), hardboards of all types, canvas boards, and to improvised supports of cardboard or fabric. Ordinary white latex house paint can also be used and is more economical for large paintings.

Heavy textured papers will serve nicely for experiments and for quick sketches. Mount these on a heavier backing if you wish to make them more permanent. Size them with acrylic medium or thinned white glue before painting or the surface will be too absorbent.

The Stained Glass Window. Oil, 16″ x 20″ Ardis Shanks-Holmes. Courtesy the Robert Rice Gallery, Houston. A study of meticulously painted textures—glass, metal, cloth and flowers in a simple but interesting arrangement. Note the effective use of highlights on the metal container and on the petals of flowers.

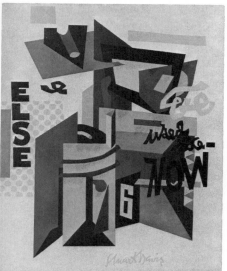

Owh! In San Pao. 1951. Oil on canvas, 52¼″ x 41¾″. Stuart Davis. Whitney Museum of American Art. Signs and symbols of our commercial culture suggest action, noise and "busyness." Artist Davis used them to create tightly structured compositions in which the concern is for visual impact rather than any subjective or emotional quality.

Stretchers

Stretchers are wooden strips designed for making an open frame on which canvas is attached and stretched. In the beginning, you will probably paint on canvas boards or pre-stretched canvas. As you become more experienced, you may wish to stretch your own canvas.

Materials needed are canvas, stretchers (with wooden wedges or keys), small hammer, and one-half inch tacks. (A staple gun may be substituted for the hammer and tacks.) The procedure, briefly described, follows:

1. Assemble the stretchers to make a frame by hammering their slotted ends together until they are tight. Check the corners with a triangle. They should form a 90° angle or else your finished painting will not fit into its frame.

2. Cut the canvas, allowing about one and one-half inches for folding on all sides. If your stretchers measure 18 inches × 24 inches, the canvas should be cut to 21 inches × 27 inches.

3. Distribute the canvas equally over the frame. (The printed numbers, showing the stretcher size, should be on the back side.) Fold the one and one-half inch allowance over the edge of the stretcher frame and hammer the first tack in the center of the strip.

4. Moving from side to side, continue to tack (or staple) the canvas to the sides of the stretcher strips until all sides are completely fastened.

5. Finish the corners by folding the canvas under and tacking it. Either cut off excess canvas or tack it to the back of the stretcher frame.

6. Place the wedges or keys into the corners of the strips and hammer them in place to complete the stretching of the canvas. The more deeply the keys are hammered into the corners, the more tautly the canvas is stretched.

Gore et Mandra. 1957. Oil on canvas. Enrico Donati. Whitney Museum of American Art. Overlapping planes in light and dark values move the eye of the viewer in and out of spaces that are mysterious and changing. Are these craggy shapes stones, an underground maze? Note the variety of textural qualities in the way paints have been applied and how values appear balanced whatever way the picture is turned.

Alley. Oil on gessoed panel. Student, Washington Co. (Md.) Public Schools. The major shapes of the buildings were established with contrasting but balanced light and dark values. Values in the trees were applied as textures; other textures were achieved with scumbles and fine brush lines. The vertical telephone poles contrast with the predominantly horizontal lines of the buildings and divide the sky into a variety of shapes.

Miscellaneous Materials

Turpentine, for cleaning brushes and palette; clean rags; charcoal, for sketching. Tracing paper is useful for transferring a detailed drawing to the support but is not essential.

Easels

Studio or table type, or may be improvised. The canvas should be supported in such a way that you can step back and evaluate your work as the painting progresses. For this reason, you should not paint with the canvas lying on a table.

CARE OF MATERIALS, TOOLS

It is important to the success of your painting that painting tools and materials be cared for properly. If you are purchasing your own materials, a lack of attention to proper care of brushes and paints will prove expensive. Establish good work habits early and you will find that you will be rewarded with longer lasting tools and materials.

Squeeze paint tubes from the bottom, rolling up the emptied tube. Wipe the top of tubes clean and replace caps promptly and carefully.

At the end of a painting session, clean brushes thoroughly. Remove paint by gently squeezing the bristles or hairs in a soft cloth or paper towel, then wash the brush in turpentine. Complete the cleaning by washing the brush in warm soapy water. Shape the brush with your fingers, then store it, bristles up, in a brush holder or jar. Even the most inexpensive brush will be a better tool if you take proper care of it.

Clean your palette, scraping away muddy mixes and bits of leftover paint. If you want to save leftover paints, cover the palette with plastic wrap or aluminum foil until the next painting session.

EXPLORATORY ACTIVITIES

Before you actually begin, it is wise to learn something about your materials and tools through some simple experiments. Since color is often the prime consideration, let us start there.

The arrangement of colors on the palette is largely a matter of personal choice. It is best to separate warm and cool colors, to isolate white paint, and to allow a generous area for mixing. Develop an arrangement that suits you and then use it consistently to avoid having to search for a color.

Handling Color

It is important to learn the proper names of colors and to be able to identify them. Brush a bit of each color from the palette on a scrap of canvas or a piece of heavy cardboard that has been sealed with glue or shellac. Write the name of the color beside the sample. Experiment with mixing colors on the palette and on the canvas to see the variations that occur. Use both brushes and palette knives in mixing the paints and note the differences.

Values

Mix colors with white and with black in a range from light to dark or vice versa. Add black and white to two previously mixed colors. Note that some colors appear to be stronger than others.

Intensities

Experiment by adding a color to its complement—blue to orange, red to green, and yellow to violet. (How will you obtain violet on your palette?) Note the dulling effect that occurs.

Save these color experiments and refer to them as you paint. They will assist you in choosing colors and in mixing colors.

Glazing

A glaze is a *thin, transparent* color wash made by mixing a bit of paint with enough painting medium to achieve the degree of transparency desired. A glaze is applied over dry underpainting to modify or correct a color or to unify the composition. In a properly applied glaze, the underlying color should show through.

Mix glazes in individual pans or saucers since they are quite thin and will run. A glaze tinted with a *darker* color applied over a *light* underlying color is often more effective than a *light* glaze over a *darker* color. To see how glazes affect colors, paint three or four stripes, at least one inch wide, of color onto a scrap of canvas. After the paints have thoroughly dried, mix a glaze tinted with burnt sienna and brush it over the stripes of color. Note how each color is affected by the transparent color of the glaze.

Glazes may be applied over sections of a painting or over the entire painting. You may experiment further by wiping away some of the wet glaze with cheesecloth.

Remember that glazes should be transparent and that they are brushed on only after the underlying paint is dry.

Fear. 1949. Oil on canvas, 60″ x 40″. Yves Tanguy. Whitney Museum of American Art. Surrealist artist Tanguy created a nightmarish scene in which fantastic forms appear to grow out of each other. Surrealists found their strange symbols in the subconscious mind, from dreams and hallucinations and painted them in ways that defy reason and logic. The actual color of this painting is, primarily, a silvery metallic gray with bits of reds and yellows.

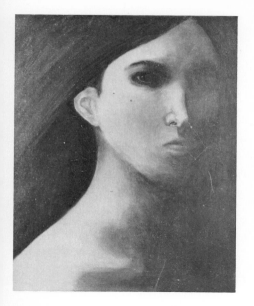

Self Portrait. Oil. Student, Fort Lee (N.J.) High School. Joan DiTieri, instructor. Sharp contrasts in light and dark values produce the effects of strong lighting resulting in a dramatic treatment of the subject. Note the "brushless" quality of the painting produced by greatly thinned oil glazes.

Scumbling

A *scumble* is the reverse of a glaze. Whereas glazes are thin, transparent paint mixtures, paints used for scumbling are opaque and usually require no addition of painting medium except to make them workable. Like glazes, scumbles are applied over a previously painted area which may be dry or wet. To apply a scumble, pick up the paint with a palette knife or brush and *lightly* drag it over the underlying color. Do not attempt to cover the surface evenly but, instead, permit the underlying color to show through. Note that the scumble color hits the high spots, the tops of the ridges of dry, or partially dry, paint. It is this textural quality that makes scumbling effective; it produces areas of broken color that take on an added sparkle and brilliance. Use a knife when applying a scumble to a wet area; skim the surface, do not cover it completely. A brush works better on a dry surface.

Experiment with scumbles to achieve varied textural effects: a snowy street, white-capped water or weathered wood.

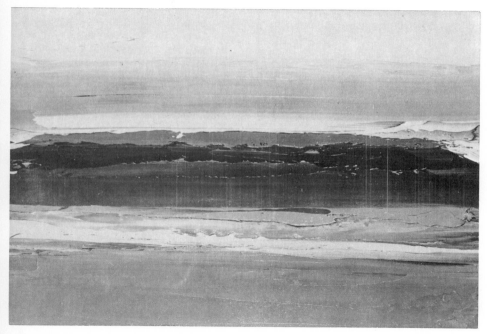

Sunday Morning. Oil. Arthur Secunda. Honolulu Academy of Fine Arts. Photograph courtesy Bocour Artists Colors. A powerfully evocative painting achieved with an economy of means. Broad horizontal bands of color suggest a quiet emptiness, perhaps a deserted beach. Scumbled impasto accents in a light value suggest surf and provide textural interest. Note that the light values at the top of the painting create the effect of great space and distance.

Textures

Glazes and scumbles are used to produce certain textural, or surface, effects. Brushes and painting knives, however, are used regularly to produce textural effects. The importance of brush strokes and the marks produced by painting knives should not be overlooked. Remember that an orange is usually *round* and that brush strokes should follow its contours; a box has *straight* sides and should be painted with straight strokes.

Use bristle brushes to indicate rough surfaces, such as the bark of trees, craggy stones, and other uneven surfaces. A soft brush can be used to add finishing details or color accents. Use a soft brush when attempting to paint smooth, even surfaces, such as metal, glass or ceramics.

Experiment with brushes and knives to discover just how these tools can be most effectively used. Try to complete a small painting using only the palette knife or your largest brush. You'll be surprised to find how many small details you can omit!

GETTING STARTED

By this time, you probably have an idea of what you would like to paint. The scene outside your window, your own backyard, a corner of your bedroom—all have possibilities. Or, perhaps you would prefer something on a smaller scale—an arrangement of objects on a table top? Whatever your choice, bear in mind some of the points made in Chapter II on organizing a painting: you are interpreting subject matter, not photographing it. You are free to change things. You may eliminate details or add new elements to achieve a more effective composition or to add interest to your painting.

Explore your subject matter by doing some small sketches in which you shift things about—making a house bigger, a tree taller or eliminating the pattern on a wallpaper background. Try different color harmonies, using crayons or pastels for quick results. Most importantly, be sure that you show the arrangement of *values,* where you will have your light, medium and darkest tones of color. These lights and darks will determine whether objects take form and stand out or blend into the background.

When you have selected the small sketch that most pleases you, do not discard it. Use it as a reference for making an enlarged drawing which will be transferred to the canvas. Refer to it as you choose colors.

The paper on which you enlarge the drawing should be the same size as the canvas you will use; this will eliminate the bother of having to make adjustments later. Choose a paper that is not too heavy if you intend to transfer the drawing by blackening the back of the paper and tracing the major lines of the drawing. Whether you use this method of transferring the drawing or draw it freehand, directly on the canvas, *keep the canvas clean!* Pencil lines should be light; vigorous erasing ruins the texture of canvas. If charcoal is used, the finished drawing should be sprayed with fixative to keep the charcoal from smudging. Many artists prefer to sketch the drawing with fine brush lines of a thinned-out neutral color.

Texture Study. Oil. Student, Washington Co. (Md.) Public Schools. Thick, or impasto, application of oil paints. Brushes and sticks were used to create a richly textured surface that suggests movement and depth. When applying paint in this manner avoid over-mixing colors: note the contrasting values in this example.

Fantasia In Blue. 1954. Oil on canvas. 60″ x 52″. Hans Hofmann. Courtesy Whitney Museum of American Art. The spontaneous, explosive quality of Hofmann's painting influenced the "action painters" and "abstract expressionists" who were concerned with the *act* of painting itself.

Now that the drawing is transferred to the canvas, you may choose to complete it in one of several different techniques. The descriptions that follow will help you in determining which you would like to try for a beginning. As you complete more paintings, experiment with different methods to find those that suit your style of working.

PAINTING TECHNIQUES

Alla prima

In this technique, colors are applied wet-in-wet, with a broad use of brushes and painting knives. The basic idea is to complete the painting as directly and swiftly as possible, with final color effects achieved at once. Usually, the painting is completed in one or two painting sessions.

If you choose this method, begin with a comparatively small canvas that you can complete fairly rapidly. As a first step, cover the canvas (or a small Masonite panel) with gesso and set it aside to dry. When the gesso is dry, cover the surface of the panel completely with an application of transparent color, thinned to a watercolor consistency. (Colors such as umber, ochre, viridian, burnt sienna or cadmium yellow are appropriate.) Since a good bit of this wash, or *imprimatura,* may show through in the final painting, color choice should be based on the subject to be painted and on the effect desired.

When the imprimatura is dry to the touch, draw the major directional lines of the subject in bold, simple strokes of a neutral color. A bristle brush is recommended for this purpose.

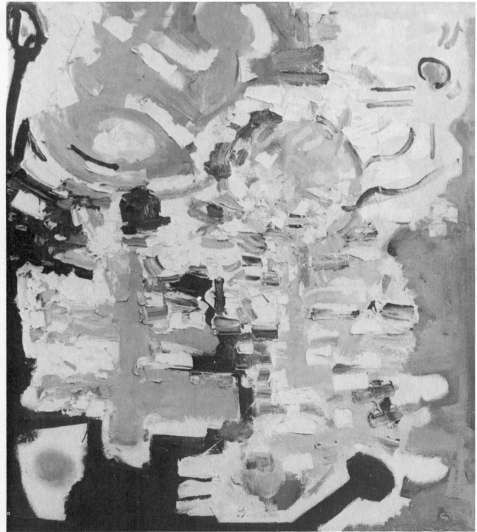

In the next step, build up the basic shapes in your composition: Apply the fresh paint into the wet, underlying color; don't bother with staying within the exact boundaries of the shape. Try to achieve the color you want in the *first* application, without having to lighten or darken colors here and there. After you have painted in the basic shapes and background, the addition of highlights should complete the painting. If some of the areas have dried to a dull, matte finish, spray them with retouch varnish to bring up color brilliance.

The alla prima method is quick and its directness prevents your getting involved in painting trivial details, but it also demands a good bit of self-confidence. If you are not quite ready for this quick approach, a more traditional technique such as the one that follows might be more to your liking.

Underpainting Techniques

In underpainting techniques, paintings are built-up, or developed, in stages that require several working sessions. Artists use underpainting techniques for various purposes but, generally, the underpainting provides the "skeleton," or underlying structure, on which the painting is built. In the basic procedure, described below, paints are applied thin-to-thick, beginning with a thin stain of turpentine and paint.

1. If you do not feel comfortable working from a sketch, trace your full-size drawing to the canvas or canvas board. Rough it in with charcoal and spray it with fixative.

2. Mix a neutral tone, perhaps with blue and burnt sienna, and thin it with turpentine. Use this stain to establish major shapes and light and dark areas. (You may prefer to let the white of the canvas serve as the lightest areas.) Remember that you are building the framework, the major shapes and values; do not get sidetracked with small details at this point.

Before going on to steps 3 and 4, evaluate what you have done. Check it against your original drawing: are major areas, values and lines clearly shown? If so, set the canvas aside to dry. If you have thinned the paint sufficiently, this shouldn't take too much time. When the paint stain has dried to the point where it will not lift, proceed with the following steps.

3. Begin applying *opaque* paints in colors desired and *in the values which you have established.* Apply the paint freely with a brush or palette knife. Do not attempt to stay strictly within outlines; instead, paint into the edges of paint to avoid a "cut-out" look. (You may let some of the underlying stain show through.) Continue until all the major forms are painted.

4. Depending on your composition, you may be able to add details now. If adding details requires painting over some of the forms, set your canvas aside to dry until you can paint over it without disturbing underlying paint. You may wish to add fine details, textures and highlights after the paint surface has completely dried.

Instead of working with a transparent stain (step 2), you may wish to begin applying the colors the finished painting will show. If so, use middle values as a guide; darker values, light values and highlights can be added after the canvas has dried somewhat. Even if you omit working with the color stain (step 2), keep the first applications fairly thin until you are certain of the colors you are going to use. It is easier to scrape away a thin layer of paint if mistakes must be corrected.

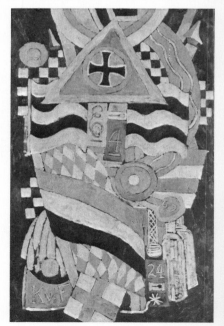

Noir and Numbers. Mixed media. Edward Jacamo. A black-on-black composition in which oil and enamel paints are combined with sand and sawdust.

Portrait of a German Officer. 1914. Oil on canvas, 68¼″ x 41⅜″. Marsden Hartley. The Metropolitan Museum of Art. Military symbols are combined in a forceful unity to express the officer's power and personality. What is the mood of the painting?

The techniques described above are the basic, traditional ways of completing an oil painting. As you gain experience, you may wish to experiment with other techniques of underpainting involving textures and glazes. Thin paint or acrylic gesso can be spread on the canvas and then scraped or textured with a painting knife or other tool to create a lively surface for painting. (Permit to dry thoroughly before proceeding with painting.) Or, you may complete a composition in flat colors to be finished with glazes. (See preceding section on "Glazes") The following technique, which is centuries old, is another type of underpainting that involves a quite different approach.

Grisaille Technique

In grisaille, only grayed, neutral colors are used. These grays, always light and opaque, are used to model and to establish values in an underpainting technique.

Grays may be warm or cool, depending on the effect desired. White, mixed with umber, is commonly used. Further variation is obtained by adding small amounts of ochre or Prussian blue.

A toned ground is applied thinly to the entire surface of the support with a painting knife. When the toned ground is dry, outlines should be drawn in and sprayed with fixatif. The modeling of objects and the establishment of light and dark areas then proceeds, using only the grays. The general tone should be somewhat subdued, with little attention to detail, with outlines softened. When the first painting, or grisaille, has dried, further grisaille may be applied to sharpen details and to strengthen darks. *Throughout the application of grisaille, neutral colors should be used.*

The painting is completed by applying glazes to define the middle tones and to strengthen the darker areas.

Grisaille is not widely used by contemporary painters. You might find it interesting if you like to work in a methodical manner and if you are interested in more traditional techniques. It will also help you to become more aware of the importance of color values since the success of the grisaille technique depends largely on carefully established values.

Mixed Media

Oil paints lend themselves to a variety of mixed media techniques. Collage materials, sand, bits of stained glass, string, and commercial texturing materials, are a few of the many materials used in these experimental techniques.

A light sprinkling of sand or light application of collage materials may be successfully adhered to a canvas support. If heavier materials are incorporated, a more rigid support is necessary.

Acrylic media—gesso, modeling paste and the acrylic medium—are ideal materials to use in mixed media techniques. The acrylic materials should not be used *over* oils but may be used to coat supports and to adhere collage materials *before* oil paints are applied.

Acrylic gesso may be heavily applied; then combined or scraped to produce a textured surface. Textured materials such as cloth or papers may be pressed into it while it is still wet. An application of acrylic medium may be used to seal these materials before oil paints are applied in an opaque or transparent manner. Modeling paste, spread in a layer approximately ⅛ inch thick, may be textured or modeled and will adhere to heavier objects such as wood strips, glass or metal scraps.

Conventional non-acrylic gesso may be used to create textured surfaces on rigid boards; if sealed with shellac, these surfaces may be painted with oils.

VARNISHING

Varnishing a painting serves two purposes. Varnishing revives the gloss which is lost when paints "sink in" or become flat; it also serves to protect the painting from dust and dirt in the atmosphere.

A painting may be varnished with retouching varnish within a few weeks of its completion. A final varnish with picture varnish may be applied six to twelve months later.

Retouching varnish may be applied with a spray can. Picture varnish may be applied with a soft utility brush or with a cheesecloth.

Matte picture varnish may be used where a high gloss finish would be objectionable.

SUGGESTED PROBLEMS

1. Select several objects in the classroom and arrange them, experimenting with grouping. Using charcoal, sketch a pleasing arrangement, abstracting and distorting forms to create a semi-abstract composition. Work for strong directional lines and contrast of values. Transfer sketch to white ground, using a thin oil glaze to establish major shapes and lines. Establish background with a thin glaze of neutral color. Use contrasting opaque strokes of thicker colors, applied with knife or brush, to build up major forms, to create textural interest.

2. On white canvas or canvas board, sketch a still life arrangement based on an arrangement set up in the classroom. Apply a thin glaze of cadmium yellow to the entire surface of the canvas. (Lines of sketch should be visible through glaze.) When the yellow glaze has dried, use glazes of burnt sienna and alizarin crimson to establish middle tones. Use glazes of viridian and ultramarine over previously applied glazes to create darker values. Use a thin sable brush, perhaps a liner, dipped into darker color, to create textural interest and to define contours.

3. Through a series of "thumbnail" sketches, develop an imaginative landscape or street scene to express a certain mood or atmosphere. (Rainy night; parade; carnival; desolation; a deserted beach.) Determine the general color key: light, warm, subdued, somber, etc. Cover the entire surface of the canvas with a very thin wash of color that will enhance the final color effect. When the wash is dry to the touch, use a bristle brush to sketch, in a neutral color, the major masses and lines of movement. Complete painting in the wet-in-wet technique, using the bristle brush to develop masses and areas. Use smaller bristle or sable brushes to add details and highlights. Try to complete the painting in one or two class periods.

4. With charcoal and white chalk on gray paper, draw a self-portrait of a classmate. Emphasize clearly defined lights and darks. (Let the paper serve as a middle tone.) Transfer the drawing to canvas and complete the portrait in grisaille technique, using only light, opaque grays for modeling. (Do not limit grays to black and white combinations. Add varying amounts of umber, ochre and Prussian blue to white to obtain variety in grays.) Finish with glazes of color that establish flesh tones, eye color and hair color. Each glaze should be allowed to dry before another glaze is applied over it.

Untitled. 1976. Oil on canvas. Burton Wasserman. The viewer is immediately involved in Wasserman's painting which becomes more complex as we study it: forms appear to change and relationships shift before our eyes. The painting is demanding in that it requires us to spend time *looking*.

Bio-Technique: Proposition Six. Oil on canvas, 36″ x 48″. Bob Nunn. Courtesy Susan Bethel. Smoothly brushed surfaces and sharply defined forms create an effect of photographic realism.

5. Build up the surface of a board with acrylic modeling paste or gesso. While the application is still wet, press paper or fabric shapes firmly into the surface. String or twine may be added to provide linear interest. Seal the surface with acrylic medium or shellac. Finish painting with thick and thin applications of color, using knives, brushes and glaze techniques.

6. On canvas board or canvas-textured paper (seal paper with thinned white glue or P.V.A.), complete a figure study, using a sable brush and washes of *one* oil color, such as burnt sienna or umber. Experiment by repeating the problem, using a bristle brush and "dry-brush" techniques.

7. On canvas or panel, sketch an arrangement or composition of your choice. Use only improvised painting tools to apply color. Consider these: a putty knife, spatula, metal strips, edges of cardboard and sticks. Create contrasts in color, texture and value.

Nomad. 1963. Oil on canvas, with plastic paint, wood and metal attachment, 84″ x 210″. James Rosenquist. Albright-Knox Art Gallery, Buffalo, N.Y. Gift of Seymour H. Knox. "Pop" art incorporates bits and elements of images that reflect our popular culture. In this example, ads from billboards, TV, magazines and posters are painted in sleek surfaces similar to the effects produced by an airbrush.

Aviary, Tropical Birds. Fabric collage. Ken Morrow. Courtesy M. Grumbacher Inc. Assorted fabrics and heavy lace were adhered to a Masonite panel with acrylic medium and allowed to dry, after which the entire surface was painted black. When the black background had dried, the lace and portions of the fabrics were painted with acrylic colors, powdered metallics and acrylic glazes. Note the balanced arrangement of plain and textured areas and of light and dark areas.

Collage Techniques

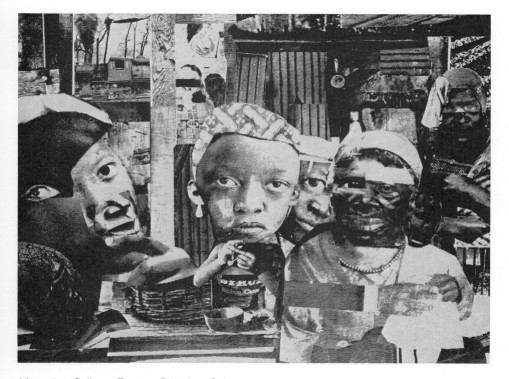

Memories. Collage, Romare Bearden. Collection of the Cordie-Ekstrom Gallery, New York. Faces, textures and other images that have meaning for the artist are cut from old engravings and rearranged to form a direct and compelling visual statement. The eyes of the figures stare out and demand our attention.

In the summer of 1912, Georges Braque pasted several strips of patterned paper, simulating wood grain, on a sheet of drawing paper. He then sketched, in charcoal, a bunch of grapes, a wine glass and, beneath the grapes, a fruit bowl or compote. Additional strips of the woodgrain paper were added to the bottom of the picture and around the compote. The completed work, *Compotier*, or *Fruit Bowl*, is generally considered Braque's first collage.

At about the same time, Pablo Picasso incorporated a piece of oilcloth, simulating chair caning, into an oval painting which was framed by a length of hemp rope. The finished painting was titled, *Still Life With Chair Caning*.

Which picture was painted first? The answer is not quite certain. Braque and Picasso, both Cubists, were closely associated during that period and both shared the same anti-art motives and ideas popular at that time. Artists were frustrated with the romantic emptiness of fine art. They worked to make contact with reality, with everyday life, and to make art more meaningful to people. There is no uncertainty, however, regarding the importance of the two paintings.

They marked the beginnings of modern collage and, with it, the beginning of a revolution in modern art. Braque and Picasso, incorporating into their paintings the material things from everyday life, such as newspapers, wallpapers, cloth, cardboard, sand and lettering, provided a then-shocking new vocabulary for artists seeking more direct and meaningful ways of expressing their ideas.

Juan Gris, among the first artists to adopt the collage technique, made wide use of bottle labels, patterned papers, and the classic material, newspaper. Braque continued to work primarily with papers and cardboard. Picasso, ever the innovator, experimented with a wide variety of materials. In addition to oil paintings incorporating collage materials, he produced the classic papier colles and a number of relief constructions using wood, tin, cardboard and other materials.

Although Braque, Picasso, and Gris had all but ceased their collage work by the mid-twenties, their paintings that followed continued to show the influences of this new means of expression. The technique of collage was firmly established by the Cubists and its impact on the art movements that have followed cannot be overestimated.

Futurism, dada, surrealism, constructivism and the many contemporary concepts in both painting and sculpture have been influenced by the collage philosophy. The projection of paintings into the third dimension, constructions in-the-round, and a reversal of the ideas concerning "proper" pictorial space have grown out of the collage idea.

CHARACTERISTICS

The term collage is derived from the French *coller*, meaning *to paste*. The term is used to describe the pasting or adhering of a wide variety of materials to a ground or support. Paper remains the classic material, although fabrics are widely used by contemporary artists. Practically any material or object that can be successfully adhered to a support can be used, and has been used, as a survey of contemporary collage techniques reveals.

Collage, by its very nature, lends itself to experimentation and discovery. As you begin to work with collage, take a fresh look at familiar materials: papers, fabrics, foils and threads. Many of these materials, ordinarily discarded, now offer exciting possibilities. How can they be used to create shapes, textures, color and movement in a composition? What visual or emotional effects do they produce?

As with no other medium, you may arrange and rearrange elements, fixing or adhering them only when the results are visually and emotionally pleasing to you. Directness and simplicity are comparatively easy to achieve in collage if you select your materials carefully. Resist the urge to use *every* scrap of material available; use only two or three in the beginning. Restraint and understatement in the choice of materials will produce more pleasing results than a hodge-podge of too many unlike textured materials.

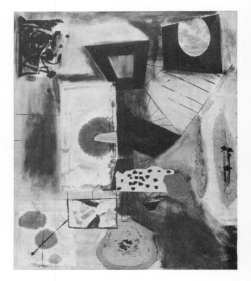

Joy of Living. 1943. Collage. Robert Motherwell. Courtesy Baltimore Museum of Art. Motherwell's collage does not suggest recognizable forms; when it is studied carefully, however, it reveals a variety and richness of textures and values. Does the title have meaning for you?

Junction. 1958. Collage, 56″ x 77½″. Conrad Marca-Relli. Whitney Museum of American Art. Scraps of painted canvas were used to create symbolic shapes that seem to jostle each other in a lively pattern. How has the artist used value to emphasize the dominant black shapes?

Collage. Transparent watercolor and corrugated paper. Student, Spruce High School, Dallas. Bob Nunn, instructor. The rough corrugated board contrasts with the smooth painted surfaces, provides a contrasting color and introduces a horizontal line pattern against the vertical movement of the painted shapes.

Study reproductions, films or slides of the work of Braque, Picasso, and Gris to learn how they incorporated their textured materials into the total composition of a painting. Examples of collage techniques and ideas as they have been adapted by contemporary artists will provide new ideas concerning both materials and techniques. The collage philosophy is particularly important in assisting you in understanding the work of many contemporary artists such as Marca-Relli, Johns, Rauschenberg, Nevelson, Bontecou, Dine, and others.

BASIC MATERIALS, TOOLS

Although materials to be pasted or adhered are many and varied, the basic tools and materials necessary for collage are simple and relatively inexpensive.

Adhesives

P.V.A. (polyvinyl acetate) and white emulsion glues (Elmer's, Wilhold, etc.) are most satisfactory. Acrylic medium, in addition to adhering materials, may also be used to glaze previously applied papers and fabrics. A concentrated paste, such as Runny, is satisfactory and can be diluted to the desired strength. Acrylic modeling paste or Duco cement may be used to adhere heavier objects to a rigid support. Common library paste may be used in relatively light weight projects. Rubber cement stains some materials and unless applied very carefully does not produce a permanent bond.

Cutting Tools

Scissors; matte knives; single-edge razor blades.

Still life. Tissue collage. Student, Lutheran High School, Los Angeles. Courtesy Gerald Brommer. A tightly unified semi-abstraction based on a still life arrangement. Note how the large shape of middle value seems to hold all the other shapes together, and the balance of very light and very dark shapes. The horizontal placement of the bottle contrasts with the vertical lines of the shapes and lines above, to hold the viewer's eye within the painting.

Collage. Colored tissue on panel. Student, Fort Lee (N.J.) High School. Joan DiTieri, instructor. Sheets of colored tissue were pasted, in layers, over the entire surface of the panel. The design was created by cutting into the surface of the panel, at varying depths, to reveal the underlying colors. A repetition of curving shapes unifies the total design. Note the variety of light, medium and dark values.

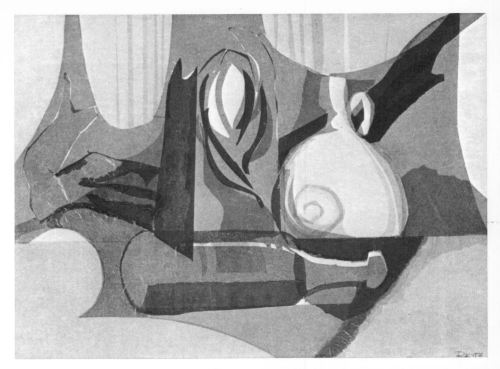

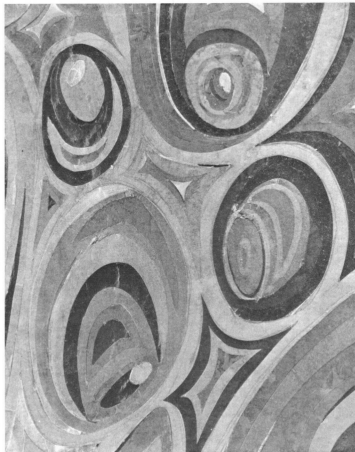

Still Life. Collage. Student, Baltimore Public Schools. A single, large white shape was cut from drawing paper and mounted on black poster board. Details were added with scraps of colored tissue and inked lines.

Newspaper Collage. Student, Fredericksburg (Texas) High School. Barbara Pratt, instructor. Portions of the head and bridle are built up with strips of cardboard to add variety to the evenly-patterned background. Note how the placement of the newspaper shapes at varying angles enlivens the overall surface.

Supports

Supports for collage should be carefully chosen. Lightweight cardboards may be used for light applications of paper where there is limited use of strong adhesives. These lightweight boards are apt to warp or buckle under several layers of collage materials and adhesives. Therefore, sturdier supports, such as Masonite, canvas boards, upson board, and Cellotex, are more suitable for general use and are essential for heavily built-up surfaces and relief collages. Supports may be used as is, but, if a white ground is essential to the composition, the support may be coated with gesso or flat white paint. Ordinary white household paint is satisfactory and less expensive than artists' colors; latex is recommended.

Brushes

Inexpensive bristle brushes, in a variety of sizes, are recommended for use with adhesives. If cleaned properly, they are quite serviceable.

Miscellaneous Materials

Sponges; plastic buckets and bowls; smaller water containers, such as jars. Sheets of thin plastic or newspaper for covering work areas. Brayers or rolling pins are helpful in smoothing pasted areas.

INTRODUCTORY TECHNIQUES

Materials commonly used in collage techniques are many and varied. Papers, fabrics, threads, yarns, and boards present an enormous range of colors, textures and patterns. In addition to these, natural materials— bark, shells, twigs, and assorted dried materials, such as grasses and plant material. Found materials and objects may include screening, bits of metal, plastics, cork, and an endless assortment of small objects that can be pasted or cemented to a surface. A home or school workshop will provide more than you can use.

A collage may be designed to make use of a single type of material, such as paper or fabric, or it may incorporate a variety of materials. You may wish to paint selected areas to unify the collage elements or to modify the patterns or textures of previously applied collage materials. In another approach the surface of the support may be built up or textured before collage materials are adhered. The possibilities are seemingly unlimited except by the imagination.

Compositions may be pre-sketched or may evolve through experimental arranging and rearranging of the materials to be adhered. As you plan your collage, select simple, basic shapes and work toward balances of color, textures, and values. Your first collage may be limited to one material, for example, paper in a variety of colors, to simplify the problems of good composition and arrangement.

Basic collage techniques and the materials required for each include the following:

Torn and Cut Paper Collage

Plain, patterned, and textured papers: include poster and construction papers, newspaper, kraft paper, wallpapers, corrugated and packing papers, sandpaper, oriental papers, and art tissue.

Papers may be cut, torn, shredded, and, if saturated with a thinned adhesive, modeled. Plain papers may be painted, stippled or printed, then cut or torn into desired shapes.

Colored art tissue is a paper that offers many design possibilities. Overlapped tissue shapes produce subtle and interesting color variations. Tissue may be crumpled, twisted and, if placed on a support made wet with adhesive, worked into interesting textures and ridges.

Cellophane, foils, paper towels, road maps, magazines, playbills and shelfpapers may also be used.

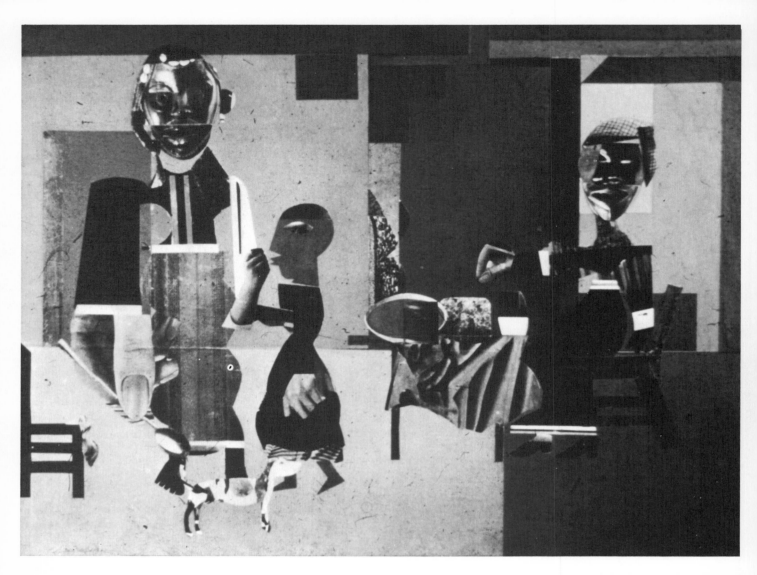

Illusionists at 4 P.M. 1967. Collage. Romare Bearden. Bearden is particularly adept in creating the kind of composition that stops short of being too realistic, too explicit; there is the element of the abstract or surrealistic that excites the imagination, requiring the viewer to interpret symbols and images. Who are the "illusionists"? What is the significance of "4 P.M."?

Self-Portrait. Collage and acrylic. Student, Fort Lee (N.J.) High School. Joan DiTieri, instructor. Note the proportions of plain and patterned surfaces in this carefully balanced compostion. The pieces of newspaper are arranged to repeat the shape of the hair and blouse with the large, dark letters repeating the dark tones of the hair. Overall, a skillful use of the collage technique.

It's What's Happening. Collage. Student, Baltimore Public Schools. Magazine clippings mounted on black poster board. A variety of vertical and horizontal placements create movement and points of emphasis.

End of the Game. Student, Baltimore Public Schools. Shapes cut from colored tissue were used to establish a background for the cut and torn patterned papers that create textural interest in hair, shirt and foreground.

Textile and Yarn Collage

Textiles, like papers, offer an endless variety of colors, textures and patterns. Choose those that will best meet your needs and help to achieve your final design; avoid those motifs which tend to distract from your design.

Heavier fabrics include corduroys, tweeds, woolens and a variety of upholstery fabrics. Burlap provides a wide range of colors and may be used as a single element or to provide a background for fabrics, or shapes applied over it.

Sheer materials such as organdy, voile, net and organza provide contrasts against heavier, coarser weaves. These may be overlapped to achieve subtle variations of color since they are semi-transparent.

Textiles may be altered by the application of paints and glazes of color. Acrylic colors, textile paints or dyes should be used for this purpose. Stitchery can be used to create a pattern on a fabric or to change its texture. Experiment with stitches in a variety of threads and yarns.

Heavier fabrics sometimes require special care in pasting or adhering. Stronger adhesives are usually required. To ensure even bonding, a weight should be placed on top of the fabric shape to press it firmly against the support until it has dried.

Some adhesives, particularly rubber cement, stain fabrics. Experimentation will provide the best guide in the choice of adhesives. Thinned white glue is a good choice in most instances.

In general, it is best to avoid over-handling of fabric shapes once they have been cut, unless a frayed edge is desirable.

Since some fabrics shrink, it is best to cut fabric shapes a bit larger than the design requires if a shape is to be placed directly into a wet adhesive. Rumpled or wrinkled fabric will not lie flat so you may need to press the fabric before cutting the shapes.

Untitled. Collage and tempera. Student, Lutheran High School, Los Angeles. Courtesy Gerald Brommer. Painted areas are combined with cut and torn paper elements. The small figure in the boat (foreground) provides scale, making the sun and the mountain loom even larger in the overall composition.

South Vietnam. Collage and ink drawing. Student, Fort Lee (N. J.) High School.

Projection. Montage. Sylvia Sorrells. Magazine illustrations mounted on Masonite panel. Note that unity in composition is achieved by a careful balancing of plain and textured areas and by controlling the direction of straight and diagonal lines.

Mixed Media Collage

The first collages produced by Braque and Picasso were mixed media collages. Braque chose a charcoal drawing to unify and integrate the wood-grain paper in *Compotier*; Picasso used oil paint with the cane patterned oilcloth of his still life composition.

In addition to charcoal and oil paint, other media may be incorporated with collage techniques. These include chalks, watercolors, synthetic media, inks, dyes, casein, crayons, pastels, and varnishes. These media may be applied through painting, drawing or printing techniques.

Acrylic media, because of their extremely versatile nature, are especially recommended for use in collage techniques. They may be used to color, to adhere, to texture, to glaze and to build up areas on a support. Acrylic media may be used in combination with practically all other media except those which are oily or greasy, such as oil paints or oil pastels. When dry, they are insoluble in water and provide an excellent sealer or finish for collage surfaces.

Mixed media should be used selectively as they improve or strengthen the composition. An application of paint may unify previously adhered paper shapes; an oil glaze may subdue a texture that overpowers the design or be used to add color to a neutral background. Dyes, dropped on wet tissue, may blur or soften areas of color. On the other hand, painting or drawing may provide the major interest in a composition while the collage materials play only a supporting role.

1

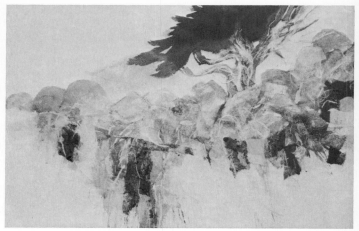

2

Demonstration. Watercolor and rice paper collage. Gerald F. Brommer. While many collages incorporate highly colored and patterned papers, more subtle effects can be achieved through the use of papers that are interesting for their own textures, such as rice papers. California artist Gerald Brommer demonstrates the use of a variety of rice papers in his composition, *Carmel Theme: Trees, Rocks and Fog.*

(1) Quick watercolor sketch, indicating local color and large shapes of rocks and tree. The handle of a brush makes light lines when scratched into wet washes. The painting is done on a dampened sheet (15″ x 22″) of heavy watercolor paper.

(2) After the painting was dry, small pieces of eight different types of rice paper were glued over most of the surface. Some are even, dark-valued pieces while some have heavy white threads in them.

(3) When the collage has dried, washes of watercolor are pulled over it with a large flat brush. Rice papers absorb watercolor at different rates, creating fascinating textures.

(4) More washes are added with large brushes but no detail is applied yet. Keep away from the small brushes as long as possible.

(5) Final lines, shadows and details are added to show depth and form. Collage helps express the textures of the location and adds a richness to the surface of *Carmel Theme: Trees, Rocks and Fog.*

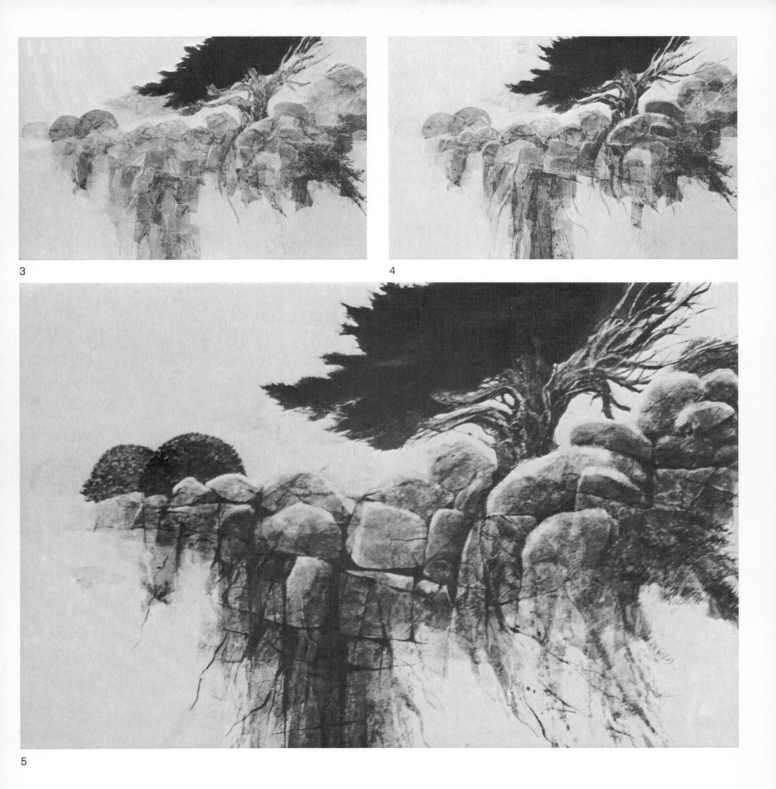

3

4

5

Relief Surfaces and Collage

Collage surfaces produced with paper, fabric, drawing and painting techniques are essentially flat. In order to develop an appreciation for the sculptural or three-dimensional possibilities of collage, experiment with designs in which you create relief surfaces or use three-dimensional materials. Relief, or built-up surfaces, can be used to provide contrast or interest in an otherwise flat design, or they may be used over the entire surface.

A rigid support is essential in this technique because of the weight of the relief materials and three-dimensional objects that may be applied in the design. Boards, such as Masonite, plywood, hardboard, and bookbinders board, are good choices for these supports or bases. The following materials can be used to build up relief surfaces over all or part of the design: gesso, plaster, spackle, acrylic modeling paste, papier mâché or shredded paper modeling material.

Once applied, these materials may be treated in a variety of ways: while wet, they may be textured by combing or scratching with sticks, nails or other sharp instruments that will produce an interesting texture. Found objects may be stamped into the wet surface; the design produced may be repeated or overlapped. Plaster, spackle and acrylic modeling paste, when thoroughly dry, may be carved, cut or filed. If the surfaces of the relief are to be glazed or painted, first seal them with shellac, varnish or acrylic medium to prevent over-absorption of the glazes or paint.

Sand, fine gravel, vermiculite and crushed glass are but a few materials that can be sprinkled over wet adhesive, plaster or modeling paste. If so used, they should be pressed firmly into the adhesive to ensure a strong bond.

Various found objects, including washers, corks, wood or metal shapes, stained glass, mosaic tiles, and pebbles, may be imbedded in wet plaster, spackle or modeling paste. They may also be adhered to the support with an appropriate adhesive. Epoxy cement or strong white glue is necessary for nonporous metal and glass.

Fabrics, such as cheesecloth and old sheeting, may be dipped into plaster, P.V.A., thinned white glue, or acrylic medium and then worked into shapes on the surface of the support. When dry, these hardened fabric shapes may be glazed, painted or left as is.

Nails or tacks may be driven into the support and strung with fine wire to form an armature for plaster or plaster-saturated fabrics, which may then be painted, glazed or shellacked.

Collage Print. Printed from a collage of cloth, twine, wood slivers and coarse sand on a base of textured modeling paste, sealed with acrylic medium. Courtesy Binney and Smith.

SUGGESTED PROBLEMS

1. Using plain papers, select three values of a single color or white, gray and black—and create a collage composition to cover the entire surface of a board. Emphasize harmonious shapes, balance of values and movement.

2. Create a composition from a variety of cut and torn papers. Use ink, brush and pen to accent contours, provide texture and to define characteristics of objects.

3. Using cut and torn art tissue, create an abstract composition to interpret an architectural theme. Use sticks or cardboard edges, dipped in tempera, to define shapes, to create texture and movement.

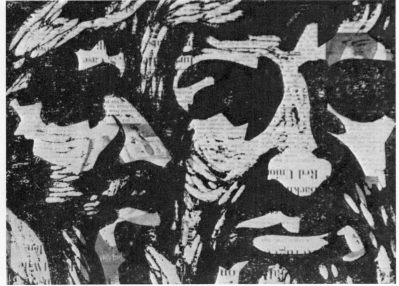

Two Prophets. Block print on collage. Edward Hale. Shapes of newspaper were adhered at random on the printing paper before the block was printed. Note that the newspaper provides textures and values absent in the block print. Other papers that would provide interesting backgrounds for prints include painted papers, art tissue and wallpapers.

4. Lightly sketch a still life arrangement on a board, indicating major shapes and masses. Using a combination of fabrics and papers, complete the composition, emphasizing simplified shapes, value contrasts, balance of plain and patterned papers.

5. Using tempera, casein or acrylic paints, create a composition to express a particular mood or emotion. Establish major areas with paint, using collage elements to provide accents and textural interest. When collage elements are thoroughly dry, use further applications of paint to provide transition in texture and to unify the composition.

6. Spread plaster or acrylic modeling paste thinly but evenly over the surface of a rigid board. While the plaster or paste is still wet, cover it with a piece of cheesecloth, net or similar open weave fabric. With the hands, work and push the fabric into the wet surface, producing ridges and ripples in the fabric. Permit the fabric to dry, then finish the composition with paints, inks or oil crayons. Varnish or shellac the finished composition, if desired.

7. Select three or four sheets of patterned and plain papers, in related colors. Cut *each* to cover the entire surface of a rigid board. Using wheat paste, adhere the paper, one piece over the other, to the board, so that the paper is layered. Before the layers of paper dry, use a single-edge razor blade or mat knife to cut into the paper, removing one or two layers at a time, revealing the underlying color or pattern. Experiment with tearing. Emphasize related shapes, variety of textures, color relationships. Finish with varnish, shellac or a thin glaze of oil or acrylic colors.

Crayon and Chalk Techniques

Crayons and chalks are among the oldest art media known to us. Primitive crayons were used as early as the sixteenth century and chalks are even more ancient in their origin. The word crayon is derived from the French *craie,* meaning stick, or pencil. The French term, however, has an earlier origin in the Latin *crēta,* which refers to chalk. This suggests, perhaps, that the earliest crayons were chalks combined with a primitive binder.

CHARACTERISTICS

The versatility of modern crayons is not always fully realized: crayons provide a remarkable range of color effects from pale, subtle tints to rich glowing depths of color. In addition to their use on papers, crayons can be applied to a great variety of other surfaces—boards, wood, and fabrics. When used with other colors, crayons provide an almost unlimited range of mixed media techniques and visual surprises.

Mural. Oil crayon. Student. Courtesy American Crayon Co. Colors were rubbed to achieve a hazy, subdued background that suggests the smoke and smog of a city; the foreground is developed with stronger colors and bolder lines.

Crayons most commonly found in the art classroom are wax, oil or water color crayons. Powdery, dry sticks are generally called chalks or pastels, rather than crayons. Experiment with each of these and you will find many possibilities for creating new and exciting effects in both color and texture.

Before you begin your experimentation, consider the way you hold a crayon and the manner in which you apply it. Most crayons, particularly wax crayons, suggest a pencil-like handling that can limit you to tight, controlled lines and bland colors. In the beginning, remove the paper wrapper and use the crayon on its side to apply broad bands of color; use the tip of the crayon to create bold, sharp lines and to define shapes and forms. Remember, too, that colors can be applied layer-on-layer to create deep rich colors that are similar to the effects of oil colors.

Until now you have probably used crayons on different types of drawing papers without realizing that crayons can be used on many other surfaces or supports. Before you get underway with your crayon experiments, collect a variety of papers—newsprint, colored poster papers, watercolor papers, and canvas boards. Don't overlook fabrics! Old white sheets, canvas, and even old light-colored window shades make excellent surfaces for crayons of all types. Collect scraps of wood to use as grounds or supports for wax and oil crayons; search the basement or garage, at home, or ask your local lumber supplier for small scraps. Don't overlook plywood and various kinds of hardboards which can provide interesting textures and patterns.

Exploratory Techniques

Select a paper or board with a texture that appeals to you and experiment with different ways of applying the crayon. Remove the paper wrapper from a wax crayon and, holding the crayon *under* your hand, apply the color in broad, even strokes. Apply a second color, varying the pressure, so that some of the first color shows through. Now use the point of the crayon to create different types of lines and textures. Can you create shapes such as bricks, leaves and shrubbery?

Place a piece of wire screen, net or corrugated board under the paper and then pull the side of the crayon across the surface of the paper. (These patterned papers may be saved for use in a collage.)

Experiment with color glazes: apply blue lightly over yellow; red over orange; red over pink. Note the subtle color changes that occur.

Sgraffito techniques produce exciting lines and textures. In this technique, sharp or pointed tools, large needles, nails, splintered wood, and compass points are used to incise, or scrape into, fairly heavy applications of wax or oil crayons. Objects that produce interesting multiple lines include corrugated metal fasteners, metal hair clips, and broken pieces of combs. A box of found objects provides endless possibilities.

Other crayon techniques are best described in terms of the crayon to be used. Try all of them; the effects produced by each are quite different.

Abstract. Acrylic. Baltimore Public Schools. A series of thin washes of acrylic paint brushed over wax crayon resist.

Self-Portrait. Conté crayon. Student, So. Kingstown High School, Wakefield, R.I. Jean Hogan, instructor. The fine-grained conté crayon produces smooth textures in a carefully drawn straight forward self-portrait. Abstract shapes frame the face and break up the negative space of the background into more interesting proportions.

Crayon Resist

The design or composition is sketched lightly on white or manila paper or board. The wax crayon colors are then applied heavily to selected areas; remaining areas are reserved. The entire surface of the paper or board is then brushed with one of the following: India ink, tempera paints, watercolor, colored inks, dyes or thinned acrylic paints. (If India ink or black tempera paint is used, brighter crayon colors are recommended.) The waxy crayons resist the inks or paints and will show through in brilliant colors.

The crayon can be applied in flat areas, in layers or in thick and thin lines to achieve a variety of patterns and textures. Textural effects vary with types of paper and methods of crayon application. Rough-textured watercolor paper produces a tapestry-like surface. Slick, shiny surfaces are less interesting since they do not hold the crayon well. ("Pressed" crayons are not recommended for resist techniques because they lack the necessary waxiness to resist the liquid colors.)

Crayon Scratchboard

There are several variations on this popular technique, which is sometimes called crayon etching. In the usual version, the design is sketched in pencil and then crayon is applied heavily to *all* areas. A thin, but opaque, application of tempera paint or India ink is then brushed over the entire design. After it has dried, the paint or ink is then scratched off completely or in part with pointed tools such as pins, large needles or hairpins.

Spanish Landscape. Wax crayon. Courtesy Binney & Smith. A variety of crayon techniques can be seen in this imaginative landscape. The sides of crayons were used to create the flat areas of color in the foreground and on the mountains in the background; points of crayons were used to define shapes and to create textural interest in the trees and plants.

Painted Batik. Wax crayons. Student, Baltimore Public Schools. Melted wax crayons were painted on lightweight fabric with a bristle brush. After the crayon hardened, the fabric was gently crumpled, then dyed in a cool household dye. After the dye bath, the fabric was pressed, with an iron, between sheets of newspaper.

In a variation on this technique, the sketch is omitted. Instead, the crayon is applied over the entire surface in free, overlapping shapes that may, or may not, relate to the drawing that is planned. The tempera or ink is applied as in the first version. When the surface is dry, the drawing is done over the tempera or ink with the pointed tool, and the etching, or scratching-out, continues as in the first version. Obviously, a more careful drawing is necessary but the unique color effects produced make the effort worthwhile.

Encaustic Techniques

Traditional encaustic techniques require special equipment which may not be available in your art classroom. You can achieve encaustic effects successfully, however, by substituting materials more readily available and improvising equipment and tools. The technique described in the following paragraphs makes use of common wax crayons and equipment and tools you can find at home or in the classroom.

1. *Wax Crayon Encaustic*

In preparation for this technique, scraps of wax crayon should be shaved or grated on scrap paper and poured into small cups or other containers. (Vegetable graters, cheese graters, knives or thin slivers of wood can be used to prepare the crayon shavings.) Colors should be separated, one color per cup. If colors are to be mixed, they can be mixed on the surface of the board.

A composition is lightly sketched on a fairly rigid board that has been coated with white tempera paint. If sgraffito techniques are to be used to create textural effects, the layer of white tempera paint makes scratching into the surface much easier.

With the board on a flat surface, the crayon shavings are then sprinkled onto the shapes and areas of the composition. The encaustic technique may be used on selected areas or over the entire surface of the composition. Colors may be mixed or blended in certain areas or used in solid applications of a single color.

Following the application of crayon shavings, a sheet of *thin* paper (kraft paper, shelf paper, newsprint) is placed over the entire surface of the arrangement. A warm electric iron is applied only long enough to melt the wax crayon. The iron should be moved from section to section in a lifting motion. An iron that is too hot applied in a gliding motion, will cause uncontrolled melting and spreading. If more, or different, colors are needed, the procedure may be repeated.

The encaustic may be finished in a variety of ways. The results may be left as is and burnished with a soft cloth. Gold powder paints may be rubbed in for a metallic finish. Additional drawing details may be added with a brush dipped in paint, ink or melted crayon. Lines and textures may be scratched into the surface deeply enough to reveal underlying crayon colors or white tempera undercoat.

In a variation on this technique, the board with the crayon shavings is arranged as described earlier. Instead of an electric iron, a heat lamp (such as the type used for therapeutic purposes), is directed over the surface of the board to melt the crayon shavings. This procedure makes possible a more carefully controlled melting of the crayons since the surface of the painting is always visible.

2. Wax Crayon and Paraffin Encaustic

This technique, utilizing wax crayons and paraffin (the type used in canning foods), requires the following materials and tools: an electric hot plate with heat control, card or mat board, large bristle brushes, paraffin, muffin tins or TV dinner plates, crayon scraps and turpentine for cleaning brushes.

Paraffin should be broken into small chunks and placed in sectioned pans on the hot plate, with the heat control on the low setting. As the colorless paraffin melts, pieces of wax crayon are added to provide desired colors. The paraffin thins the melted crayon, causing it to flow more easily from the brush. A clean stick or wood dowel can be used to trail the colored wax onto the surface of the board if thin lines are desired. One pan of paraffin may be left uncolored; when applied over colors, the plain paraffin will produce a translucent effect.

The composition, on a plain white board, should be preplanned and sketched in careful detail. The wax must be applied quickly to avoid its cooling on the brush before it can be applied to the board.

Textures may be varied; rough or rippled areas provide contrast against smoother areas. These rough textures can also be used to provide a point of interest or to create a rhythmic movement within the composition. Again, sgraffito techniques may be used as before to produce linear or external interest.

3. Paraffin Encaustic and Collage

In this mixed media technique, the clear, uncolored paraffin is used to adhere colored art tissues to a support such as hardboard cardboard. A white surface provides the most effective ground because it will reflect the colors of the tissue more effectively.

A composition emphasizing large, simple shapes is sketched on the board. When the sketch is completed, a large bristle brush is used to apply melted clear paraffin onto a section of the board. While the wax is still soft, the shapes of colored tissue are pressed quickly, but firmly, into the waxed areas. The procedure is repeated until the desired coverage is obtained. If shapes and colors are overlapped, it is necessary to brush paraffin between the layers of tissue.

Upon completion of the paraffin and tissue overlay, accents of encaustic painting may be added with melted wax crayon. (A bit of paraffin may be added to the crayon as it melts.) Shading, lines or details may be added with a brush or clean sticks of wood.

Other collage materials, such as string, net or other light weight materials, may be added under a layer of melted paraffin.

Wax Crayon Transparencies

In this experimental technique, crayon shavings are placed between two sheets of plastic wrap. Before applying a warm iron, cover the arrangement with newsprint or other lightweight paper. The iron should be applied for only a few seconds to melt the crayon and fuse the sheets of plastic wrap. The resulting transparency may be mounted in a frame or may be used as an element in a collage composition. Taped to a window, it will resemble a muted stained glass design.

Harlequin. 1943. Encaustic. 44″ x 34″. Karl Zerbe. Whitney Museum of American Art. An extraordinary use of textures by a contemporary master of the encaustic technique. Melted wax colors are applied, layer upon layer, to create subtle changes in color, value and texture.

107

Wax Crayon Transfer Drawing

In this unusual drawing technique, two sheets of paper are required. The *color sheet* is prepared in the following manner: colored chalk is applied rather heavily to a drawing paper that has enough tooth, or roughness, to hold the chalk. Next, a layer of white wax crayon is applied evenly over the chalk. In the next step, the white crayon is covered with wax crayon of a different color. This color sheet, with three layers of media, is now complete.

A *transfer sheet* of plain smooth paper, such as poster paper, newsprint or typing paper, is placed face down on top of the prepared color sheet. For better control of the drawing, the designs may be lightly sketched on the back of the transfer sheet.

A stylus, hard pencil, tongue depressor or other sharp tool is used to draw or trace the composition on the back of the smooth paper. The pressure on the drawing tool will transfer the color from the prepared sheet to the smooth paper.

Experimentation with colors will produce interesting and unique effects. Experiment with these combinations: red chalk, white crayon, black crayon; yellow-green chalk, white crayon, blue crayon. Lines will vary, depending on the pressure applied to the drawing tool and on the nature of the tool itself. Experiment with a variety of tools; two or three different tools may be used in one drawing.

Oil Crayon Techniques

Oil crayons can be used in many of the techniques described for wax crayons: they may be used on the tip, on the side and thick, impasto application is possible. Like wax crayons, oil crayons may be used in a variety of sgraffito and resist techniques.

The varied surfaces and supports used for wax crayons are equally suitable for oil crayons.

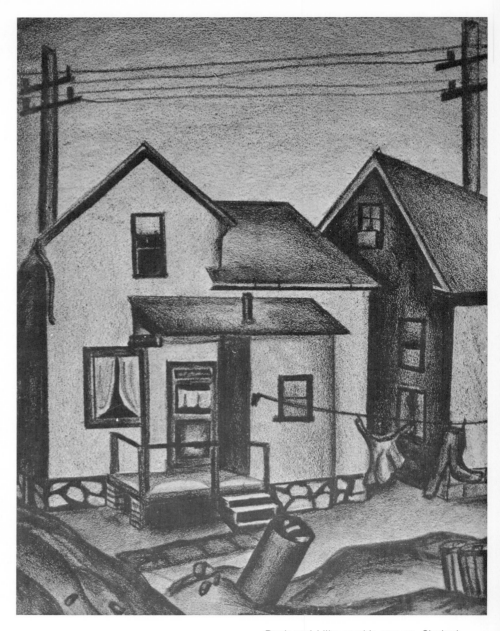

Backyard. Lithographic crayon. Student, Akron (Ohio) Schools. Courtesy American Crayon Co. A support of illustration board is ideal for lithographic crayon: its pebbled texture catches bits of crayon, producing a grainy, slightly textured surface. Values are clearly defined and well-balanced; details such as laundry and trash can create the atmosphere of a typical backyard.

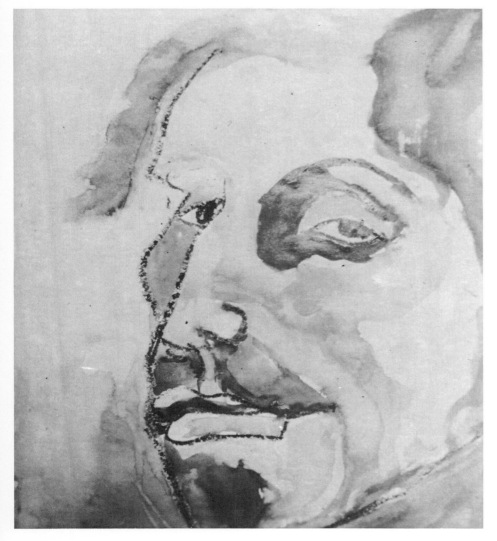

Portrait. Crayon and watercolor. Student, Baltimore Public Schools. Wax crayon over dried watercolor washes is used to define contours of the face.

Oil crayons possess unique characteristics of their own, however, that make them an extremely versatile painting media. Because of their softer, oily quality they may be blended or rubbed on paper, board or canvas. Transparent effects can be created by going over the oil crayoned surface with a brush which has been dipped in turpentine. In a reverse of this process, the canvas can be slightly dampened with turpentine before the oil crayons are applied over it. Impasto techniques are possible on canvas, canvas board, or on other surfaces with sufficient roughness. Heavier, layered applications are not as successful on slick, smooth surfaces; color effects are apt to be patchy and the textural possibilities are limited. Glazing is achieved by applying a thin layer of a dark color over a lighter one, such as blue over yellow, red over orange.

Mixed Media Techniques

Oil crayons may be used over dried washes of transparent watercolors, acrylic colors, tempera paints, inks or dyes. An oil crayon glaze can be used to accent an area of interest in a photo montage or collage composition. Felt tip markers, grease crayons, lead pencils and colored pencils—all can be combined with oil crayons in mixed media techniques. Deeply luminous effects may be achieved by using oil crayons on such surfaces as metallic papers, colored poster papers and "Coloraid" designer's papers. On darker papers, outlining or sketching the composition with a felt tip marker or with a wide-nib pen and India ink produces bold, dramatic effects.

WATERCOLOR CRAYONS

Techniques

Watercolor crayons, depending on their quality, can be used in much the same manner as traditional transparent watercolors. Applied directly on a dry paper, they may be blended with a brush dipped in water. "Wet-in-wet" techniques are achieved by wetting the paper with a sponge or brush. Then the crayons are applied while the paper is still wet or damp. The degree to which the colors are blended will depend on the effect desired; a wetter surface causes more blending.

As with other crayons, watercolor crayons may be used on the tip or side in a variety of drawing techniques. When used in this manner on rough paper, effects similar to dry-brush techniques are possible. Blocking-out or resist techniques are accomplished in the same manner and with the same materials—wax, rubber cement, and others—as in traditional watercolors. Lifting wet colors from the paper is more difficult since some brands of crayons leave stubborn streaks of color that cannot be lifted nor lightened.

Supports

Supports or surfaces for watercolor crayons include practically all of those suggested for use with other crayons. One limitation should be kept in mind: if traditional transparent effects are desired, the type of paper used becomes an important consideration. Because these techniques require a greater use of water, heavier papers made especially for watercolors are required. Softer, thinner papers buckle or disintegrate under generous applications of water. They should be reserved for those drawing techniques that do not involve water.

Mixed Media Techniques

Watercolor crayons may be used in mixed media applications recommended for traditional transparent and, to a lesser degree, opaque watercolors. Large washes of color are best applied with a brush and traditional watercolors from tube or pan. Their application with a crayon is tedious and lacks the free-flowing quality that can be achieved with traditional washes.

Watercolor crayons can be used in combination with wax crayons, oil crayons, ink (applied with brush or pen), tempera paints, and collage techniques. Resist, sgraffito, and glazing techniques are accomplished in the same manner as with traditional watercolors from tube or pan. Refer to the chapter on transparent watercolors and repeat some of the experiments described there.

Crayons on Wood Supports

Wax and oil crayons can be used to achieve exciting, brilliant effects on a variety of woods, including scrap wood, planks, and Masonite. Boards made silvery by weathering provide unique, subtle backgrounds for crayon. Sources for scrap wood include lumber yards, school wood shops, a cabinet maker's scrap bin, and home workshops. Wooden paddles, used for stirring paints, are good for small projects and may be obtained from hardware and paint supply stores.

Preparation of the wood depends on the type of wood, its color and grain, and the effect desired. Rough edges and stubborn soil should be eliminated by sanding; shapes can be used as found or slightly shaped with a saw. Shaping should suggest the finished form. Intricate, contorted shapes should be avoided since they distract and compete with the richness of the crayoned surface. The surface of the wood may be textured by scratching, sawing, cutting, or filing before the crayon colors are applied.

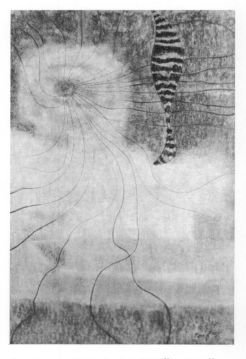

Sea Forms. 1951. Pastel, 38⅛″ x 25⅛″. William Baziotes. The Whitney Museum of American Art. Softly blended colors form a background for lines and textures that suggest fanciful sea creatures.

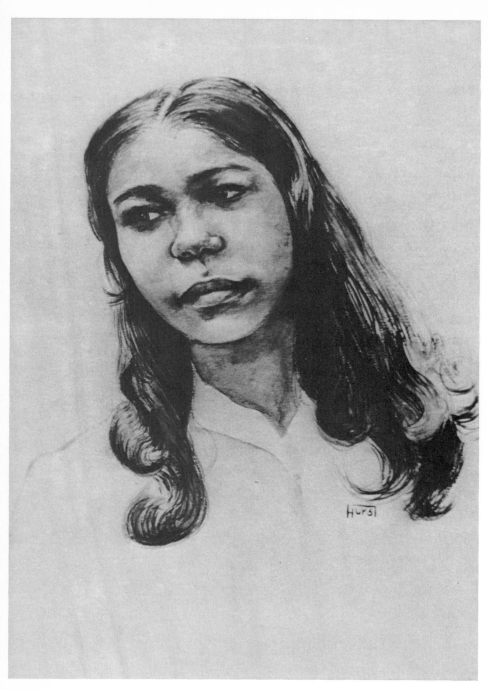

Portrait. Pastels. Student, Baltimore Public Schools. In this example, colors and values are softly blended in a smooth application of pastels. Close attention is given to the texture of the hair which provides contrast against the otherwise smooth areas of the painting.

Pre-treatment of wood surfaces is not always necessary. Light colored woods, particularly those with interesting grains, are often best used as they are. *Transparent* washes of inks, dyes, acrylic colors, and watercolors can be used as a ground, without obscuring the grain, if an underlying color is essential. Darker woods may be left untreated for muted or somber effects, or they can be stained with color. If they are so dark that colors will not show clearly, they may be gessoed or painted in a lighter tone. Generally, crayons applied to wood need no further sealing or finishing, especially in the case of oil or wax crayons. Wax crayoned surfaces may be buffed with a soft cloth to heighten their luster; oil crayon compositions may be varnished to protect their surfaces. Watercolor crayons and inks are not as durable. If protection is important, floor wax may be applied lightly and then buffed. If collage elements are part of the composition, they may be sealed with acrylic medium or shellac.

CHALKS AND PASTELS

When we handle chalks and pastels, the first thing about them that strikes us is their powdery, fragile nature. Even when we handle them gently, they smudge our fingers and, if dropped, they break rather easily. These characteristics of most chalks and pastels are responsible for the generally held impression that these materials lack permanency and are, therefore, less *serious* media. These impressions are, in fact, highly erroneous. Pastel and chalk paintings have survived for hundreds of years and, if we consider early cave drawings as "paintings," then chalks are a prehistoric art medium. It should be remembered that the "seriousness" of any painting medium depends entirely on the quality of the painting produced through its use, not on the characteristic of the medium itself.

Tree Study. Pastels. Student, Washington Co. (Md.) Schools. The rough-textured paper is important in this study of a gnarled tree. The texture of the bark could not be as effectively illustrated on a smooth paper.

Loading Platform. Pastels. Student, Seattle, Washington. Courtesy American Crayon Co. The complex forms and textures are clearly defined in light and dark values. The negative space has been broken into a variety of sizes by the inclusion of telephone poles which "divide" the sky into interesting areas. Careful drawing is essential in a painting where there are many complex shapes and forms, as in this illustration.

Characteristics

Chalks and pastels vary greatly in hardness and color quality. Finer chalks contain little binder and are, therefore, very soft; their pure pigments produce clear, rich colors. Chalks of this quality respond to even the lightest handling and are best used in broad, free strokes that exploit their velvety qualities. Chalks of poorer quality contain more binder and their pigments are less permanent; chalks of this type are harder and the colors produced are often weak and streaky.

Pastels may be powdery, waxy or oily depending on the binders used. The powdery types are generally harder and more brittle than chalks. But, they may be used in much the same manner. Being harder, however, they are more appropriate for highly detailed work where fine lines are desired. Wax and oil pastels require greater pressure in application and require careful handling. They lack the soft, velvety qualities of good chalks and their colors tend to build up unevenly. Their waxiness or oiliness, however, make possible an interesting range of mixed media techniques not possible with the drier, powdery chalks and pastels. Because they are not as likely to rub off, they do not require fixing as do the dry powdery media.

Fixing

A painting or drawing in pastels or chalks is fixed by spraying all or part of it with a liquid that fixes, or seals, the surface. The medium does not rub off, or fall away from, the paper or support. The sealing of the surface makes handling of chalk and pastel paintings much easier. They are less apt to smudge hands and clothing.

Fixatives vary in composition but all perform essentially the same function. Certain types are *workable* fixatives, meaning that after they have dried, additional layers of color may be applied. Generally, it is best to avoid overuse of fixative. Colors may be changed, textures destroyed or spots of color may be removed by an uneven spray. If you wish to apply color over a fixative, permit it to dry thoroughly so that underlying color will not be disturbed. Oil pastels do not require fixing.

Papers and other Supports

Chalks and pastels, like wax and oil crayons, are most effective when applied to papers or boards with a degree of roughness (tooth). The high points on these textured supports break up tones and lines and lend sparkle to colors. In addition, the roughness of the support tends to hold the powdery color, keeping it from sliding or falling away from the surface. An excessive application of color, layer upon layer, will fill in the depressions in the paper. This destroys the grainy quality that is characteristic of fine works in chalks or pastels.

Practically any rough paper can be used successfully with chalks and pastels. Extremely coarse surfaces, however, are not suitable for highly detailed work because they quickly break up fine lines. Papers manufactured especially for use with chalks and pastels are available in art supply stores. Some of these are fine-ribbed in texture, some are velvety, and others have gritty surfaces that cut particles of color from chalks and pastels. These papers are available in a range of subtle colors and tones, including grays, blues, and browns. More common papers often found in the art classroom are quite suitable, especially for first experiments.

Still life With Gun. Colored chalks. Student, Baltimore Co. (Md.) Schools. Colors are smoothly blended to simulate the textures of metal, wood and bone. Fine, over-lapping strokes create details and accents on the stock of the gun and on the animal horns. Note how the shadows cast by the objects serve to break up the background space and to give the illusion of depth.

Oil pastels vary greatly in composition and quality. Oilier pastels may be blended on the support with a brush which has been dipped in turpentine; for this type of pastel, canvas or canvas-like supports are appropriate. Boards or papers sealed with acrylic medium also provide suitable working surfaces.

Other supports that may be used include cloth from old window shades, cheesecloth glued to a fairly rigid backing, such as bookbinder's board or Masonite, canvas boards, oatmeal paper, and kraft paper. The color of the background or support is not too important unless part of it will show through. If this is the case, then choose a color that enhances the painting, or coat the support with gesso or with flat white paint.

Applications

Although the chalks and pastels described here vary somewhat in characteristics, some general guidelines can be followed in the use of all of them. Spend some time in becoming acquainted with this material. Learn how it may be used alone or in combination with other art materials and techniques. Select a paper or board with a slightly rough texture and explore the following applications.

Handling of the stick. Hold the stick under the hand for broad freely applied bands of color; use the end or corner of the stick for fine lines.

Textures. Work to achieve thick-to-thin lines, rough-to-smooth application of color. With wax or oil pastels, experiment with level and impasto, or thick, applications of color.

Values. Achieve values by using the side of the stick, by drawing fine, closely spaced lines and by blending or rubbing tones. Try to achieve value and texture at the same time by using the stick to create the textures of leaves, bricks or grasses in a variety of values. Use the side of the chalk to show the side of a building in one broad stroke.

Colors. Blend colors by over-laying strokes, by rubbing and by applying contrasting or related colors in fine lines or cross-hatching. Experiment with graying, or reducing the intensity of color, by applying a color over its complement—green over red, blue over orange, or violet over yellow. Experiment with analogous, or related colors: Apply yellow, in broad strokes, to cover an area about the size of a postcard. With green and blue chalk or pastel, apply thin, closely spaced lines over the yellow area. Hold the paper at arms length to see how the colors affect each other. Experiment with other analogous color combinations.

Class Demonstration. Oil pastel with pen and ink. Bob Nunn, Dallas Independent School District Courtesy Susan Bethel. Oil pastels were applied heavily over portions of a pen and ink drawing. The pastels were thinned and softened with a brush dipped in rubber cement thinner.

Les Amoureux. 1930. Oil pastel and charcoal on canvas. Andre Masson. The Baltimore Museum of Art. A whimsical, active composition of curved lines on a background of free-form shapes. Note the textural effects produced by the rough surface of the canvas.

Drummer. Oil pastels on toned paper. Student, Baltimore Public Schools. The movement of the drummer's hands is suggested by the manner in which the color is applied near the hands and the top of the drum. The posture of the drummer and the lines around his head emphasize the intensity of movement and concentration.

TECHNIQUES

Wet Surfaces. Interesting textural and color effects can be achieved by applying chalks and pastels on wet surfaces or grounds. Coat a medium weight paper or board with white tempera paint, acrylic medium or liquid laundry starch. While the application is still wet, do a quick drawing, using the sides and points of chalks. With washes of transparent watercolor, brush in the major shapes and forms of a simple landscape. While the paint is quite wet, use chalks to define contours and to add textural interest, such as foliage, bricks, and stones.

Resist. Crayons and wax or oil pastels may be used as resist materials with any water base paints, inks, casein paints or acrylic paints.

Sgraffito. Using wax or oil pastels, apply colors in even layers, one over another. With a sharply pointed stick or compass point, scratch into the layers to reveal the underlying colors. Experiment with various color combinations; scrape away some areas, with a razor blade or metal strip.

SUGGESTED PROBLEMS

1. With wax crayon, lightly sketch a still life arrangement on rough textured watercolor paper. (Select objects that present a variety of shapes and textures.) Apply bright crayon colors very heavily, creating a variety of textures and patterns. Reserve some areas of the paper, letting white show through. Brush the finished color application with slightly diluted India ink.

2. Sketch a composition, figure or animal on a scrap of light colored wood, letting the shape of the wood suggest the shapes. Outline with felt tip marker or brush and India ink, then apply crayon heavily to all areas. Experiment with glazing and sgraffito techniques. Buff the finished work with a soft cloth.

3. Dip white cotton cloth (muslin, sheeting) in water, then squeeze the cloth until water no longer drips. Stretch cloth over a smooth working surface, attaching at the sides with staples, thumb tacks or tape. Create a design on the fabric with colored chalks. Place freezer paper, waxed side down, over the design and press with a warm iron until the fabric is smooth and dry. Mount design on rigid support with P.V.A. or acrylic medium. The finished work may be lightly sprayed with fixative to seal the surface.

4. Lightly sketch a self portrait, or portrait of a classmate, on canvas, canvas board or shade cloth. Establish major color areas with the sides of oil crayon, blending colors by rubbing or with a brush dipped in turpentine. Use the point of the crayon to define contours and to add textures, highlights.

5. Using sides of chalks, create a composition on a toned textured paper. (Charcoal paper or poster paper.) Use no line; work only in light and dark, letting the paper serve as the middle tone.

6. With pastels, make a drawing of an animal, with a minimum number of lines. Concentrate on selecting those characteristics that best identify the animal. Work for a variety of thick and thin lines.

7. With washes of transparent watercolor or tempera, establish the major shapes and color areas of a landscape or street scene. Complete with pastel application, deepening values and adding textural interest. Experiment with ways of applying pastels, using sides and points of the stick; in selected areas, apply pastels before color washes are dry.

8. On canvas or sealed board, use a thin oil wash of a single color to develop masses in a figure study. Use bold, heavy lines of oil pastels to create value contrasts, accents and details.

Mythical Landscape. Mixed media. Student, St. Louis (Mo.) Public Schools. Large areas of overlapping colors were applied with the sides of colored chalk. Light and dark tones of tempera were used to create the skeletal trees and to suggest buildings. The use of the sides of chalks and pastels encourages bold, direct compositions with simplified forms and values.

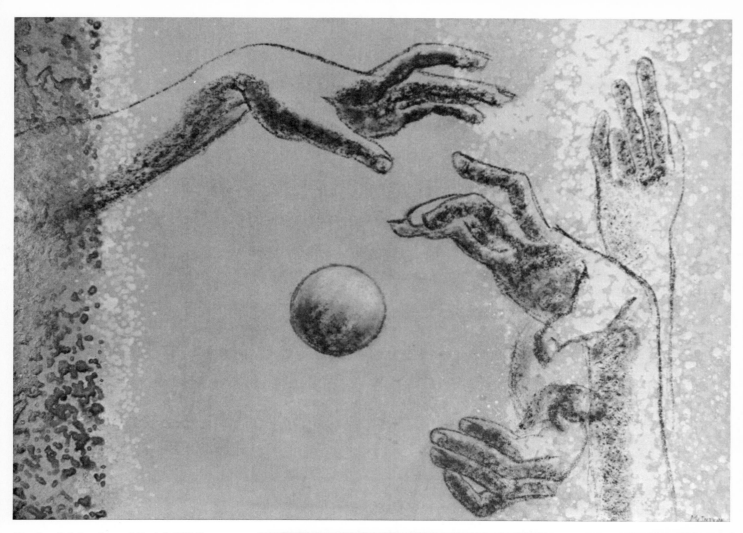

Hands, #1. Acrylic and Pastel. 22½″ x 29½″ Mary McIntyre. Courtesy the Robert Rice Gallery, Houston. Hands are drawn over a textured background of acrylic colors. Note the movement created by the hands as they reach toward the ball. How is the painting balanced?

Untitled. Oil pastel resist. Student, Dallas Independent School District. Libby Nickel, instructor. India ink was brushed over heavily applied oil pastels. Lines outlining the objects were not covered with pastels and, therefore, absorb the ink, creating the dark lines.

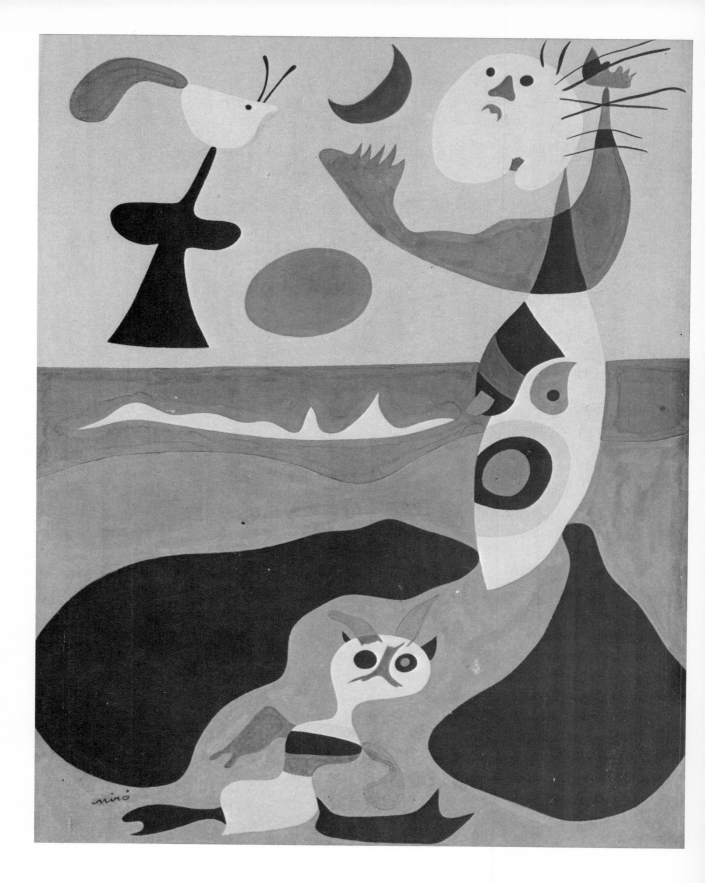

Painting with Tempera and Casein

A Hill Setting: Fredericksburg, Texas.
Gouache, 18″ x 32″. J. Wayne Brown.
Courtesy the Robert Rice Gallery, Houston.
In photo-realism, the artist expresses the
stark simplicity of a Texas farm. An absence
of people and activity evokes feelings of
loneliness and isolation. The dry-brush tech-
nique is ideal for the meticulous rendering of
the textures of the dry grasses and the
weathered woods of the houses and farm
buildings.

Summer. 1938. Gouache. Joan Miró. The
Baltimore Museum of Art. The free-floating
fanciful shapes stir the imagination: are they
people, animals or birds? The gouache me-
dium is suited to Miró's sharply defined
edges and areas of flat color. Do these
shapes suggest summer?

Tempera and casein paints belong to
a group of watercolors referred to as
gouache colors. What is gouache? A
gouache is opaque watercolor. Unlike
transparent watercolors, gouache
colors have great *hiding,* or covering,
power and can be used to create
smooth, opaque areas of colors
impossible to achieve with trans-
parent colors. The term gouache is
also used to refer to a type of paint-
ing. It is, generally, free and charac-
terized by spontaneous, vigorous
brush strokes. A painting of this type
may combine several types of paint,
including tempera and casein, and
still be referred to as a gouache. For
our purposes, gouache will include
those *opaque* watercolors most com-
monly used in the art classroom—
tempera and *casein.*

Tempera paints—often referred to as showcard or poster paints—are the opaque watercolors most widely used in the art classroom. They may be used alone or combined with other drawing and painting media to produce paintings, posters, signs, and other projects where *permanency* is not an important factor.

Tempera paint, even when thoroughly dry, is not permanent. Colors may be lifted with a wet brush and will not withstand much reworking or overpainting. Corrections may be made only with the greatest care.

Dried tempera paint cracks and flakes off a painting rather easily, especially if a lightweight paper is used as a support. Tempera paints used in the classroom are not made with the egg yolk binder used in the manufacture of finer, longer lasting temperas used by the professional artist.

Casein paints, on the other hand, are generally used for permanent painting. Although mixed with water in use, they are highly water-resistant when dry. This permanency is a result of the casein binder which contains a strongly adhesive milk base. Because the dried casein colors will not lift, or come off, corrections in a casein painting can be made quite easily. As long as the underlying color is dry, glazes and scumbles can be applied and values and intensities of colors can be changed as desired. This degree of permanency makes casein a much more versatile paint than tempera. Casein is more useful in a variety of mixed media techniques.

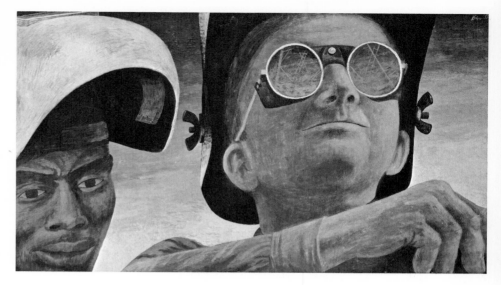

Welders. 1943. Tempera on cardboard mounted on composition board. Ben Shahn. Museum of Modern Art. Emphasis is gained by strong contrasts of light and dark values, the close-up of the heads and by the emptiness of the negative spaces surrounding the men.

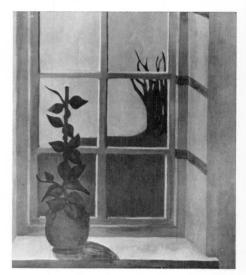

Window. Gouache. Student, Fort Lee (N.J.) High School, Joan DiTieri, instructor. The effect of light is important in this composition: sharp contrasts in values define forms and indicate the source of light. Note how the dark form of the plant is balanced by the dark tree in the upper right portion of the painting. The smooth flat application of paint assists in achieving the hard-edged planes and shapes.

CHARACTERISTICS

Although casein paints differ from temperas in quality, permanency and versatility, they share some common characteristics. Because of these likenesses, it is possible to follow some general guidelines in working with either type of paint.

1. *Supports and grounds* may include a wide variety of gesso boards, wood panels, watercolor boards, and papers. If casein is used in the transparent manner, a white watercolor paper is recommended. Otherwise, darker, colored papers may be used, since both casein and tempera have great covering power.

2. Heavy impastos, or thick layers, of tempera or casein will crack off a flexible surface and must be built up *gradually* on a rigid support. Appropriate supports may include heavy illustration board, gessoed Masonite or other hard board. Impastos should not be applied with a palette knife but should, instead, be built up by brushing on successive layers of paint.

3. Drying times are relatively short for both tempera and casein. Both tend to dry somewnat lighter in value than they appear when wet. If white has been liberally added to colors, casein colors may appear a bit chalky.

4. Corrections and overpainting are possible with both tempera and casein but in varying degrees: a dry casein underpainting will withstand many corrections; corrections in tempera should be made most carefully with a minimum of brush work to avoid lifting the underlying color.

5. Most techniques peculiar to watercolor are possible in tempera and casein: colors may be applied with brush, sponge or brayer; crosshatching, stippling, spattering, and scratching-out are possible.

6. Palettes of nonporous materials are best for tempera and casein paints because they will not absorb water and, therefore, retard the drying-out of paints. Palettes which provide color cups, or wells, are best for tempera and are recommended for the preparation of casein washes to be used in the transparent manner. Muffin tins serve well for tempera paints; porcelain butchers' trays are ideal for casein.

TEMPERA

Tempera is an extremely versatile paint. It can be used for easel paintings, murals, posters, papier-mâché work, in crafts design, and for painting stage scenery. When combined with crayons, inks, chalks, and collage materials, it is useful in a wide variety of mixed media techniques. Tempera has an added advantage: it is inexpensive when compared with the more permanent caseins, oils, and acrylic paints.

Materials; Tools

Colors are available in both liquid and powder forms. (Pan colors may be obtained but these are not as versatile as liquid or powder forms.)

Almost any type of brush can be used with tempera: bristle, oxhair, and camel's hair brushes in a variety of sizes, round and flat, are all appropriate for various effects. In addition to these, stencil brushes, sponges, and household paint rollers may be used.

Five A.M. 1953. Tempera on mat board. Mark Tobey. The Baltimore Museum of Art. Dynamic flashes of white lines were used by Tobey in painting cities and city life. Lines suggest lights and threading traffic. Can you see why Tobey's painting has been called "white writing"?

As noted earlier, fairly rigid supports are recommended, particularly if a more permanent painting is desired. However, for general classroom use, assorted drawing papers, kraft paper, and even newsprint may be used, depending on the project at hand.

Water containers should be of a generous size. Coffee tins and food jars that will hold at least a pint of water are recommended. It is important that brushes be washed frequently to keep colors clear and clean. This is particularly important if white is to be added to only a few colors; a brush *dirtied* with white will cause all colors to appear chalky and dull.

In addition to muffin tins, plastic egg trays, sectioned TV dinner trays, and cafeteria trays may be used. Choose the palette most appropriate for the number of colors and the amount of paint required for the work to be done.

If work surfaces are covered with clean newspapers, clean up will be much easier. Clean, absorbent rags are needed for wiping brushes.

Resist Materials

An almost unlimited range of textural effects can be achieved with tempera paint and materials that resist the paint. These materials include wax crayon, oil crayons, rubber cement, paraffin, and ordinary candle wax. The use of these materials will be discussed later in this chapter.

Exploratory Activities

If you have not painted with tempera, it is good to take time to learn its characteristics. The consistency of liquid color as it comes from the jar is not always "ready" for brushing. The paint should be mixed to a smooth, creamy consistency that will provide good coverage and dry to a smooth, flat finish. Unintentional ridges in the dried paint surface are caused by paint that is too thick or by a brush that is too stiff. If paper shows through in spots, the paint is either too thin or it has not been evenly mixed. In general, paint that is mixed to the consistency of light cream is about right for achieving a smooth, opaque surface.

Experiment with making a color lighter by adding white to the color; add black to the color to make it darker. Try painting a range of seven or eight values—from very light to very dark.

Colors are dulled by mixing them with their complements: add orange to blue, red to green, and yellow to violet to learn how to lower the *intensity* of colors.

When you are able to mix colors to the proper working consistency, experiment with a variety of brushes and other painting tools to learn the textural effects that can be achieved. Which brush is best for achieving a sharp, clean outline? How many different textures can be simulated with a stiff bristle brush? On scraps of poster board or paper, produce as many different patterns or textures as you can, including dots, stripes, stipples, and cross-hatching.

Do not limit yourself to brushes, but use sticks, sponges, brayers, and small strips of stiff cardboard. Paint a tree, using only a bit of sponge and a stick as brushes.

Remote Field. 1944. Tempera, pencil and crayon on cardboard. Mark Tobey. Museum of Modern Art. Gift of Mr. and Mrs. Jan deGraaff. Associated with the "action" painters, Tobey's paintings are characterized by a personal calligraphy, or handwriting, that was influenced by Oriental script. Here, a tangled web of lines appears to float over the entire field of the canvas, expressing the spontaneity of the *act* of painting.

Figure. Tempera and ink resist. Student, Boude Storey Middle School, Dallas. Julie Turbeville, instructor. In an ink resist technique, it is important to keep in mind that the ink can provide the darkest values and the outlines of forms, as illustrated in this painting. It is important, therefore, to keep these areas free of paint if that is how you choose to use the inked areas.

When you have learned something of how to mix tempera, how to control colors, and how the paint may be applied, you are ready to move ahead to a tempera painting. In the beginning, you may wish to keep the composition simple: an arrangement of a few objects on a table top, or perhaps a simple landscape. The problems suggested at the end of this section will provide some starting points for you.

TECHNIQUES

The following techniques provide many visual surprises, including lively textures and gradations of color that make for more exciting paintings.

Washout Technique

Paint all *negative* areas with fairly thick white tempera paint. Allow it to dry completely. Then, with a large, soft brush, cover the entire surface with black India ink and, again, allow to dry completely. (Best results are obtained when ink is used full strength but ink may be diluted by adding one part water to five parts ink.) Finally, gently wash the entire painting surface under a cold water faucet or spray attachment until the black ink flushes off the negative areas painted white. Black areas and lines will appear where the white tempera paint was *not* applied. If the ink is difficult to remove from some of the painted areas, brush it gently with a soft sponge, or rub it lightly with your fingers. Place the wet painting on newspaper to dry.

The washout technique works best on a stiff cardboard with a slight grain or tooth. (Slick, shiny boards are not suitable because almost all of the paint and ink will wash off, producing a weak, faded effect.) Other sturdy papers, such as construction papers, are successful if carefully handled.

Heavy colored construction paper will provide the exciting addition of color to the black-and-white composition; the overall effect will resemble a multicolor block print. Variations on the washout technique may be achieved by using colored inks and paints, by reversing the process by painting the *positive* areas white or by working on gray-tinted paper for a two tone effect.

A washout "engraving" is possible: In this technique, the entire surface of the board is covered with creamy white tempera paint and allowed to dry. Lines are scratched through the dried paint with a sharp instrument, such as a compass point, and the surface is coated with India ink and treated as in the regular washout technique. The line quality produced is quite unique, resembling an engraving.

Wax Resist

This technique involves the use of wax crayons, oil crayons, candle wax or paraffin. (Pressed crayons, containing less wax, are not suitable.)

In this technique, shapes and lines are heavily applied to the paper or board with the wax crayons, with portions of the paper or board allowed to show through. (Brighter colors are more effective.) When the application of crayon is completed, black tempera paint is brushed over the entire surface of the painting. The bright waxed crayon lines and shapes will resist the paint and shine through in sharp contrast against the black tempera paint. Interesting textures result from the unevenness in crayon application and from the manner in which the paint adheres to the unwaxed paper areas.

Many different effects are possible and various combinations of materials should be explored. Instead of black tempera, white tempera may be used. A design or composition done entirely in black crayon and then covered with white tempera produces an especially interesting textural effect. Like wax crayons, paraffin and candle wax preserve the color of the paper or board on which they are applied. The paraffin blocks (available from hardware or food stores) should be broken into smaller chunks; candles can be used as is or broken into shorter lengths. These waxes are generally more effective for reserving larger areas.

Oil crayons are used in the same ways as wax crayons. As in the wash-out technique, papers and boards with some tooth are more appropriate, although the technique may be used on almost all types of papers and boards, except fragile tissues and slick, shiny papers.

Brayer Painting

Painting with a brayer almost forces you to simplify, to think big, since the size of the painting tool itself prevents your giving too much attention to small detail.

The Princess and the Pea. Tempera resist. Courtesy Binney and Smith. In this illustration of a children's story, the emphasis is on patterns and textures. Each mattress or layer of the bed has a different pattern of lines, shapes and values. The textured surface is created by brushing India ink over areas of *dried* applications of thick tempera paints and wax crayons.

Boats. Brayer painting. Courtesy Binney and Smith. Movement is achieved through the repetition of the shapes of the sails and textures. Broad areas of color were rolled on with a brayer; areas of solid dark color and fine lines were applied with a brush.

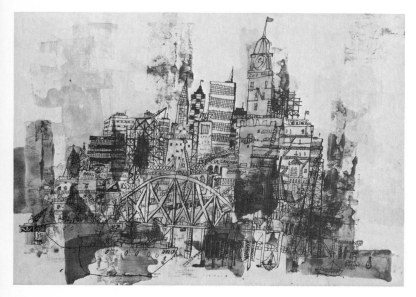

The City. Tempera. Student, Houston Public Schools. Large areas of tempera were applied with a brayer and allowed to dry. Note the balancing of light and dark colors across the total surface. Lines drawn with India ink were then used to create a variety of textures and patterns.

Experiment with different types of brayers in addition to those generally provided in the art classroom. Use household paint rollers, from hardware and paint supply stores. Since it is necessary to dip or roll the brayer into the paint, paint trays slightly wider than the widest brayer are needed. Large enamel, metal or plastic trays are ideal. Smaller trays of foil or cardboard, similar to those used for prepared or frozen foods, are suitable. Improvised trays may be made by lining shallow cardboard box lids with foil, waxed paper or plastic wrap.

Large pieces of paper or board, at least 18 inches x 24 inches, encourage boldness and provide more space for experimentation. Kraft paper, shelf paper, newsprint, and the reverse side of wallpaper are more suitable than the smaller, standard size art papers. Corrugated board from packing boxes provides the exciting addition of texture: pull off the top layer of paper and roll the paint over the ribbed, middle layer of the board.

Powder Tempera Techniques

Powder tempera, mixed according to the manufacturer's directions, may be used in the same manner as liquid tempera. Other techniques are also possible and provide for greater versatility and exploration in the use of powder colors.

One of these techniques involves the combination of dry powder tempera with an adhesive. The adhesives used may include one or more of the following: P.V.A. (polyvinyl acetate) thinned with water, acrylic medium, white glue thinned with water, a mixture of water, and white paste or even liquid soap. Bristle brushes and stiff boards are most suitable.

The technique is simple: the brush is dipped into the adhesive, then into the powder paint. From this point, the painting proceeds as with other painting media. The degree to which the color is mixed—in the pan or on the board—is a matter of choice.

The use of acrylic medium, P.V.A., or white glue produces greater adhesion, a more permanent painting, and thicker impastos are possible. (The mixtures of paste or liquid soap are apt to crack if heavily applied.) Brushes used with these adhesives should be kept wet at all times and should be promptly and carefully cleaned at the end of the painting session. When dry, acrylic medium and white glue cannot be dissolved in water.

Other Uses For Tempera

A flat, even application of tempera may be used as a ground for the application of pastels, chalks, crayons or transparent watercolors. (Use white, or other light values, with transparent water colors.) Tempera painting may be combined with collage techniques in a mixed media composition.

SUGGESTED PROBLEMS

1. On a sheet of white drawing paper,draw a rectangle 5 inches x 7 inches. Using one color thinned to a creamy consistency, paint the entire surface of the rectangle. Work for a smooth, even application of color that is free of brush marks.

2. Select one bristle and one oxhair or camel's hair brush. Using one color, create horizontal line patterns across a sheet of drawing paper. Work for a variety of lines with each brush: thick-to-thin, thin-to-thick, broken line and scratchy, dry-brush lines.

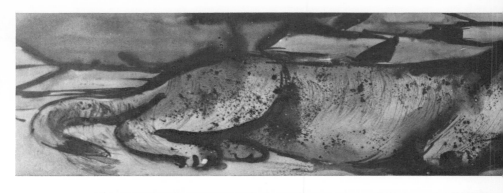

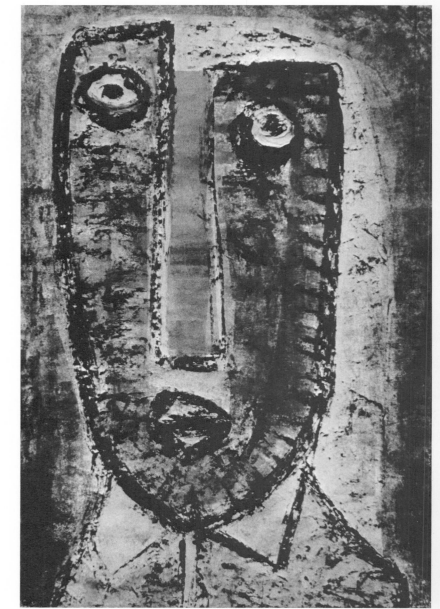

Big Cat. Mixed media. Courtesy Binney and Smith. Powder paints were sprinkled into wet watercolor for a sparkling textural interest. Additional textures are dry-brushed.

Abstract. Tempera. Student, Sarah Zumwalt Jr. High School, Dallas. Courtesy Susan Bethel. An abstract composition based on a still life set up in the classroom.

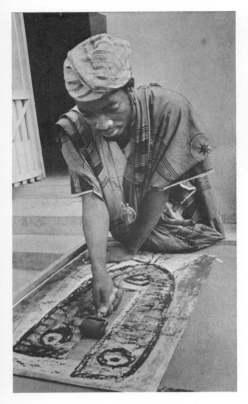

Scholar. Tempera and pastels. Muraina. Courtesy Standard Oil Co. The general outlines and details of the face were drawn with bold pastel lines. The painting was then completed with tempera paint applied with a brayer. Note the simplified and exaggerated forms. The artist had never seen paints until he was a young adult.

3. On a large sheet of drawing paper or board, create at least ten different textures or patterns using one color and the following tools: sponge, stick, cardboard scraps, stiff bristle brush, and rubber kitchen spatula.

4. Sketch a single object such as a fruit, vegetable, small box or ink bottle. Using one color, plus black and white, paint the object to reveal its basic form. Experiment with cross-hatching to create values.

5. Lightly sketch a still life arrangement on a textured board. Develop major areas and forms with tempera paints. Use wax crayons, in related colors, to create patterns, color glazes and textures in selected areas. Finish with brush strokes of tempera or inks.

6. Cover a board or heavy paper with a smooth application of dulled tempera color (gray, blue-gray, gray-green). Use brighter, lighter tones of pastels or chalks to sketch a posed figure. Experiment with overlapping lines of color and cross-hatching.

7. Cover a board or heavy paper with a flat, even application of white tempera paint. Allow paint to dry completely, then use transparent watercolors to sketch a simple landscape.

8. On a textured mat board or rough textured paper, sketch a subject of your choice. Paint the negative areas with thick, white tempera paint, experimenting with a variety of brush techniques. When the paint has completely dried, coat the entire surface of the painting with India ink. When the ink has dried, hold the painting under a faucet or spray attachment and gently flush the ink from the painted areas. Put aside to dry. Add details with pen, brush, and ink, if desired.

9. Repeat problem as described in 8, using gray paper or construction paper in a color of your choice.

10. Using wax or oil crayons on textured drawing paper, create an imaginary animal, insect or bird. Apply crayon heavily in a variety of lines and textures; leave some areas of the paper open or free of crayon. Cover with a wash of white or black tempera paint.

11. With a variety of cut and torn paper shapes, create a collage composition to interpret a theme or subject such as "Florist's Window," "Jungle," "The Shelf." Adhere papers to stiff board with acrylic medium, thinned white glue, P.V.A. or rubber cement. Use tempera paints to create patterns to establish values and to provide transition between collage and paint surfaces. Experiment with sticks and sponges in applying paint. When paint has dried, the surface may be sealed or finished with spray varnish.

12. Mix a single color of dry powder tempera with acrylic gel medium and, with a spatula or scrap of stiff cardboard, spread it evenly on a stiff white board. Create textural patterns by patting surface with a stick, crumpled wax paper or cardboard edge. Leave the dried painting as is, or use it as a ground for further painting.

13. Cut a shape or pattern for a stencil from stencil paper or tagboard. Create a composition by stencilling the shape in various positions on the paper or board; experiment with overlapping. Use both the negative and positive shapes. Experiment with sponge, dry brush and spatter techniques in applying tempera paint.

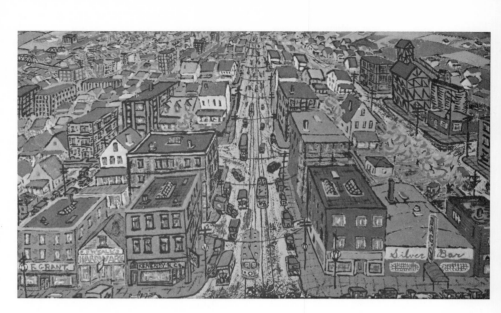

Roof Tops. Tempera. Student, Chicago Public Schools. Courtesy American Crayon Co. Note that as the buildings recede in the distance, they are drawn *smaller* and placed *higher* in the painting. Details such as signs, doors and windows are easily seen in the foreground but are less detailed or eliminated in the buildings in the distance.

Floral. Tempera and ink resist. Student, Fort Lee (N.J.) High School. Joan DiTieri, instructor. The success of this technique depends on a careful planning of a variety of sizes, shapes, colors and patterns. The textural quality and darkest values are produced by the adherence of India ink to the areas *not* covered by thickly applied tempera paints.

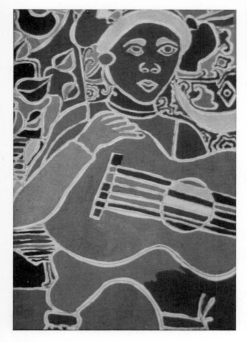

Figure with Guitar. Tempera. Student, Spruce High School, Dallas, Texas. Courtesy Susan Bethel. A line in light value is used to outline the shapes and textures throughout the painting. There is no attempt to simulate three-dimensional form. The figure, painted in flat colors, contrasts with the patterned background.

CASEIN

Casein paint is a very versatile medium. Although used primarily for rich, opaque effects, casein paints can be used in the transparent manner when thinned with water. Like tempera paints, they are water soluble in use. But, unlike tempera, they become insoluble with time and exposure to air. This difference makes casein a far more versatile paint than tempera. Colors may be superimposed, or overlaid, without lifting or pulling the underpainting. This means that corrections can be made easily; the correction is simply painted over the dry underpainting.

A wider range of effects in color and texture are also possible. Glazes and scumbles are easily applied and, if built up gradually, limited impastos are possible. Textures may include sgraffito techniques, scratching into the painted surface.

There are artists who use a casein painting which has been sealed with an acrylic varnish as an underpainting for oils. Casein has proven effective on cement, plaster or lime walls which makes it appropriate for murals and similar interior projects. Crafts designers have used casein on wood, gesso, and other rigid, non-greasy surfaces.

Casein colors, especially those made with pure pigments, possess great tinting power; that is, colors remain clear even when greatly thinned with water. Casein colors dry to about the same value as when wet. The dried paint surface is rich with a slightly velvety texture that is smoother than dried tempera.

Casein paint dries quickly and, because the dried paint is insoluble in water, some precautions must be taken in handling paints and painting tools. Paint tubes should be recapped immediately; brushes, brayers and other painting tools should be kept wet while in use and then promptly and thoroughly cleaned at the end of the painting session. Many artists use their oldest, most worn brushes for casein painting since casein paint is hard on brushes.

Materials and Tools

Materials and tools used for casein are basically the same as those used for other watercolors. Differences in the handling of the materials depend on the manner in which the paints are to be used and will be described wherever needed.

Colors and Mediums

Tube paints are available in hundreds of colors but a basic beginner's palette of yellow ochre, Venetian or Indian red, ultramarine blue, black and white is quite sufficient. Others may be added as needed or desired. Water is all that is needed for the mixing of casein colors. Professional artists who use highly diluted casein colors in the transparent manner often add casein emulsion to the water to produce a stronger painting medium. The emulsion is not essential for the beginner, who can manage quite well without it.

Supports

If casein is used in the transparent manner, white or near-white supports are essential. If traditional watercolor paper is used, it should be dampened and stretched as for transparent watercolors.

For opaque or gouache techniques, almost any type of support can be used including colored papers and boards of all types. Kraft paper, Masonite, canvas boards, gesso panels and stretched canvas are also appropriate. Stretched canvas should be reinforced with a backing of cardboard to make it more rigid; dried casein paint is brittle and will crack off a flexible canvas. The canvas itself should be semi-absorbent.

If paints are to be applied thickly, a rigid support is needed. The thickness should be gradually built up in layers.

Brushes

Practically any kind of brush can be used for casein, depending on how the paint is to be used. Smooth applications of paint require soft brushes of the type used for other watercolors—round or flat brushes in oxhair, camel's hair or sable in a variety of sizes. If the paint is to be applied more thickly, bristle brushes of the type used for oil paints are needed. In addition to brushes, sticks, sponges, and tools for scraping and scratching lines may be used. (Do *not* apply casein paints thickly with a palette or painting knife; impastos in casein must be built up, in layers, for proper adhesion.) As noted earlier, old brushes may be used with casein. Worn bristles can be trimmed and the brush used for dry-brush or stipple techniques.

Palettes

Non-absorbent palettes are required; old white plate, white enameled butcher trays, a sheet of glass placed over white paper, a sheet of white Formica—all are quite suitable. A palette with separate wells is best when casein is diluted for transparent techniques; a muffin tin or other type of sectioned tray or pan will also work.

Water Containers

Because casein dries quickly, water containers should be large enough to permit frequent and thorough washing of brushes and tools. Clean water will also make for clear, less chalky appearance of colors. Clear glass jars are ideal.

EXPLORATORY TECHNIQUES

As you begin working with casein, it will be helpful to remember some of the techniques learned with transparent watercolors and tempera.

Washes are laid in very much the same manner as for transparent watercolor. Remember that a casein wash is not as transparent as a transparent watercolor wash. Other differences will become apparent with experimentation.

Lay a series of thin washes, in bands of color, on white paper or board and set them aside to dry. Over these dried washes, lay a second wash of related or contrasting colors. Note that the second wash does not blend with the first. Instead, it acts as an overlying glaze through which the underlying color can be seen. Experiment further by combining thick and thin washes in a variety of colors, noting color changes, covering power, and textural qualities of the paint.

Values

Lay a medium heavy wash of color. While it is still wet, load a brush with white paint and brush it boldly across the wash. Note the *feathering* of color. Experiment by adding white or black to a color before applying it to paper.

Textures

Lay a medium heavy wash of color. While it is still wet, use an absorbent tissue and sponge to lift the color from the paper. Spatter lighter and darker colors into the wet wash.

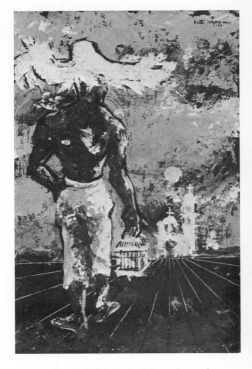

Bird in Hand. 1951. India ink and casein on panel. Keith Ingermann. Courtesy Baltimore Museum of Art. Scumbles of light tones were applied over a background of dried India ink. A few details are added with brushed lines in India ink. The receding lines in the pavement were scratched in with a pointed tool.

Lay a heavy wash of dark color or black over a large area of heavy paper or board and allow it to dry. Scratch into the dried wash with a compass point, large needle or razor blade to achieve a variety of line. Dip a bristle or stencil brush into fairly thick white paint and, after working excess paint from the brush, experiment with scumbles applied over the dark wash. Note the textural qualities produced.

Glazing

With a large, soft brush apply white, red, yellow, and blue paint in horizontal stripes at least one inch wide on paper or board. Work for a smooth, thick application. Allow paint to dry thoroughly. With a *clean* brush and *clean* water, apply thin, vertical washes of red, yellow, blue, green, orange and violet over the original washes. Note color changes.

Impasto

Squeeze a generous amount of tube color into a small, shallow pan. Mix the paint with a small amount of water until it will spread easily. With a palette knife, transfer the paint to a stiff board and spread it quickly over the surface to a thickness of approximately one-eighth inch. Use a palette knife or a scrap of cardboard to texture some areas of the paint, leaving remaining areas smooth. When the paint has dried completely, use painting knives and a variety of brushes to build up succeeding layers of paint over the original application. Permit each layer to dry before adding another. Experiment with color, applying it in thick, thin, and overlapping strokes. (Avoid excessive piling-up of paint; it is apt to chip or crack off when dry.)

Mixed Media

Many of the materials listed for mixed media techniques with other watercolors may also be used with casein.

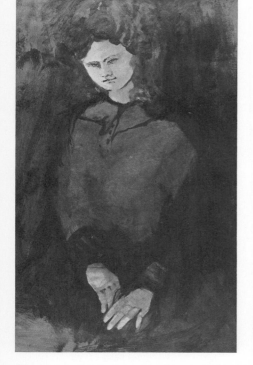

Figure. Casein. Student, John Marshall High School, Los Angeles. Values are built up through succeeding washes of color. A dramatic effect is achieved by the contrasts of the light values of the face and hands against the dark background.

(See mixed media techniques for transparent watercolors and tempera paints.) These include the following:
Ink lines over opaque colors.
Ink lines over transparent colors.
Collage with opaque or transparent colors.
Pastels and chalk over opaque colors.
Crayons over opaque colors.
Because of their great versatility, casein paints have been used in widely varying ways. Transparent application has been practiced by many artists. Gouache techniques, which exploit the velvety matte or semi-matte characteristics of casein, are preferred by purists. Other artists have sought to imitate the qualities of oil paintings in the quicker drying casein medium. A combination of techniques has been the answer for many artists who feel that technique, after all, is only a tool.

Select the casein techniques that work best for you. As long as painting methods are basically sound, there is no *right* or *only* way of handling painting media. The practice of using casein, however, in an attempt to imitate the effects of transparent watercolors or oils seems rather pointless. Why not start with transparent colors or oils instead? Generally, a painting should reflect the characteristics of the medium used. Attempts to simulate the effects of other media often appear gimmicky.

Underpainting for Oils

If casein is used as an underpainting for oils or glazes, the casein must first be sealed with casein varnish and allowed to dry for approximately two hours. The painting may then be completed by application of oil glazes or by direct painting methods. Casein-oil paintings may be done on absorbent canvas manufactured especially for casein painting or on any canvas or canvas board which has been coated with casein titanium white to make it more absorbent.

General Guidelines

As you begin to use casein paints, you may need to remind youself to mix the paint to the consistency required for good coverage and to mix enough paint to cover a specific area. Remember, too, that it is important to keep brushes wet at all times.

Although it is wise to plan your paintings carefully, avoid overly detailed drawings on your canvas or paper. Casein lends itself to the rendering of great detail and a "picky" drawing may result in a painting that resembles a "paint-by-numbers" project. Instead, sketch only the large shapes and enough detail to provide necessary "landmarks."

Paint in large areas first, with the largest brush available. Since extensive overpainting is possible with casein, less important elements and fine details may be painted over a previously painted area; therefore, there is no need to paint around them nor to block them out with a resist material. Use sharp contrasts of color and value; bold line patterns on areas of flat color add texture and interest. Dark colors, used sparingly, may sharpen contours or help to unify a composition.

Throughout your painting sessions, study the works by artists who have used casein paints effectively. Artists who have worked in casein include Morris Graves, Adolph Gottlieb, Arnold Blanch, Doris Lee, Federico Castellon, Henry Gasser, and Emil Ganso.

SUGGESTED PROBLEMS

1. On heavy white drawing paper or white-surfaced board: with pencil, sketch a simple landscape, including as much detail as is necessary to indicate major elements and important forms. With a soft brush, apply a neutral tint (a grayed cool color) to establish middle values and establish pattern. Leave the white of the paper for lights. Complete painting in full color. Re-establish lights by applying opaque white or by scratching out with tip of a knife or razor blade.

2. On white drawing paper: with soft brushes, apply thin washes of gray and brown to create the special effects of a snowy landscape. Use a dry-brush technique to indicate trees, dried grasses or other textural interest. Limit colors to those indicated; use no white paint.

3. On heavy white paper: with pencil, lightly sketch a simple landscape in which the sky is the dominant feature. Lay a loose, watery wash of blue or gray over the entire area. With an absorbent tissue, quickly lift color from the sky area to obtain a soft, cloudy effect. Experiment, by varying the pressure on the tissue, until the desired effect is obtained. Before the wash has dried completely, use an ink eraser to rub out larger light areas. Complete the painting, strengthening dark values by applying additional washes where needed. Scratch out fine white lines in foliage, trees or wherever indicated.

4. On toned charcoal paper: in pencil, lightly sketch a figure from a posed model. Indicate only major lines of movement and body masses. Avoid details. With a large, soft brush use only black paint to establish darkest values and to define contours, letting the color of the paper serve as a middle tone. Add highlights with a smaller brush, and opaque white paint.

Jockey. Casein on canvas board. Baltimore Public Schools. Semi-abstract composition based on the head and shoulders of a jockey and overlapping shapes of horses. There is no attempt to show three-dimensional space; the emphasis is on bold, direct painting on a two-dimensional plane. Action is suggested by the slashing, light and dark patterns.

Football Player. Casein, Student, Lutheran High School, Los Angeles. The alert crouch of the player is captured in a freely-painted figure composition.

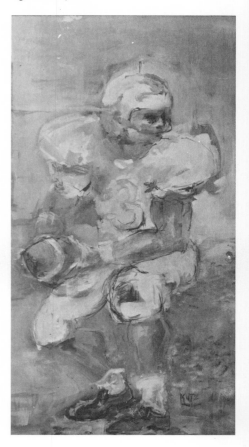

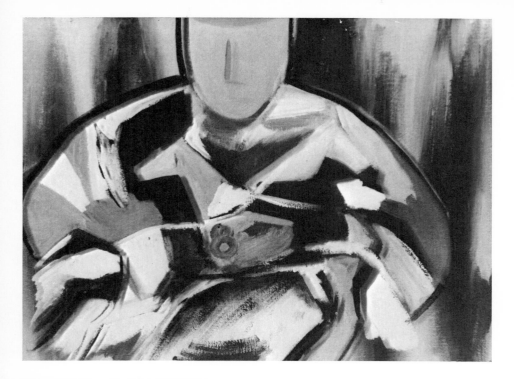

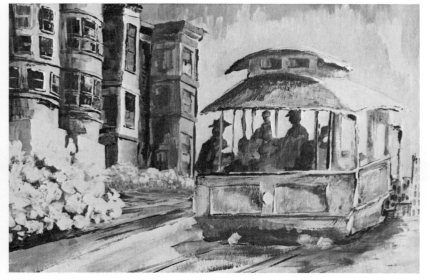

Cable Car. Casein, 18″ x 24″. Student, Lutheran High School, Los Angeles. Courtesy Gerald Brommer. Note the variety of rich textures and the brush techniques used to achieve them. Windows and other details on the buildings are added with dry-brush; the flowers and shrubbery appear to be dabbed on. The marks of the brush are clearly evident in the sky, the street and on the cable car.

5. On a rigid support: sketch a still life arrangement based on an actual arrangement in the classroom. (The arrangement should contain a variety of shapes, textures and patterns.) Give attention to the establishment of major shapes and significant detail. Lay a thin wash of a single color—yellow or red—over the entire composition. From this point, complete the composition with direct painting, first establishing the darkest values to determine all-over pattern. Experiment with glazes of related or contrasting color over the yellow or red underpainting, or permit the underpainting to show through in selected areas. Use dry brush and spatter techniques to achieve textural accents.

6. On a gesso board (or canvas board coated with casein titanium white): sketch a subject of your own choice, giving attention to unified composition and careful drawing. Complete the painting by a careful building up of washes or layers of paint to achieve a completely mat surface. Experiment by cutting, scratching or sanding through layers of paint to reveal underlying colors. When a velvety paint quality has been achieved, buff the entire surface of the painting with a soft cloth.

7. On any heavy paper: cover paper with even, opaque color in a subdued tone. Paint a portrait of a classmate, using brighter tones of pastels, oil crayons or wax crayons.

8. On paper of your choice: use a large, soft brush, in a combination of transparent and opaque techniques, to indicate major elements in a street scene. Permit paint to dry. Complete composition with pen and India ink. Experiment with a variety of pen strokes and with spatter techniques.

Bibliography

HISTORY

Baigell, Matthew. *A History of American Painting,* New York: Praeger Publishers, 1971.

Beier, Ulli. *Contemporary Art In Africa,* New York: Frederick A. Praeger, 1968.

Goodrich, Lloyd and Baur, John I. *American Art of Our Century,* New York: Frederick A. Praeger, 1961.

Janson, H.W. and Dora, Jane. *The Story of Painting for Young People From Cave Painting to Modern Times,* New York: Harry N. Abrams, Inc., 1962.

Johnson, Charlotte Buel. *Contemporary Art,* Worcester, Mass.: Davis Publications, Inc., 1972.

Lewis, Samella S. and Waddy, Ruth G. *Black Artists on Art* (Four volumes), Los Angeles: Contemporary Crafts, Inc., 1969-1973.

Read, Herbert. *A Concise History of Modern Painting,* New York: Frederick A. Praeger, 1963.

Rublowsky, John. *Pop Art,* New York: Basic Books, Inc., 1965.

Wasserman, Burton. *Modern Painting: the Movements, the Artists, their Work,* Worcester, Mass.: Davis Publications, Inc., 1970.

TECHNIQUES

Brommer, Gerald F. *Drawing: Ideas, Materials and Techniques,* Worcester, Mass.: Davis Publications, Inc., 1972.

Brommer, Gerald F. *Transparent Watercolor: Ideas and Techniques,* Worcester, Mass.: Davis Publications, Inc., 1973.

Brooks, Leonard. *Painting and Understanding Abstract Art: An Approach to Contemporary Methods,* New York: Van Nostrand-Reinhold, 1964.

Guptill, Arthur L. *Oil Painting Step by Step,* New York: Watson-Guptill Publications, 1965.

Gutiérrez, José and Roukes, Nicholas. *Painting With Acrylics,* New York: Watson-Guptill Publications, 1965.

Janis, Harriet and Blesch, Rudi. *Collage: Personalities, Concepts, Techniques,* Philadelphia: Chilton Book Company, 1969.

Kampman, Lothar. *Creating With Poster Paints.* New York: Van Nostrand-Reinhold, 1968.

Mayer, Ralph. *The Artists' Handbook of Materials and Techniques* (Third Edition), New York: The Viking Press, 1970.

Meilach, Dona Z. and Ten Hoor, Elvie. *Collage and Assemblage,* New York: Crown Publishers, Inc., 1973.

Petterson, Henry and Gerring, Ray. *Exploring With Paint,* New York: Van Nostrand-Reinhold, 1964.

Sheaks, Barclay. *Drawing and Painting the Natural Environment,* Worcester, Mass.: Davis Publications, Inc., 1974.

Sheaks, Barclay. *Painting with Acrylics: From Start to Finish,* Worcester, Mass.: Davis Publications, Inc., 1972.

Woody, Russell. *Painting with Synthetic Media,* New York: Van Nostrand-Reinhold, 1965.

Glossary

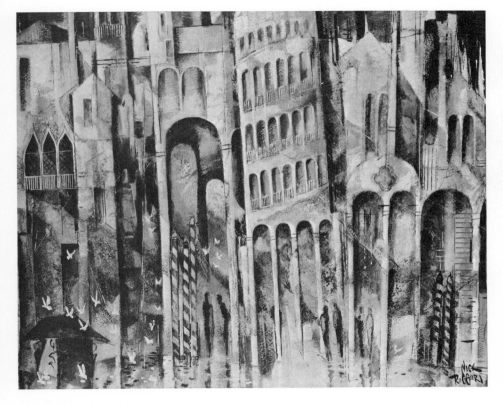

Venetian Quarters. Acrylic. Nick Ruggieri. (Courtesy M. Grumbacher, Inc.) Colors were blocked in over a broad pencil sketch. This was followed by a series of washes and glazes of various colors. Acrylic gloss medium was used to varnish the completed painting.

Alla prima. A method in which a painting is finished in one session with paints applied wet-in-wet without the use of underpainting.

Analogous colors. Colors that adjoin each other on the color wheel. (An analogous color scheme is usually composed of at least three adjoining colors.) Example: yellow, yellow-green and green.

Asymmetrical balance. Often referred to as "informal" balance. In painting, the positioning of unequal elements in such a way that *visual* balance is achieved. For example, a large building on one side of a painting could be balanced by a smaller building *and* a tree on the other side.

Balance. Having to do with stability; *balance* in painting refers to the harmonious adjustments the artist makes among all the elements he uses—line, color, texture, value, form and space.

Complementary colors. Pairs of colors that lie opposite each other on the color wheel. Examples: blue and orange, yellow and violet, red and green.

Color. The surface quality of a form or surface derived from sunlight. An object that is yellow has absorbed all the hues of the spectrum *except* yellow, which it reflects. In painting, color is also used to mean "paint"—dry pigments mixed with liquids which bind and/or extend the pigment.

Emphasis. The importance or stress that is placed on a form or forms in a composition in order to have it appear more dominant, visually. Emphasis may be achieved by *placement, contrast* or *action.*

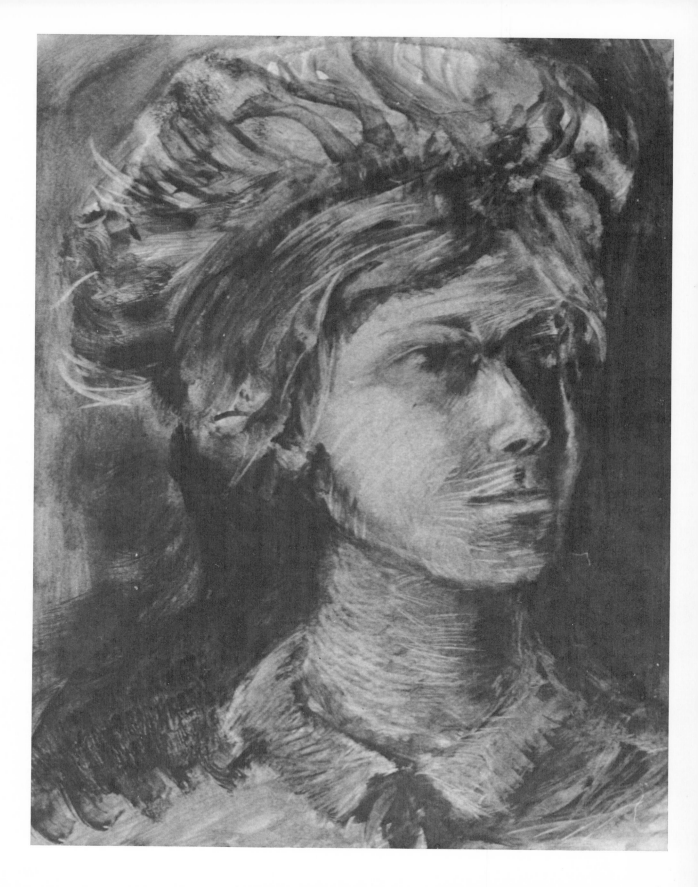

Portrait. Oil wash. Student, John Marshall High School, Los Angeles. Courtesy Beatrice Thompson. The larger areas of light and dark values were applied in washes of thinned oil colors. Highlights and textural lines in the hair, face and clothing were achieved by scratching into the still-wet washes.

Encaustic. From the Greek word *enkaustikos,* meaning to "burn in." In painting, the technique of applying melted wax on a rigid panel. The waxes are applied in a liquid form with brushes or a special tool called a cauterium. Simpler techniques have been developed by modern artists.

Form. The shape or structure of a thing; the three-dimensional appearance of an object or figure, having length, width and depth.

Gesso. A plastic or liquid material that is used to coat a panel to make it more receptive to paint. Because it lacks flexibility, gesso should be used only on a rigid support.

Gouache. Paint that is made by mixing pigments with zinc oxide paste (Chinese white) which makes the colors opaque. In painting, gouache may also refer to the technique of adding white to any watercolor. Poster colors are an example of gouache paints.

Ground. In this text, the support or surface on which the painting is executed. Examples: canvas, paper, hardboard. Ground is also used in referring to the coating that is applied to a panel or canvas prior to painting.

Hue. The name of a color, such as *red, blue* or *yellow.*

Impasto. Thickly applied paint.

Intensity. The degree of brightness or dullness of a color. The intensity of a color is changed by the addition of its complement, the color that lies directly opposite it on the color wheel.

Line. Technically, the extension of a point having length and width. Examples: lines drawn with a pencil or brush. Also, *implied* line, as the separation that is seen when objects overlap in space.

Local color. The actual color of an object, without highlights or shadows.

Mass. The bulk or quantity of matter; in order to have mass, an object must exist in *three* dimensions—length, width and depth. In painting, *mass* is simulated by illusion since the surface of the canvas has only two dimensions—width and length.

Matte. Lacking gloss; a flat finish. Ex.: Tempera and casein paints dry to a *matte* finish.

Medium. This term may be used in three different ways that relate to painting:
1) The liquid in which paint is suspended or carried. Plural: mediums.
2) The technique for expression used by the artist. Example: Van Gogh's *medium* was painting. Plural: media.
3) The paints and related materials used by the artist. Ex.: paint, gesso, brushes. Plural: media.

Montage. A composition or picture made by combining elements such as photographs, magazine illustrations or drawings, either whole or in part.

Mural. A wall painting; mural is derived from the Latin word for wall, *murus.*

Palette. Two meanings:
1) The surface on which the painter arranges and mixes colors.
2) The group of colors chosen for use in a painting.

Pigments. Dry colors from which artists' paints are made. A paint is made by combining a pigment with a binder and/or a vehicle such as oil.

Primary hues. Those hues that can be derived only from nature—red, yellow and blue.

Proportion. Having to do with relationships of height, width, depth and space. In determining "correct" proportions, it is necessary to see a thing in relationship to something else, or how it relates in scale. In painting, proportions may reflect the human scale or may be distorted to heighten a visual effect or emotional quality the artist is attempting to achieve.

Rhythm. An ordered, planned, systematized relation of a part to a part and of a part to a whole. Most commonly, rhythm is achieved by *repetition* but rhythm may also be achieved by *progression* and *continuity.*

Scumble. A thin application of *opaque* color over a dry underlying color. A scumble is usually *lighter* than the underlying color.

Secondary hues. Hues obtained by mixing two *primary* hues. For example, orange is a *secondary* hue made by mixing the *primary* hues of red and yellow.

Shade. A *dark* tone of a color: maroon is a *dark* tone of red; navy blue is a *dark* tone of blue.

Space, positive. An area that is defined by a boundary, line or contour such as a human figure, a tree in a landscape or a vase in a still-life arrangement.

Space, negative. The areas that surround a positive shape. In a landscape, the sky might become the *negative* space surrounding the tops of buildings.

Support: In painting, the surface on which the painting is executed such as paper, board, canvas or Masonite. A support is often referred to as a "ground."

Symmetrical balance. Often referred to as "formal" balance. In painting, the placement of identical elements on either side of a vertical axis so that one side is a "mirror" image of the other.

Tempera. A waterbase paint that is produced by mixing pigments with a vehicle and binder, usually a vegetable glue. Fine temperas incorporate egg yolk as a binder; tempera used in today's classrooms are generally made with glue.

Tertiary hues. Hues obtained by mixing a *primary* color with a *secondary* color. For example, red-orange is a tertiary hue obtained by mixing a *primary* hue, red, with a *secondary* hue, orange. Also called *intermediate* colors.

Texture. The surface quality or "feel" of an object: sandpaper has a "rough" texture, satin is "smooth," fur is "soft." Textures may be natural, as the bark of a tree, or simulated, as in a painting, to imitate an actual texture.

Tint. A *light* tone of a color: pink is a *light* tone of red.

Tooth. A slight roughness or coarseness on the surface of a ground (paper, canvas, board or paint surface) that assists in holding or bonding the paint (chalk, pastel, crayon) to the ground.

Unity. In painting, the quality that is achieved when the art elements and principles of design function together in an integrated way, each supporting the other, in the achievement of a visual harmony.

Value. The degree of lightness or darkness in a color, as compared to white or black. For example: pink is a *light* value of red; maroon is a *dark* value of red.

Varnish. A liquid that is applied to a painting (or other solid surface) to seal, protect or change the surface in some manner. Varnishes vary in transparency, flexibility and strength, depending on their composition.

Wash. A thin, liquid coating of color. A wash of oil colors is often called a "glaze."